PICTORIAL VICTORIANS

PICTORIAL VICTORIANS

The Inscription of Values in Word and Image

JULIA THOMAS

OHIO UNIVERSITY PRESS

ATHENS

Ohio University Press, Athens, Ohio 45701
© 2004 by Ohio University Press
Printed in the United States of America
All rights reserved
Ohio University Press books are printed on acid-free paper ∞ ™

12 11 10 09 08 07 06 05 04 5 4 3 2 1

Library of Congress Cataloging-in-Publication Data

Thomas, Julia, 1971–
 Pictorial Victorians : the inscription of values in word and image /
Julia Thomas. p. cm.
 Includes bibliographical references and index.
 ISBN 0-8214-1591-3 (cloth : alk. paper)
1. Illustration of books, Victorian—Great Britain. 2. Illustration of
books—Great Britain—History—19th century. 3. National characteristics
in art. I. Title.
NC978.T48 2004
741.6'4'09410903 4—dc22
 2004010773

CONTENTS

ILLUSTRATIONS

Plates

Figures

ACKNOWLEDGMENTS

So many people have been generous with their help and advice during the writing of this book. The research originated during my time as a special research fellow and I am indebted to the Leverhulme Trust for giving me the opportunity to work on this and other projects. In particular, I would like to thank Robin de Beaumont, Karen Gardner, Paul Goldman, Lorraine Janzen Kooistra, David Sanders, and Andrew Williams. The images were tracked down with the help of Lynda Nead, Christopher Wood, Rachel Boyd at Richard Green Fine Paintings, and staff at the Bridgeman Art Library, London. Rob Thomas had the unenviable task of scanning them. A special mention must go to Neil Badmington for being such a wonderful neighbor, to David Skilton for his expertise in ladies' underwear, and to Catherine Belsey for everything.

Friends and family have been supportive throughout. My father has never wavered in his encouragement, and my mother fostered a childhood fascination with illustration by reading to me from countless Ladybird storybooks. Those pictures are etched in my memory. Stuart has contributed more than he will ever know, not least in the diversions that have made the writing of this book seem so easy and pleasurable.

Versions of chapters 1 and 6 appeared in *Visual Culture in Britain* and *Nineteenth-Century Contexts* (http://www.tandf.co.uk).

PICTORIAL VICTORIANS

INTRODUCTION:
WAR AND PEACE
Word and Image in Mid-Victorian Culture

I

Perhaps the best way to begin a book about pictures that tell stories is to tell a story about a picture. The year is 1857 and the Art Treasures exhibition has opened in Manchester to much critical acclaim. But not everyone is happy with the "treasures" on display. Amid the excited chatter echoing around the gallery on this particular day comes a voice of dissent. It emanates from a female spectator engaged in a heated dispute, not with a fellow visitor, but with one of the paintings. To her horror, the picture shows a kept mistress, perched on her lover's knee, who has suddenly realized the error of her ways. The *risqué* subject matter is too much for this viewer, and she denounces the artist for daring to paint a "what-d'ye call."[1] There is, however, a swift response to her complaints, and from a rather unexpected quarter. As she finishes speaking, the mistress answers back from the canvas, justifying her position by declaring that she and the other objects in the painting are there for a purpose: to strike horror into "bad men" and to provide a warning to "right-minded girls."[2] She concludes by attempting once and for all to silence her critic:

> *So, Madam, please to moderate the rancour of your tongue;*
> *For, as I have observed before, I'm neither fair nor young.*
> *Yet let me hope the whole effect,—my features wan and pale,*
> *At least may point a moral, if they can't adorn a tale.*[3]

This story is all about "tales." It comprises the opening poem in a book of verses and caricatures written by "Tennyson Longfellow Smith," and takes its inspiration from another "tale": William Holman Hunt's narrative painting, *The*

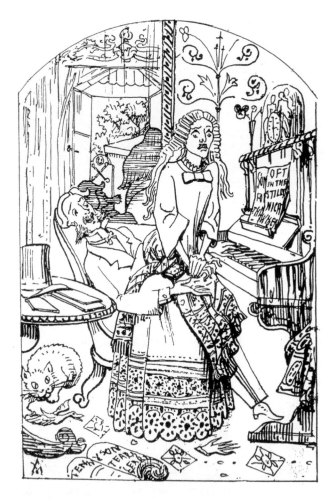

Figure 0.1 "The Awakened Conscience," *Poems Inspired by Certain Pictures at the Art Treasures Exhibition, Manchester,* by Tennyson Longfellow Smith (Manchester, 1857).

Awakening Conscience (plate 1). Stories, it seems, can be found in images as well as texts. Not only is Tennyson Longfellow Smith's comic verse about a picture that tells a story, but it is illustrated by a *Punch*-like caricature of Hunt's painting (figure 0.1).

Smith's volume, although not quite the work of literary genius that his full name aspires to, succeeds in bringing together the two genres that dominated Victorian Britain and are the focus of the following study: narrative painting and illustration. Smith reworks the stories told in a number of Pre-Raphaelite images shown in the Manchester exhibition as parodic poems and pictures. To us, looking back on the mid-nineteenth century from a multimedia society that is so similar and yet so different, it is these two modes of representation that

stand out and seem almost alien: our novels do not usually have pictures; our art tends to despise storytelling. Perhaps it is because of their otherness that narrative painting and illustrated texts have come to define the Victorian period and to shape our understanding of what this period is. Our idea of these years seems inseparable from chocolate-box genre scenes and wood engravings of crinolined women and men in stovepipe hats. I am not suggesting, of course, that these genres were specific to the mid-nineteenth century, or even to Britain. Rather, I examine the factors that made them so popular that at this historical moment one critic could assert, without a hint of irony, that a picture "rises in the scale of art in proportion as it is a story,"[4] and another could describe illustrated books as "a distinctive feature of the age."[5] It is not so much that these genres were distinctly Victorian, but that the Victorians attempted to create a distinct identity for them, to differentiate them from their appearance in other times and cultures.

The identities that were created for these genres involved cementing the relation between them. As Martin Meisel has suggested, this was a culture in which different art forms coincided: plays, paintings, and novels adopted common styles and subject matters in a way that cut across generic boundaries.[6] In the case of illustration and narrative painting, this was intensified by the fact that throughout this period it was painters themselves who illustrated texts. Artists like John Everett Millais, Arthur Hughes, and Luke Fildes made their livings by both painting and designing plates to accompany literature. The common concerns of illustration and painting could be seen even in the work of those earlier illustrators who were not known as painters. George Cruikshank and Hablot K. Browne ("Phiz") looked back to the satiric prints of Rowlandson and Gillray, but were also influenced by Hogarth.[7] Indeed, it is Hogarth who provides the closest link between narrative painting and illustration because, in addition to his moralistic and symbolic images, which inspired Victorian painting, he came increasingly to be regarded as the founder of British illustration.[8] In 1890, when Fildes discussed the influence of the art of the illustrator on the art of the painter, he identified Hogarth as "the great Father of the English Illustrators."[9]

Fildes's assertion is surprising considering that, in relation to his total output, Hogarth undertook relatively few commissions that could strictly be described as illustrations, but it does suggest the ways in which Victorian illustration and painting adopted the same narrative elements. At times, painting and illustration even looked alike. Narrative pictures were widely reproduced as engravings, and this diminished the visual differences between them and the images found in books and periodicals.[10] A Victorian audience, therefore, might have regarded these types of representation not as necessarily separate entities, but as

part of the web of practices and discourses that circulated in their rich multi-media culture.

This is not to deny the distinct ways in which these genres make their meanings. When Fildes turned one of his illustrations into a narrative painting, he was compelled to make a number of changes to the image to increase its effectiveness in the new format. *Houseless and Hungry*, an engraving that showed an impoverished group of people queuing for tickets to stay overnight in the workhouse, originally appeared in the *Graphic* magazine in 1869, where it was placed alongside an article on the Houseless Poor Act. When the picture was reproduced as the painting *Applicants for Admission to a Casual Ward* (1874), this lengthy narrative was replaced by a short passage from a letter by Charles Dickens. But the painting was in many ways independent even of this text, Fildes's addition of symbols and dramatic episodes giving it more visual impact than the illustration and enabling it to tell its own, relatively autonomous, story.

The problem with discussing the similarities and differences between narrative painting and illustration, however, is that the genres themselves are not homogeneous. One cannot simply identify their distinct requirements by pointing to the modifications that occur in the transformation from one to the other, because each of these categories is constituted by subgenres with their own characteristics and modes of address. An illustration in a magazine like the *Graphic* signifies differently than an illustration that appears in a novel, while the conventions of a social realist painting are distinct from those of genre painting. "Narrative painting" is, after all, an umbrella term for what the Victorians called "scenes from everyday life," "literary," "genre," "historical genre," "anecdotal," "domestic," or "subject" pictures. John Ruskin used the term "poetical paintings" to describe images that told stories, but even this category was not uniform, since it included a hierarchy of "poetical" images, with literary and historical pictures subordinate to those paintings in which the artists attempted to "write" their own stories.[11] In the same way, Victorian illustration was never the stable, unified practice that such a classification implies. It is easy to lose sight of the extraordinary diversity that characterizes the illustration of texts in the mid-nineteenth century, to forget that the label "illustration" encompasses a variety of publications, all with different pictorial conventions (magazines, journals, newspapers, fictional and nonfictional books, posters), as well as different mechanisms of reproduction (wood, copper and steel engraving, etching, aquatint, mezzotint, lithography, photography), not to mention the different styles adopted by individual artists.

In the light of the diverse practices that make up illustration and narrative painting, a book like this one, which juxtaposes the two, might seem mis-

guided. Certainly, the majority of critics have tended to view each genre in isolation, as a mode of representation that signifies in its own specific way. I suggest, however, that there is one characteristic that unites them, even in their differences: they both combine the textual and visual, displaying the union between "pen and pencil" that Gerard Curtis has identified as a key feature of mid-nineteenth-century culture.[12] Illustration depicts, or "pictures," textual narratives, amalgamating word and image on the printed page, while Victorian paintings assume the role of "picture-narratives," telling stories and employing written devices, such as titles, quotations, and pictured words, that allow them to be "read." The hybridity of these genres seems surprising, especially considering the continued influence of Gotthold Lessing's *Laocoön*, a book that was originally published in 1766 and went through several editions, translations, and reprints in the mid-nineteenth century. Lessing argues for a strict demarcation between the so-called "sister" arts, on the grounds that each genre has different characteristics that should determine its content: painting is visible and stationary, its figures and colors coexisting in space, while poetry is progressive, its parts occurring one after the other. By asserting that the pictorial is most suited to the depiction of one single moment, a body arrested in time, Lessing's thesis seems to be at odds with Victorian illustration and narrative painting, which attempted to represent sequential events.[13]

Victorian narrative painting and illustration crossed the boundary between text and image. This overlap was even more explicit because words themselves were frequently part of these images, whether as the writing that accompanied an illustration, the title of a painting, or texts that appeared in the picture and told its story. *The Awakening Conscience* employs many of these devices, with its painted music sheets, a quotation from Proverbs on the frame, and biblical citations in the exhibition catalogue. Such an intertwining of the visual and textual, particularly in the context of a painting that tells a story, works to subvert the idea that there is a fixed distinction between these realms. The construction of narratives is not just a textual activity but one that can take place in a visual arena, while the inclusion of writing within the space of an image emphasizes its own graphic nature. Even the interpretation of such pictures depends not solely on perception or reading, but on an interaction between them that throws into question any idea that either process should be seen as self-contained. Illustration requires the viewer to shift between words and images, and this is also a feature of the narrative painting. In George Bernard O'Neill's *Public Opinion* the dual process of gazing and reading is the subject of the picture itself (plate 2). Here the visitors to an art gallery look alternately between image and text, their exhibition catalogues on prominent display. In the right foreground of the

painting a mother trains her child to "read" pictures, pointing to the relevant passages in the catalogue.

It is this alternation between the visual and textual that generates the meanings of narrative painting and illustration, allowing them to be read as one would read a text. But this does not necessarily imply that images work in the same way as words. Ironically, David Wilkie, the Scottish painter largely credited with reviving narrative painting in the nineteenth century, took his cue from Lessing and argued for an acknowledgement of the differences between text and image. His *Remarks on Painting* argues against the idea that they are interchangeable: "words, though they represent ideas very imperfectly, cannot express pictures: but though words do not express pictures, neither do pictures represent words."[14] Some years later similar concerns were voiced by Elizabeth Eastlake, who vehemently contested Ruskin's assertion that painting is "a noble and expressive language."[15] Eastlake criticizes Ruskin's account as "erroneous," insisting that painting is valuable only to the extent that it differs from other art forms.[16]

Eastlake's rejection of the comparison between poetry and painting, however, is not an objection to the use of the word "language" to describe both genres; rather, she argues that each art has its own essential "language." But for more recent critics it is the use of this signifier that is central to debates about the relation between word and image.[17] Questions of whether an image can be "read," of whether the pictorial is a sign system governed by culture and convention, have come to a head with the increase in semiotic analyses of visual material and the focus on the interplay between the textual and visual.[18] Critics such as Norman Bryson argue that art is bound up in language and, like language, is a site of power that is culturally constituted and constituting.[19] Others, however, emphasize the difference of the visual. David Summers uses the phrase "linguistic imperialism" to describe the equation of art with words that he believes has taken place in theoretical movements like structuralism, poststructuralism, and semiology.[20] According to Summers, art is not a language and cannot be explained in terms of theories of language, but makes its meanings in distinct and unique ways.

Summers lays part of the blame for "linguistic imperialism" on painting itself. It is easy for critics to make the analogy between text and image and repress the difference of art because traditionally Western images are so "textlike," denoting the object that they refer to in the same way as descriptive words.[21] Naturalistic and mimetic paintings encourage an analogy between text and image because they conceal their painterly difference—an effect that would, presumably, be exacerbated in the case of the Victorian narrative picture, with its scenes of contemporary life and abundance of minutely rendered objects. In

fact, Summers reaches a conclusion similar to that voiced in 1934 by Roger Fry, who argued for the subordination of narrative images because they seduced critics into analyzing the content of pictures, rather than paying attention to artistic otherness, what Summers calls art's "unsayable" quality.[22]

Even if Summers is right, is it so easy to divorce the textual and visual in genres like narrative painting and illustration, which depend precisely on a relation between words and images? These art forms do not fit into one category or another: they cannot be wholly classified as texts, but neither are they purely imagistic. The interaction between the two modes is intensified in mid-nineteenth-century illustration, with the popular technique of wood engraving allowing pictures and words to be printed together on the same page. Victorian illustration is characterized by vignettes that appear in the space of the text and pictorial letters that combine word and image.

Perhaps the problem with the accusation of "linguistic imperialism" lies in the very definition of what is a "language-based" approach to art. Ferdinand de Saussure, the first exponent of semiotics, was a linguist, but his theory cannot be categorized simply as a theory of language: to say that an image is a signifier is not the same as saying it is a word. Saussure asserts that, even though linguistics is the "master-pattern," language is only one example of a semiological system.[23] Signifiers include, but are not restricted to, words. They can also be visual: a set of traffic lights, or the symbols that distinguish male and female lavatories. In a fundamental way Saussure's theory actually discounts the idea that word and image are the same, because at its core is the notion of difference between signs. Admittedly, this idea of difference is itself very different than those essential qualities of images identified by Lessing and Eastlake and intimated by Summers, but it does suggest that while word and image are bound up in each other they cannot be reduced to each other's terms. For Saussure, difference is not based on a sign's unique and positive characteristics but is generated by the signifying system itself, in a sign's negative relation to other signs. Each sign gains its value from being what the other signs in the system are not: a picture acquires meaning to the degree that it is not a text, a book, a word, and so on.

This notion of difference is negative, but it is also relational: it depends on the coexistence and interdependence of other signs. Jacques Derrida has elaborated this theory to argue that if a signifier gains its value by its difference from another signifier then it must include the trace of that other, an allusion to the excluded meaning. These theoretical ideas provide the framework for my examination of illustration and narrative painting in the mid-nineteenth century, because it is this presence of the other within the self-same that the constant play

between the visual and textual in illustration and narrative painting exposes. As Derrida states, "[T]he works of art that are the most overwhelmingly silent cannot help but be caught within a network of differences and references that give them a textual structure."[24] But this does not mean that images are ever identical to texts: a relation between genres is not the same as an equivalence; a visual signifier is not the same as a verbal signifier. Indeed, I would argue that, far from being one and the same, these modes of representation are in constant dialogue.

The following chapters focus on this dialogue between word and image as it manifests itself in the form of the narrative picture and the illustrated text, as well as on the ways in which this dialogue generates specific stories. Although this aspect of meaning production is relatively unexplored in the case of narrative painting,[25] the relation between text and image in nineteenth-century illustration has been the subject of recent critical attention. Collections of essays such as Catherine J. Golden's *Book Illustrated* and Richard Maxwell's *The Victorian Illustrated Book* have attested to the cultural significance of the genre, as has the work of critics like J. Hillis Miller and Lorraine Janzen Kooistra.[26] Kooistra argues for a "bitextual" approach to illustration that employs mechanisms of visual and verbal interpretation, in order to show how the interaction between pictures and words produces meanings. But this relation, however intimate, does not necessarily bring with it an erasure of artistic boundaries. The Victorian illustrated text has frequently been seen as a divided genre, in which image and word fail to coincide.[27] Its disharmony exposes the fact that these texts amalgamate art forms that do not function in the same way. Mid-nineteenth-century illustration, then, does not disguise but *insists* on Saussure's negative relation between signs, the fact that the pictorial and textual make their meanings in their difference from each other.

Ironically, this was apparent even in Victorian accounts of illustrated books that emphasized the "suitability" of image and text. A review of an illustrated edition of Tennyson's *Enoch Arden,* which appeared in the *Athenaeum* in 1865, is typical in this respect. In praising the illustrator, Arthur Hughes, for demonstrating "a remarkable and valuable example of aptitude on the part of an artist to illustrate a particular poem," the review not only evaluates the book in terms of the relation between pictures and words, but also acknowledges the fact that they are not identical, and does so, moreover, at the very moment that it alludes to the fidelity of the images.[28] If the genres were exactly the same then there would be no need to discuss how they "fit" together. In fact, the whole notion of pictures and texts as seamlessly overlapping was undermined by actual illustrative practice, in which it was common for a publisher or engraving firm to sell off used blocks or steel plates for publication elsewhere. Gift books reproduced illustrations outside their original settings, and these pictures were sometimes ac-

companied by texts different from those that they were intended to illustrate. One contemporary reader commented on how the pictured heroes and heroines in novels by Walter Scott turned up again in the most unexpected situations.[29]

The relation between the textual and visual, therefore, does not necessarily result, as Summers seems to imply, in their conflation; it does not lead as a matter of course to a "deep comparison" that "conceals" art from our understanding and erases its difference.[30] On the contrary, the juxtaposition of text and image in illustration and narrative painting can work to throw that difference into relief, to expose the boundaries between the two, the very points at which any "comparison" collapses. Whether consciously or not, viewing an illustration involves "testing" the suitability of pictures and words, an assessment that is grounded in the notion of their noncoincidence, the fact that they are similar but not the same. This seems to have been acknowledged by Victorian writers themselves. George Eliot wrote somewhat despairingly to Frederic Leighton, the illustrator of one of her novels, that "illustrations can only form a sort of overture to the text. The artist who uses the pencil must otherwise be tormented to misery by the deficiencies or requirements of the one who uses the pen, and the writer, on the other hand, must die of impossible expectations."[31]

While Eliot's recognition that texts and images have their own "requirements," and the corresponding implication that one genre cannot simply be translated into another, seem to suggest that the picture has a certain freedom to pursue its own ideals, there is also a hint here of the hierarchical distinction between word and image that can be found in other Victorian accounts. Eliot's understanding of illustration as an "overture" to the text, a prelude or frontispiece that can, presumably, be dispensed with, can be seen in the light of B. E. Maidment's recent description of the Victorian period as a "verbal" culture, characterized by its move away from a belief in the sufficiency of the graphic image to the dominance of texts.[32] Ironically, Eliot's remark owes something to the Victorian assumption that images should come *after* rather than before words. As one writer on illustrated books commented, "the painter should follow the writer, and not precede him"; "follow," of course, suggests both that the image is of secondary importance compared to the text and that it should take the text as its guide.[33] At times, however, the artist was unable to "follow" the text at all, for critics frequently identified the "excess" of great literature, the points at which it could not be transformed into the visual: "Thoughts and words, arguments and consolations, are things which even a Raphael could not draw, nor a Titian paint," observes a reviewer of "Picture-Books" in *Blackwood's Edinburgh Magazine* in 1857, and he justifies his opinion by pointing to Millais' designs for Byron's *Dream* in *The Poets of the Nineteenth Century,* which might be impressive but did not quite match the brilliance of the text: "[I]t is

not, perhaps, within the reach of 'black and white' to express that tenderest blending of impulses, or to come up to the description of this unrivalled poem."[34] The relation between visual and verbal was not a stable one in the mid-nineteenth century, however. The power of the image was heralded even from the outset of the illustrative revolution, and as early as 1844 critics were warning that "those means, which at first were called in to aid, now bid fair to supersede much of descriptive writing: certainly they render the text of many books subsidiary to their so-called illustrations."[35]

II

Even as it generates the meanings of narrative paintings and illustrations, the relation between text and image renders these meanings unstable and undecidable. This is a relation that is always in process, renegotiated from one picture and historical moment to the next. It is a relation not just of difference in the Saussurean sense of the word but of Derrida's "differance." "Differance" names the impossibility of full intelligibility in a system in which a stable or present meaning is constantly "deferred" or postponed. This notion has some striking implications for the narrative painting in particular, because it suggests that the story that the narrative painting tells is not self-evident or fixed. Despite the outspoken objections of the spectator in the Manchester exhibition, even a seemingly transparent image like *The Awakening Conscience* can evoke multiple interpretations.[36] In fact, the indeterminacy of its narrative was the source of some irritation to Ruskin, who wrote a letter to the *Times* in which he attempted to correct what he saw as misreadings of the painting:

> There is not a single object in all that room—common, modern, vulgar (in the vulgar sense, as it may be), but it becomes tragical, if rightly read. That furniture so carefully painted, even to the last vein of the rosewood—is there nothing to be learnt from that terrible lustre of it, from its fatal newness; nothing there that has the old thoughts of home upon it, or that is ever to become a part of home? Those embossed books, vain and useless—they also new—marked with no happy wearing of beloved leaves; the torn and dying bird upon the floor; the gilded tapestry, with the fowls of the air feeding on the ripened corn; the picture above the fireplace, with its single drooping figure—the woman taken in adultery; nay, the very hem of the poor girl's dress, at which the painter has laboured so closely, thread by thread, has story in it, if we think how soon its pure whiteness may be soiled with dust and rain, her outcast feet failing in the street; and the

fair garden flowers, seen in that reflected sunshine of the mirror,—
these also have their language—

> *"Hope not to find delight in us, they say,*
> *For we are spotless, Jessy—we are pure."*[37]

Ruskin's letter provides a fascinating insight into Victorian ideas about
how pictorial narratives were "written" and how critics felt they ought to be
"read." It also wonderfully anticipates Derrida's notion of the "trace," the ex-
cluded meaning that is always present in a system based on differance. This
painting signifies in what it does not show: the old furniture and worn books,
which expose the superficiality of their newer pictured counterparts; even the
white hem of the girl's dress makes its meanings in relation to what it is not—
"soiled." Such an interpretation might itself provide a clue as to why Ruskin
was motivated to write to the *Times* in the first place. Because it is an image of
traces rather than presence, because it relies on gaps being filled and connec-
tions being made, the narrative picture is subject to the plural interpretations
and "misreadings" that the critic so abhors. But even Ruskin is not immune
from this slippage of meaning. However persuasive his account of *The Awak-
ening Conscience* might seem, it does not tell the whole story. Kate Flint has ar-
gued that he mistakenly identifies the picture hanging on the wall in Hunt's
painting as a representation of the woman taken in adultery because it fits so
neatly into his analysis.[38]

Ruskin's "mistake" is curiously paralleled by one that Tennyson Longfellow
Smith makes in his interpretation of *The Awakening Conscience,* and this is also
bound up in the mode of spectatorship that the narrative picture demands.
Smith views the scene reflected in the mirror behind the couple not as a "gar-
den" but as a churchyard. The accompanying picture in Smith's book makes this
explicit in its depiction of a gravestone complete with skull and crossbones. The
model who speaks from the canvas even justifies Hunt's inclusion of this setting:

> *I own my windows don't, in fact, look on the church-yard sod,*
> *But Mr. H. would have it so, being obstinate and odd.*
> *'Twould give such force, he said—was full of meaning, dark and sad;*
> *And really, as he's managed it, it doesn't look so bad!*[39]

The Awakening Conscience, however, contains no graveyard and certainly no
gravestone.

Smith's "sight" of these signifiers that to other viewers remain invisible
suggests how the narrative painting is interpreted in the light of cultural refer-
ences and expectations. His misrecognition stems from the fact that he associ-
ates the fallen woman with death, a connection that was frequently made in

contemporary texts and images, most memorably in Thomas Hood's poem "The Bridge of Sighs" (1843), which described a drowned prostitute being dragged from the river.[40] This is not to say that Smith simply represents his fallen woman as irretrievably lost or situates death as her only escape. On the contrary, he refuses to depict her as an object of either sympathy or disdain—dual positions that, according to Lynda Nead, characterize the construction of the fallen woman in the mid-nineteenth century—but transforms her instead into a comic figure, a forerunner of Thomas Hardy's "ruined maid," who is funny because of the very pride that she demonstrates in her fallenness.[41] It is in his inclusion of the gravestone, however, that Smith betrays his dependence on the stereotype of the sexually fallen woman as tragic victim, reading into the painting the story of female transgression that was most common in the cultural moment at which he was writing. What he marginalizes is the tale that the picture also tells and that was coming to prominence in these years: the possibility of spiritual redemption for the fallen woman, which was given its most conspicuous voice in Elizabeth Gaskell's *Ruth,* published in 1853, the year that Hunt began work on this painting.

The construction of this emergent story depends on a very different viewing of the scene reflected in the mirror, not as a graveyard, a signifier of death, but as an embodiment of the rebirth and glory of the natural world, which for the Pre-Raphaelites, as for the Romantics before them, was an aspect of the divine. In this context, the natural setting is a reminder of the woman's former innocence, as Ruskin recognizes, but it also indicates the heavenly source of her awakened conscience. Hunt, in fact, regarded this painting as the counterpart to his *The Light of the World,* a picture in which Christ is shown knocking on the door of the soul.

Smith's reading of *The Awakening Conscience* demonstrates the inability of the painter to curtail the meanings of the narrative painting. The Victorian illustrated text, on the other hand, seems to be more controlled, or at least this is the suggestion in traditional accounts of the genre, which locate its meanings in its mode of production, and, in particular, the relation between the author and the artist commissioned to picture his or her texts. This is the approach adopted in classic works like N. John Hall's *Trollope and His Illustrators* and John Harvey's *Victorian Novelists and Their Illustrators,* and it continues to dominate discussions of illustrated books.[42] Although such analyses have been invaluable in highlighting the importance of illustration as an object of study, they tend to marginalize the role of the reader in generating meanings, a role that is vital to an understanding of illustration.[43] What I suggest in this book is that the meanings of illustration, like the meanings of narrative painting, are made in the interaction between word, image, and viewer, and it is this inter-

action that allows for multiple interpretations, the spectators bringing their own cultural assumptions to bear on representations that are themselves culturally constituted.

A desire to keep this plurality at bay seems to form the basis of Victorian expressions of authorial and artistic control. The popular view—popular among writers, at least—was that pictures should not add to or detract from the text, but should reproduce it, providing a mirror image or transcription of the words. Anthony Trollope, for example, congratulated Millais for creating illustrations that seemed perfectly to capture the author's words. Beneath such praise lies the potential danger of a polysemous image, which only language can hold in check. This is also suggested in Dickens's famous attempts to retain as much control over the illustrations of his texts as possible, selecting the two scenes to be pictured in each installment of his novels and sending detailed descriptions, along with a copy of the text concerned, to the illustrator, who would then design the plates and send them back to the author.[44] It was only at the end of Dickens's career, when Luke Fildes, who was commissioned to design the plates for *The Mystery of Edwin Drood,* complained that Dickens always chose the most textually descriptive scenes for illustration, that the author agreed to let the illustrator pick his own subjects, though the final approval of the drawings lay with Dickens.[45]

Dickens and Trollope might well have shared Mark Twain's view that a picture "means nothing without its label."[46] For Twain, the superior power of words over images is epitomized in Guido Reni's painting *Beatrice Cenci the Day before her Execution,* which, according to the writer, had crowds of weeping spectators before it, who would inspect it unmoved if they were unaware of the title and might even think it was a depiction of a "Young Girl with Hay Fever" or a "Young Girl with her Head in a Bag."[47] In fact, it is not that a picture means "nothing" here, but that it means too much; any number of titles or captions could potentially be appended to it, but the presence of each one would delimit the picture's signification. Language, then, imposes a necessary restraint on the visual, neutralizing the threat that its undecidability poses.

But are things really this simple? Perhaps the image is not as plural as Twain suggests. Edward Hodnett has argued that it is not, that it is actually the picture that "interposes a precise image for the unfettered suggestions of words," and this assertion is also found in the decades that preceded the mid-nineteenth century.[48] Sam Smiles has pointed to the development of discourses between the 1770s and 1820s that recognized images as more clear and intelligible than words and more truthful than the most descriptive text.[49] In addition to their implications for the visual image, of course, such arguments make assumptions about texts: Twain implies that the text is stable in relation to the

image, and Hodnett and Smiles make a case for textual ambiguity. Perhaps the truth of the text cannot always be relied on, or at least it is more problematic than Twain seems to suggest. As part of a signifying system that is plural and unstable, the meanings of both pictures and words are multiple, rendering any absolute control over the image an impossibility.

Paradoxically, it is this lack of textual authority that is implicit in mid-nineteenth-century attempts to curb the meanings of the visual, including those enacted by Dickens and voiced by Trollope. Ingrained in their mistrust of pictures is a concern about how the images might work with—and even *on*—the text if the command of the writer/text were relinquished. Ultimately, this is a fear more about words than images. If an artist needs such restraint and guidance in order to reproduce the author's intentions, then perhaps these intentions are not obvious or transparent to begin with. Illustration exposes the fact that texts are never in the author's control, nor are their meanings singular or fixed: an illustration is an interpretation or "reading" of the text, and, as such, can conflict with other readings.

This possibility had been glimpsed at the end of the eighteenth century with the creation of the Boydell Shakespeare Gallery, a financially disastrous artistic venture that continued to evoke discussion in Victorian Britain. In 1786 John Boydell, a London alderman, had the idea of asking leading artists to paint scenes from Shakespeare's plays, which would then be displayed in a gallery and made into engravings to illustrate a folio edition. Charles Lamb was scathing in his criticism of the scheme: "What injury did not Boydell's Shakespeare Gallery do me with Shakespeare. To have Opie's Shakespeare, Northcote's Shakespeare, light-headed Fuseli's Shakespeare, wooden-headed West's Shakespeare, deaf-headed Reynolds' Shakespeare, instead of my own and everybody else's Shakespeare! To be tied down to an authentic face of Juliet! To have Imogen's portrait! To confine the illimitable!"[50] David Bland reads this remark as "an indictment of all illustration," but it also inadvertently suggests illustration's strengths.[51] Illustration highlights textual plurality: in a perverse way it makes Lamb aware that Shakespeare's texts are "illimitable," that his view of the plays does not coincide with Fuseli's, Opie's, or the other Academicians. The pictures do not "tie down" or "confine" the meanings of the text, but, by emphasizing one particular interpretation, have the capacity to make the viewer aware of others. What is revealing is the fact that Lamb does not see these images in relation to a self-contained and monolithic text: he does not want to see Shakespeare's Shakespeare; "Shakespeare" here is nothing more than a floating signifier, the meanings of which change from one viewer/artist to the next.

In the case of Victorian critics, Lamb's apparent objection to illustration was turned on its head: illustration was dangerous not because it was seen to

confine meanings, but because it engendered them, demonstrating, as Ruskin noted, "how variously the same verses may affect various minds."[52] Images here are what words come up against; they show the points at which textual authority breaks down. Indeed, George Eliot's apparent subordination of the visual by the textual can perhaps be seen in the light of this realization, and as an attempt to counteract it. Derrida makes a similar point: "There exists, on the side of such a mute work of art, a place, a real place from the perspective of which, and in which, words find their limit. And thus, by going to this place, we can, in effect, observe at the same time a weakness and a desire for authority or hegemony on the part of discourse, notably when it comes to classifying the arts—for example, in terms of the hierarchy that makes the visual arts subordinate to the discursive or musical arts."[53]

III

The chapters that follow draw on the idea that it is the relation between word and image that defines Victorian painting and illustration. I agree with Meisel that these genres are best understood as both narrative and pictorial.[54] But I also go a step further. While the majority of critical discussions focus on *how* these genres signify (the artistic mechanisms they employ, their modes of production, and so on), this analysis looks at *what* they signify, and, indeed, the ways in which these two aspects of signification are connected. Meanings are generated, I suggest, in the very interaction between the textual and visual, the points at which they coincide and conflict. These meanings, moreover, are highly political because they are bound up in the cultural events and assumptions that mark the moments of their creation and circulation, from issues of national and international significance (slavery and colonization) to those that are seemingly more domestic (what women should wear and how they are meant to behave).

It is this notion of meaning that is at stake in Derrida's account of the establishment of a hierarchy of arts. His vocabulary suggests that the dialogue between word and image is not merely an aesthetic issue; texts and images are defined in hegemonic terms: they can be "subordinate" or "authoritative"; they involve "weakness" and "desire." This is not a neutral language. This is the language of power. W. J. T. Mitchell has argued that the relation between word and image is always defined in these terms, a factor revealing that this relation is not natural or essential but the inscription of cultural values and interests. "What is it that makes the relation of texts and images a matter for polemical dispute rather than neutral, technical description?" asks Mitchell, and his answer is that the relation itself is ideological, inseparable from questions of class, race, and

gender.[55] While the word-image relation is always political, however, the precise nature of its politics is informed by the meanings that constitute its historical context. This is the basis of Mitchell's argument in *Iconology*:

> The dialectic of word and image seems to be a constant in the fabric
> of signs that a culture weaves around itself. What varies is the precise
> nature of the weave, the relation of warp and woof. The history of
> culture is in part the story of a protracted struggle for dominance be-
> tween pictorial and linguistic signs, each claiming for itself certain
> proprietary rights on a "nature" to which only it has access. At some
> moments this struggle seems to settle into a relationship of free ex-
> change along open borders; at other times (as in Lessing's *Laocoön*)
> the borders are closed and a separate peace is declared. Among the
> most interesting and complex versions of this struggle is what might
> be called the relationship of subversion, in which language or im-
> agery looks into its own heart and finds lurking there its opposite
> number.[56]

The struggle for dominance between word and image Mitchell describes, although occurring in different historical periods, is not transhistorical or universal, but dictated by its cultural moment.

The moment that is central to this book is the mid-nineteenth century, a period in which British imperial progress was underway and under threat, when the division between the sexes was fiercely upheld and consistently eroded, and when narrative painting and illustration reached the height of their popularity. It might seem irreverent to equate these circumstances, to allude to colonization and patriarchy in the same breath as the domination of popular art forms, but I argue that these events are intertwined. This book focuses on the ways in which cultural questions of national and racial identity, gender and sexuality, are inscribed in genres that combine the textual and visual, and it attempts to explore the links between the stories that these genres tell and their dual ways of telling them. I aim, in other words, to move away from the idea that such images are "uncontroversial, undemanding and intelligible," as Mary Cowling has recently asserted, and to adopt instead a critical practice that politicizes narrative painting and illustration and identifies the points of intersection between the word-image relation that they generate and cultural values and ideologies.[57]

I am not suggesting, however, that these art forms simply reflect their cultural context, tempting as it might be to view a genre like the narrative picture as documentary evidence of the Victorian world.[58] Maidment warns that one should be suspicious of any version of the past created by the visual image. Pictures never provide naturalistic or authentic evidence, because they make their

meanings out of artistic conventions and traditions and rely on the reader's ability to interpret their codes. According to Maidment, images do not represent reality, but are ideological formations "shaped" by culture.[59]

But perhaps images are not simply "shaped" by culture; perhaps they also work to "shape" it, to determine what culture is. Culture, after all, is constituted by representations; it does not exist separately from them but is produced in these discourses and practices. Narrative painting and illustration are *part* of a culture that is itself both textual and visual, and, as such, they play a part in generating values. This is apparent even in attempts to define these genres as reflective rather than constitutive of ideology. Musing at the end of the nineteenth century on the art of previous ages, Walter Crane linked illustration and painting, remarking, "If painting is the looking-glass of nations and periods, pictured-books may be called the hand-glass which still more intimately reflects the life of different centuries and peoples, in all their minute and homely detail and quaint domesticity."[60] Ironically, Crane's very vocabulary undermines his argument and suggests that neither paintings nor illustrations are ever simply mirrors. The universal truth about art that he posits is framed by his own cultural context: "nations," "homely detail," and "domesticity" are the very values of the society in which he is writing.

But how do these values emerge, where do they come from, and why do they seem so natural that Crane can hold them up as transhistorical? Perhaps the answer lies in the art forms themselves. The ideologies implicit in Crane's words cannot be identified as ideologies because they are naturalized in the very paintings and picture-books that he describes, genres that appear so real that they seem to reflect a truth external to themselves, to mirror the world rather than construct it. It is in this way that visual images generate meanings. As Peter W. Sinnema asserts, "[A]n image is acceptable to the reader, or makes sense as a valid representation, when it aligns itself with the reader's own assumptions about the 'way things are.'"[61]

The depiction of the "way things are" in the narrative painting and illustration, however, is never fixed or stable. Pictures are part of a signifying system invaded by differance, in which each signifier contains the trace of its other and a full and present meaning is constantly deferred. Even the most propagandist wood engraving can be read against the grain. In the case of narrative paintings and illustrated texts differance is doubled: it functions not just in texts or pictures, but in the very interaction between them that determines their identity and renders it precarious. In the mid-nineteenth century this identity is splintered and fragmented. The relations between word and image that Mitchell sees as spanning different periods coexist in this one cultural moment. The idea that illustrative pictures should simply reproduce words competes with the notion that images

could generate their own meanings alongside, or even independent of, the text. Edward Burne-Jones outlined this mode of illustration in a review of Thackeray's *The Newcomes*—which was published with engravings designed by Richard Doyle—asserting that the artist should offer "no faint echo of other men's thoughts, but a voice concurrent or prophetical, full of meaning."[62] Narrative painting was also subject to conflicting ideas about its incorporation of the textual and visual. While it offered a "free exchange along open borders," the genre was haunted by the specter of Lessing, and the closure of its boundaries was effected in the latter half of the nineteenth century with the emergence of aestheticism and impressionism and the theoretical positions they embodied. Narrative painting was not "proper" painting, because it was seen to privilege content over form, stories over pictures.

It is in these fragile and multiple identities, formed by the dialogue between word and image, that narrative painting and illustration take up their positions in the mid-nineteenth century, a period fraught with questions of identity, whether of art, the individual subject, or the nation. The following chapters take this relation between the textual and visual as their starting point and analyze its implications for an understanding of Victorian culture. Chapter 1 discusses the illustrations that accompanied early British editions of Harriet Beecher Stowe's novel, *Uncle Tom's Cabin,* arguing that they played an important part in generating the meanings of slavery and race. This takes place both on a generic level, illustration constituting its own racial politics, and on the level of individual images, which work to enforce racial and national divides. Chapter 2 extends these ideas by arguing for a politics of illustration, which takes account of the cultural and ideological significance of this mode of representation, not just for race, but also for gender. The focus here is on illustrations of Tennyson's poetry, from the famous images produced by the Pre-Raphaelites to the pictures designed by Eleanor Vere Boyle, an artist whose work is largely unknown today.

Boyle's pictures and her status as a female illustrator explicitly undermine patriarchal norms. Such a questioning of Victorian values, however, was also taking place in those texts and images that appeared more reactionary, or even simply comical. Chapter 3 looks at *Punch*'s representation of the crinoline and suggests that the overturning of the conventional hierarchical relation between word and image that these pictures effect is paralleled by a subversion of gender roles. While critics tend to view the crinoline as a means of control, I contend that this undergarment actually served as a way of voicing anxieties about female empowerment and emancipation. The final three chapters examine how the political issues engrained in illustration are also a feature of the Victorian narrative painting, in which they are located in the same complex dialogue be-

tween words and pictures, reading and seeing. Chapter 4 traces the ways in which storytelling in art came to be regarded as specifically English, a definition that was due as much to the viewing processes these paintings encouraged as to the tales they told. By encouraging an empathetic and knowledgeable gaze, such images address a community of spectators. Chapter 5 is a close critical analysis of Joseph Noel Paton's painting of the so-called "Indian Mutiny" of 1857; the analysis relates the narrative devices the painting employs to its shifting racial and sexual power relations. And, finally, chapter 6 reads Augustus Egg's classic triptych of female adultery, *Past and Present,* as a space in which text and image coincide and compete, a dialogue made manifest in the opposing stereotypes of the unfaithful wife that the painting represents.

The underlying aim of each of these chapters is to suggest that hybrid genres like narrative painting and illustration are ideologically significant, their meanings generated by an unstable relation between word and image that is bound up in other relations: between country and colony, white and black, male and female. The differences of the textual and visual collude in the differences of nation, race, and gender. Perhaps, indeed, this had already been recognized, and exploited, by a certain Tennyson Longfellow Smith. It might be no coincidence that his attempts to redefine the sexually fallen woman take place across the borderline between a poem and a picture.

PICTURING SLAVERY

Uncle Tom's Cabin *and Its Early Illustrations*

I

In December 1856 William Makepeace Thackeray wrote to an English friend who had settled near New York to wish her and her family a "hearty" Christmas. With his letter he included a playing card, the three of hearts, on which he had sketched Uncle Tom, the hero of Harriet Beecher Stowe's novel, being whipped by the villainous slave owner Simon Legree while Eva, the angelic daughter of his previous owner, stands witness to the scene.[1] This peculiar Christmas card invokes, and parodies, the pictorial tradition that emerged around *Uncle Tom's Cabin* and marks it as one of the most visualized texts of the nineteenth century. It seems to have made little difference that Thackeray's picture did not, in fact, show an actual scene from the novel (Eva is dead before Legree makes an appearance). His use of these figures four years after the novel was first published and the instant recognition that he anticipated on the part of the recipients is testament to the durability of a visual culture that saw scenes and characters from this novel appearing in paintings, on china, and even on wallpaper, as well as in the numerous illustrated book editions. Stowe's text, as Marcus Wood has recently asserted, was not so much a book as a "convenient iconic storehouse."[2] According to Wood, such was the extent of its graphic legacy that the novel itself was lost to sight, "drowned in a visual rhetoric of colossal vulgarity."[3] For Wood, the variety of forms and materials in which the book was produced renders it "very hard to define where the text of *Uncle Tom's Cabin* begins and ends."[4]

Wood discusses the ways in which established traditions of representing blacks, including Regency satirical prints, fed into the illustrations of Stowe's novel and how these, in turn, influenced other representations. My analysis, however, is less concerned with the visual history that Wood so brilliantly describes than with the seemingly unproblematic assertion that the pictorialization

of the novel "drowns" the text. The book, it seems, suffers the same fate at the hand of its visual analogues as one of its characters, Lucy, does at the hand of the slave trade. But while this "drowning" might aptly describe the visual impact of the novel as a whole, it raises a number of issues when applied to the illustrated editions, which depend for their very definition on the dual presence of text and image. In illustrated books the text is never completely submerged because the words are always there on the page, facing, surrounding, or appended to the image. In this context, the ambiguity over where the text "begins" and "ends" is less a testament to the dominance of the visual over the textual than it is the very question around which the meanings of the book revolve. What I am arguing for, in other words, is the specificity of the illustrated text as a mode of representation that signifies in its relation between word and image. As Wood has so convincingly argued, illustration has an important role to play in the imagery of slavery, but it makes its meanings in different ways than do paintings or prints, and precisely because it has, or appears to have, such an intimate relation to the text.

This intimacy was central to *Uncle Tom's Cabin,* which, in Britain at least, was never separate from its illustrations. The first British edition, published by Clarke and Company at the end of April 1852, contained ten illustrations, and at least eight of the fifteen British publishers who went on to print the novel in 1852 also released illustrated versions.[5] Such was the commercial appeal of these images that it was reported that Clarke and Company had attempted to bribe Stowe for the early copies of her next book by offering her the engravings of one of their versions of *Uncle Tom's Cabin* for republication in America. The author replied that a cash repayment for the profits that the novel had made in England would be more appreciated!

Stowe's response goes some way toward suggesting why these illustrations had become so popular in Britain in the first place. Recent technological advances in engraving and reproduction techniques allowed more copies to be made more quickly; at the same time, the absence of an international copyright law meant that any non-American publisher was at liberty to issue the book, to produce any number of editions, and to accompany the text with various illustrations. According to the publisher Sampson Low, *Uncle Tom's Cabin* started a new era in cheap literature based on American reprints.[6] It was not just the text that was pirated, however. The integrity that Clarke and Company attributed to Stowe, who, they presumed, would reproduce the pictures only with their consent, was not matched in their own publishing habits. The reason why they were able to issue their edition so speedily (just a month after the book's first appearance in the United States) was that it was copied verbatim from John P. Jewett's illustrated American edition.

The proliferation of illustrated versions of the novel in the first year of its publication was unprecedented in British publishing history and can be compared with the just three illustrated editions that were published in America in 1852 under Jewett, the authorized publisher. Clarke and Company went on to produce another two illustrated versions in 1852 with varying numbers of pictures and at different prices, one with forty illustrations selling for seven shillings sixpence, and the People's Illustrated Edition retailing at four shillings. It was these illustrated versions, although not always the cheapest, that seem to have sold the most copies. Success was guaranteed for a relatively inexpensive edition, like the People's, that was initially issued in weekly penny numbers and monthly sixpenny parts with eight to ten illustrations apiece. In September 1852, just over a month after the first issue, the publishers announced that they had sold their twenty-five thousandth copy. In 1853, as the novel capitalized on its phenomenal success, the appetite for illustration appeared to have increased rather than abated: one version, published by Nathaniel Cooke, boasted above 150 illustrations.

The illustration of *Uncle Tom's Cabin* was integral to its fame and seems to epitomize a happy relation between the visual and verbal. This was recognized in the *Eclectic Review*, which suggested that the popularity of the book was demonstrated in the fact that "various artists have been employed to exhibit to the eye its most striking scenes."[7] But perhaps this relation between the visual and verbal is too close for comfort. Although there is only limited information as to how the original readers responded to illustrated books, it might have been less a question of the images matching up to the text than the text matching up to the images. Along with the title pages and frontispieces of the novel, which presented particular versions of the story intended to be seen before the first page of the text was turned, Victorian spectators were likely to have encountered many other pictures of the novel before reading the text—or if they never read the text—in the form of advertisements, song sheets, or book covers. Some readers might have purchased several illustrated editions and could refer between the images in each. The thickness of the paper on which the pictures were sometimes printed, even the different color of the pages (Cassell printed one version of the text with illustrations on hard pink paper), meant that the pictures were easily identifiable even when the book was closed. This practice, along with the lists of pictures and the corresponding page numbers that appeared in the introductory sections of these editions, suggests that viewers were encouraged to thumb through the illustrations as a prelude to reading the text. As a review of illustrated books published in 1862 commented, "On taking up a book for the first time, probably three people out of four will look to see if there are any pictures before reading a single page."[8]

It would appear, therefore, that the presence of illustrations within the book, not to mention the images in circulation beyond its covers, would have influenced the way that Stowe's novel was read. Indeed, I would go as far as to suggest that these pictures actually played a part in determining the meanings of the story. *Uncle Tom's Cabin* signifies differently when viewed in the context of its illustrations than when seen in isolation. This chapter sets out to explore these differences, looking first at the relation between word and image in British editions of the novel, and second at how the illustrations work with and against the text to construct a foreign (and American) other.

II

The rapid rise in picture books in the mid-nineteenth century led to diverse accounts of what the "proper" relation between text and image in illustration should be. Just three years prior to the publication of *Uncle Tom's Cabin,* W. J. Linton, who was himself an established illustrator and engraver, contributed to this discussion:

> Like a written commentary, or as the variation in music, the pictorial
> illustration of a book should either expound for the student the doubt-
> ful or abstruser passages of the text, or carry on the original idea
> through avenues of richer beauty. . . . It should add either distinctness
> or grace. It should bear some relation to its subject, throw some light,
> some splendour, upon it. We may venture to say—an illustration
> should be illustrative: surely not too great a requisition. Consider what
> this word illustration means. "To illustrate," says Johnson, who may be
> sufficient authority in this matter, "is—
>
> > 1. to brighten with light;
> > 2. to brighten with honour;
> > 3. to explain, to clear, to elucidate."
>
> Shakspere [*sic*] writes a Hamlet or a Lear. Therein are displayed be-
> fore us the deep workings of the human heart, not "made plain to the
> meanest capacity," but in language worthy of the theme, plain only to
> those whose capacity can hold the poet's thought. It is supposed, that
> all readers are not capable of clearly distinguishing the portraiture; that
> even the best appreciators may be further enlightened by collating their
> several readings of the text; or perhaps it is deemed a worthy task to up-
> lift some crowning honour for the work so much admired: wherefore
> we have commentaries and pictorial illustrations. But if the commenta-

tor prate of some matter altogether foreign to the play, will we for him
be any better learners of the poet's depth? Or shall we gain by the picto-
rial notes, if they run counter to the text, or treat but of things which
have no place in the argument? It matters not whether perpetrated by
word or design, an "illustration" should certainly illustrate; it should
brighten with light or honour; or explain, or clear, or elucidate.[9]

Ironically, it is the contradictions in this review that work to elucidate or "throw
some light" on the gray area of black-and-white illustration as it was practiced
and received in the mid-nineteenth century. Although Linton attempts to rec-
oncile word and image, suggesting that the two modes of representation can
work together, there is a simultaneous reminder of those moments when they
do not coincide, when the picture excludes aspects of the text, or even offers an
alternative narrative.

The ambiguities of this review lie in the ambiguities of illustration itself:
How, for example, is it possible for an illustration to expound on or clarify
those areas of the text that are "doubtful" without precisely "run[ning] counter"
to the doubtful aspects of the text? How can a picture explain a text or "carry
on" its "original idea" when it functions in a nontextual way? And these diffi-
culties, it seems, lie as much with the text as with the image. Linton's account
raises the question of whether it is ever really possible to know what a text
means in order to picture it properly, or, indeed, whether there is ever a single
authoritative interpretation. If the most informed Shakespearean scholars can
produce several different readings of the same story, then how can one decide
which is correct, or, by implication, which interpretative picture is right? If one
does not know what a text means, if there are passages that are "doubtful" or
"abstruse," then how can one be sure of what is "foreign" or "run[s] counter to"
it? The threat of illustration is that it exposes the text as ambiguous and not sta-
ble, demonstrating that it is open to diverse and even opposing interpretations.

It is precisely this disruption of text and image, the constant slippage and
renegotiation of boundaries between the two genres, that comes to the fore in
the early illustrations for *Uncle Tom's Cabin*. These pictures suggest that illustra-
tion cannot be regarded simply as an accompaniment to a superior and anterior
text, but must be seen as a more fluid practice capable of generating different
meanings and even different stories. This idea was propagated by John Ruskin,
who asserted that the image should add to, rather than "slavishly" follow, the
text. All too often, Ruskin argues, illustrations fail because they attempt to show
only what is described or implied in the words: "[I]t is not well to make the
imagination indolent, or take its work out of its hands by supplying continual
pictures of what might be sufficiently conceived without pictures," he insists.[10]

Rather, "much more ought to be given."[11] Typically, for this particular art critic, the "more" consists of accurate natural details, such as the forms of leaves and rocks, but it also allows the possibility of a picturing that is in excess of, or modifies, the text. Indeed, according to Ruskin, there are definite dangers associated with illustrations that attempt to take the text at its word and aim faithfully to reproduce its details: they are superfluous diversions that weaken the reader's attention and lead to a "feverish thirst for excitement."[12]

Ruskin's tenets are put into practice by the illustrators of *Uncle Tom's Cabin*, who often emphasize those elements of the text not described in any great detail. Even the famous scene of Tom and Eva in the arbor seems to owe more to its numerous depictions than to its limited description in the novel. The pictorialization of such incidents is, at times, an excuse for shock or titillation, like the picture of *George's Sister Whipped for Wishing to Live a Decent Christian Life* in the Ingram, Cooke and Company edition, which shows an attractive, bare-breasted woman about to be lashed. Other pictures add to or modify the author's vision and situate the illustrator as another writer, who allows the viewers privileged access to the full horror and melodrama of the situation. The suicide of Lucy, a slave who drowns herself when her child is taken away, is reported in the text with minimal description: "At midnight, Tom waked, with a sudden start. Something black passed quickly by him to the side of the boat, and he heard a splash in the water. No one else saw or heard anything."[13] "No one else," that is, with the exception of the book's illustrators, who see everything and depict the scene in some detail. George Cruikshank, who illustrated Cassell's version of the novel, shows Tom waking up in the open door of the cabin while Lucy clasps her hands above her head and throws herself from the railings of the ship and into the murky waters (figure 1.1). The excess of this pictured version is emphasized in the inclusion of the textual account underneath, a juxtaposition of word and picture that highlights the fact that they do not function in the same way or even evoke the same event. For Cruikshank, as for Ruskin, the text is not a sacred or stable entity whose purity must be retained by the illustrations. Indeed, Ruskin's account of an illustrative image that can expose the very limitations of the text, revealing what the words are unable to represent, anticipates Jacques Derrida's notion of the "dangerous supplement": an element that seems additional, "a plenitude enriching another plenitude," but that, in its very function, reveals the lack in what it adds to, becoming a substitute for the thing itself. It "adds only to replace."[14] Derrida associates the supplement with images in general, but illustrative pictures seem particularly to embody its contradictions because, while they are often regarded as supplementary, an added extra, they are integral to the generation of meanings, working to reveal textual absences and gaps.

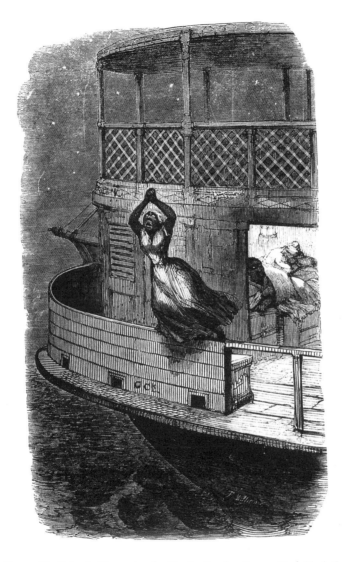

Figure 1.1 George Cruikshank, illustration for Harriet Beecher Stowe, *Uncle Tom's Cabin with Twenty-seven Illustrations on Wood by George Cruikshank* (London: Cassell, 1852).

Even when the early illustrations of *Uncle Tom's Cabin* appear to take the story at its word, they are dependent not so much on the text as on other images. The selection of the episodes for illustration seems to have been governed not only by artistic or ideological imperatives, but also by the rapidity with which the different versions had to be produced in order to secure their commercial success. In addition to Clarke and Company, Sampson Low and Henry Bohn reproduced the pictures from Jewett's editions. With such established artists as John Gilbert and John Leech working on Bohn's illustrations, the extent of the copying here is really quite

staggering. At least three of the images seem to have been traced straight onto the woodblock from Jewett's version, a factor that would explain why these illustrations, while more or less identical to the originals, appear in reverse.

Many of the common details and stylistic devices employed in the pictures that accompanied *Uncle Tom's Cabin* can also be accounted for in the fact that some editions shared the same engraver. Mason Jackson, who had experience in engraving black figures in his work for the *Illustrated London News* and the publisher Charles Knight's edition of *Arabian Night's Entertainments* (1839), reproduced the designs for Cassell and Nelson and Sons. The brothers George and Edward Dalziel, who owned the most successful engraving company of the time, also worked on Cruikshank's pictures for Cassell and on the antislavery tract *Uncle Tom's Almanack,* which was published in 1853. This common use of engravers and images led to a number of hybrid books like the People's Illustrated Edition, with its strange assortment of pictures, most of which are copied from other versions, that defy containment or unification. With its strikingly different Evas, Toms, and Topsys, the illustrations in this edition question the transparency of a novel that can propagate such radically different interpretations. In two consecutive pictures Eva not only changes features and hair color, but ages by about ten years. This discrepancy probably came about because the publishers of these cheap editions reused engravings that they had on hand and that might have been employed to illustrate other texts, a practice that beautifully undermines the whole notion of illustrative "fidelity," or the "marriage" of text and image. Indeed, the People's Illustrated Edition seems to suggest not only that text and image work in different ways but that they have different imperatives, with the illustrations rejecting the continuity of character that is essential to the realist novel and relying more on recognizable visual symbols. To a certain extent it mattered little what the individual appearances of Tom and Eva were; it was the visual juxtaposition of a little white girl and black man that signified, that came to function symbolically, even iconically.

A more implicit "inter-pictoriality" between versions of the book is suggested in the common choice of illustrated episodes. The repetition of the same incident in various illustrated editions serves, as David Blewett has argued, to reinforce the significance of these particular scenes, "fixing them in the memory, like a device of rhetoric, while also building up a collective visual comment."[15] In addition to Lucy's suicide, most of the English versions of 1852 and 1853 contain an image of the slave sale, the deaths of Eva and Uncle Tom, and Eliza fleeing across the frozen river. In the Ingram, Cooke and Company and the People's Illustrated editions Eliza's escape is depicted in strikingly equivalent terms and with parallel spatial dimensions that are not fully dictated by the text but add to the dramatic interest of the scene (figures 1.2 and 1.3). Haley, whip

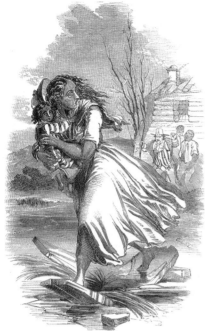

Figure 1.2 Illustration for Harriet Beecher Stowe, *Uncle Tom's Cabin; or, Negro Life in the Slave States of America*, People's Illustrated Edition (London: Clarke, 1852).

Figure 1.3 Illustration for Harriet Beecher Stowe, *Uncle Tom's Cabin: A Tale of Life among the Lowly; or, Pictures of Slavery in the United States of America* (London: Ingram, Cooke, 1852).

in hand, stands at the rear on the bank, while behind him are the two helpers, Sam and Andy. A house and tree are positioned halfway down the right-hand side, and Eliza, holding her child on her right, crosses the ice with her left foot forward and her clothes and hair streaming behind. In these two illustrations the angular composition and positioning of the spectators are identical: Eliza heads toward the bottom left of the pictures, while the viewers are situated to her left and slightly ahead, as if they too are running across the ice.

But the illustrations of this incident, while they draw on each other, also allude, even if unconsciously, to images "outside" the text. Henry Anelay's depiction of this scene for Partridge and Oakey bears a resemblance to Phiz's illustration *The River*, which had appeared in *David Copperfield* two years before (figures 1.4 and 1.5). Here, Martha's fearful contemplation of the water seems the prequel to Eliza's frantic dash across the picture space. The layout of the pictures is the same in terms of the spectatorial position. In addition, both women are watched by the men behind, there is a rickety fence on the bank, and the silhouetted buildings of the town emerge from the water. Even Cruikshank appears to

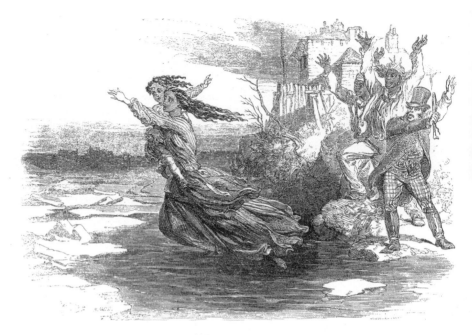

Figure 1.4 Henry Anelay, illustration for Harriet Beecher Stowe, *Uncle Tom's Cabin; or, The History of a Christian Slave* (London: Partridge and Oakey, 1852).

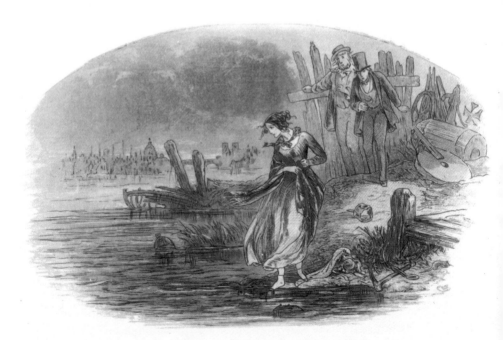

Figure 1.5 H. K. Browne (Phiz), illustration for Charles Dickens, *David Copperfield* (London: Bradbury and Evans, 1850).

have fallen prey to this "borrowing" of images, although it is from his own oeuvre. His illustration of Lucy's suicide uses iconographical details similar to those in the final plate of his pictorial series *The Drunkard's Children* (1848), in which the daughter, in the tradition of the fallen woman, throws herself off a bridge.[16]

In their references to other pictures and texts the illustrations in *Uncle Tom's Cabin* function like Peter Wagner's "iconotexts," images that generate multiple layers of meaning in their allusions across different media.[17] Peter A. Dorsey has gone as far as to argue that the similarity between Cruikshank's illustration of Lucy's suicide and an incident from William Wells Brown's *Clotel; or, The President's Daughter* would suggest that Brown had this edition open before him when he was writing his novel.[18] Such cross-referencing is made explicit in the way that the illustrations in *Uncle Tom's Cabin* frequently depict writing as another art form. The most popular scenes include George teaching Tom to write at the beginning of the novel and Eva helping him to compose a letter to send home. The pictures also show books and texts, whether the Bible, open on Eva's knee, or the posters for the arrest of the runaway slave George Harris that line the wall of the slave warehouse in the first American edition, illustrated by Hammatt Billings.

This interaction between text and image is furthered in the common use of wood engraving, which allowed the two forms to be printed together on the same page. Some versions took advantage of this technique in order to place their images as vignettes that appeared alongside, or within, the corresponding narrative. In these illustrations the pictorial is integrated with the text, while the text itself forms an integral part of the picture. The last illustration in Billings's second edition of the novel, which also included decorative capital letters, shows a group of slaves looking in wonderment at the sky, which is emblazoned with the words "FREEDOM TO AFRICA."

While such engravings seem to epitomize the unity of word and image, they can also question the conventional terms of this relation. The picture of Tom's deathbed scene in Nathaniel Cooke's 1853 version is placed midway down the page, sandwiched between George Shelby's plea for Tom to wake up and the hero's subsequent recognition of his friend (figure 1.6). The image breaks up the text for the reader, but, rather than adding to the suspense of this episode, it actually anticipates what is about to happen in the narrative; it pictures Tom looking up at George, having already opened his eyes. In this example it is the text that is secondary, that seems to repeat and interpret what the image has shown.

Uncle Tom's Cabin, then, although immersed in its own visual culture, did not necessarily bring with it an uncomplicated union of word and image. On the contrary, some of the illustrations explore the very differences between the media. The version published by T. Nelson and Sons in 1853 contains several picture stories on one page. In *Negotiating for the Sale of Little Harry* the central

Figure 1.6 Illustration for Harriet Beecher Stowe, *Uncle Tom's Cabin; or, Life among the Lowly: A Tale of Slave Life in America* (London: Nathaniel Cooke, 1853).

compartment shows Haley's interest in the boy and Eliza entering the room, while in the top left corner she bursts into tears as she tells Mrs. Shelby of the incident, and in the top right her fears are realized and she flies from the house to warn Tom of his fate (figure 1.7). The interconnected images used throughout this edition of the novel reveal some of the ways in which Victorian book illustration functions. By selecting certain incidents at the expense of others and pasting these together, illustration can construct its own relations, even its own narrative, just as this picture from *Uncle Tom's Cabin* tells the tale of Eliza and her flight as if it were a sequence of events, ignoring the parts of the story that occur between the three images on display.

Such a visual amalgamation generates its own meanings. Here the separate scenes are bound together by the very tools of slavery, a chain or series of links suggestive not only of a locket that is opened for the spectator, but of fetters. The illustration, therefore, in its very configuration, adopts a dual identity as both ornament and symbol of oppression, and the central incident, evidently enclosed in the oval frame familiar from miniature portraits, plays with this ambiguity. Its shape, in fact, is reproduced in the painting that is shown hanging on the wall of Shelby's parlor. But the picture also suggests how its visual status is interlinked with the tale it tells: as Haley scrutinizes the young boy, the image becomes a powerful signifier of how slavery is constructed by the same politics of looking that informs illustration.

Figure 1.7 Illustration for Harriet Beecher Stowe, *Uncle Tom's Cabin: A Tale of Life among the Lowly* (Edinburgh: T. Nelson and Sons, 1853).

The images that make up this engraving slip between textual and pictorial conventions. On the one hand, they subvert a linear narrative by presenting the present and future simultaneously, anticipating events that have yet to happen in the book, and, on the other, they employ specifically visual mechanisms in order to guide the "reading" process and to create a sequence of events. The spectators are not completely free to construct their own version of this story. The use of spatial relations and size centralizes the picture of the slave trader, while his focus on Harry in the bottom left corner and the arched frame mean that the viewers are encouraged to work their way around and up this page to

the much smaller images in the top corners. This device of constructing picto-
rial narratives by directing the spectator from center to margins, while perhaps
most familiar in medieval triptychs, gained popularity in contemporary paint-
ing, in which artists experimented with this tripartite form as a way of telling
tales (see the discussion of *Past and Present* in chapter 6). The mechanism has
slightly different implications in Western book illustration, however, in which
it is juxtaposed with a reading practice that moves from left to right across and
down the page. The picture demands a literal shift of direction, a different
process of viewing, when the reader turns from one medium to another. In-
deed, an illustrated book such as this does not allow for a simple movement
from introduction to conclusion but promotes a shift back and forth between
text and image, or even from image to image, marking a move away from Hog-
arthian narratives, which cemented the link between the visual and textual by
telling their stories from left to right, both in the individual scenes and in the
way that the pictorial sequences were arranged.[19]

While some aspects of spectatorship might differ in relation to text and
image, however, in both genres it is a process that takes time: the viewers need
to pause in order to "read" the illustrations just as they would in reading the
words on a page. This temporal process of viewing was positively encouraged
in Cassell's version of the novel, which introduced its readers to the illustrations
by stating that they would not be able to "peruse the following facts, and *ex-
amine* the numerous graphic illustrations from the faithful and benevolent pen-
cil of our good friend, GEORGE CRUIKSHANK, without vowing eternal
antagonism to American slavery" [my emphasis].[20] These terms suggest not
only that the illustrations were to be read or analyzed in the same way as the
text, but also that they too could have a political effect. Perhaps, indeed, as Cas-
sell seems to suggest, the conjunction between word and image allows the il-
lustrated book to be *more* effective as an ideological tool than books that do not
include pictures. By privileging certain textual moments, inviting them to be
"read" twice over, illustration can emphasize or marginalize certain aspects of
the novel, as well as create its own themes and structures. And the implications
of this are far-reaching. If pictures can actively work on the text and, to some
extent, even construct its meanings, then it follows that different illustrated ver-
sions of *Uncle Tom's Cabin* might create radically different versions of the story.

III

With the growing popularity of illustrated books, magazines, and newspapers
came an increasing interest in the figure of the Negro, which climaxed after the
success of Stowe's novel and during the American Civil War. The Negro slave,

Figure 1.8 Illustration for Harriet Beecher Stowe, *Uncle Tom's Cabin; or, Life among the Lowly: A Tale of Slave Life in America* (London: Nathaniel Cooke, 1853).

particularly for a non-American audience, was constructed in a specifically visual way, and the frequent representation of this figure owes as much to technical and aesthetic factors as it does to the sociopolitical. At a time when wood engraving was the most popular form of illustration, the reproduction of the Negro provided an opportunity for the artist and engraver to explore the capabilities of the genre and to demonstrate their skills. The technique of cutting away the white parts of the image on the block and leaving the part to be inked in relief seemed designed specifically for the representation of whites. The skin could be cut away more or less in its entirety, while the inked lines served to demarcate the features. The function of this black line of engraving, whether pierced into steel or left raised on the wood block, was, according to Ruskin, "'De-Lineation,' the expressing by outline the true limits of forms, which distinguish and part them from other forms."[21] Manipulating the wood engraving process and leaving all the skin in relief and therefore black, however, not only blurred this distinction between outline and content but could obliterate the features, making the appearance of the figure too dark. The solution was to produce tonal effects by cross-hatching, cutting the wood between sets of crossed lines, or to create a fingerprint effect by scratching out fine white lines within the raised part of the

block. Such techniques required an appropriate design on the part of the artist and tested the skill and patience of the engraver, but they also showed wood engraving at its best, giving the Negro more visual impact than his white counterpart. This can be seen in an illustration of *Uncle Tom's Cabin* from Nathaniel Cooke's version of the book (figure 1.8). While Eva appears as a hasty sketch, Tom's features are more carefully engraved, from the tonal emphasis on his cheekbones to the side of his face that is turned away from the spectator and in deep shadow. Tom, a figure who has himself been imprinted *onto* the paper, is engaged here in the act of writing, producing his own graphic marks that are linked with the words that surround him on the page. Eva, on the other hand, apart from the "delineating" black of her outline, merges *into* the paper, the whiteness of her arms and face mimicking the gaps and spaces that occur between the words and letters with which she is juxtaposed.

The negotiation of black and white that defines mid-Victorian illustration might itself be seen as part of a racial agenda. Certainly, Ruskin made the connection between the moral and social import of engraving and race, imperialism, and slavery in a series of articles that he wrote for the *Art Journal* in 1865 and 1866 at the climax of the American Civil War (later collected as *The Cestus of Aglaia*). With Ruskin's own artistic interests, it comes as no surprise that the most common "slave" in his writings is the artist, and especially the engraver, with his long hours, poor conditions of work, and an employment that not only is repetitive and tedious but often involves copying inferior work. For Ruskin, it was an illustrated book of English verses that incorporated everything reprehensible about the genre, its badness evinced in the false use of light, its distorted faces, and its appeal to an "ungoverned" and indolent female imagination. These illustrations provoke Ruskin into making a mock abolitionist address in which he entreats the English audience to turn away from its obsession with "parlour passions, and kitchen interests": "Friends, there have been hard fighting and heavy sleeping, this many a day, on the other side of the Atlantic, in the cause, as you suppose, of Freedom against slavery; and you are all, open-mouthed, expecting the glories of Black Emancipation. Perhaps a little White Emancipation on this side of the water might be still more desirable, and more easily and guiltlessly won."[22] Ruskin's analogy is, of course, metaphorical and takes its place alongside contemporary comparisons between slavery and anything from the role of the military, to the situation of the needlewoman, to the costume of the typical footman. But it is a metaphor that is couched in the literal, for the generic characteristics of illustration render it complicit with the very assumptions on which slavery is predicated: it too foregrounds the workings of the gaze—of looking, being looked at, and judging by appearances—and, in its mid-nineteenth-century manifestation, is concerned with shading and color, the relation between black and white.

Ruskin's comparison between engraving and slavery suggests the ways in which the modes and techniques of illustration can assume a political significance alongside the iconographical features of the images themselves. This can be seen to great effect in *Uncle Tom's Cabin* because the book itself came to adopt a distinct national identity depending on where it was read and produced. Jane Tompkins's highly influential and persuasive reading of the novel as typological, a story that explores the meaning of salvation and redemption through suffering and death, does not have the same force when seen in the light of British illustrated versions of the book.[23] Admittedly, she focuses solely on the text rather than addressing the illustrations (a surprising omission when one considers that her project is to recuperate genres that have been marginalized and classed as inferior), but is it so easy to separate word and image, particularly when those images have become ingrained in American culture?[24] Perhaps not, for Tompkins's reading seems to refer to these pictures even in their absence. Her thesis that all human events in the novel are "organized, clarified, and made meaningful by the existence of spiritual realities"[25] is an apt description of the second set of illustrations that Billings designed for Jewett, which include angels taking Eva to heaven; Eva coming to Tom as an angel and reading to him from the Bible; Christ appearing before Uncle Tom, who kneels and shields his eyes; and Christ looking on as Tom is whipped.

It is not so much that these illustrations simply mirror the text, providing a vehicle for its evangelical message, but that they enforce or even allow the possibility of such an interpretation. What I am suggesting, in other words, is that the images that accompanied Stowe's text had a direct bearing on the meanings of the novel itself. Thus, when the Christian images are not present, the book as a whole generates very different meanings. Of all the British editions of *Uncle Tom's Cabin,* only Clarke and Company go so far as to depict Christ materializing before Tom and a divine light shining on the hero as he lies dying, but these pictures, compared with their American counterparts, seem more like token gestures. The lack of Christian conviction in the British illustrated versions was noted by Ruskin, who complained in the third volume of *Modern Painters* of the extent to which "the sentiment . . . supposed to be excited by the exhibition of Christianity in youth is complicated with that which depends upon Eva's having a dainty foot and a well-made satin slipper."[26] In British editions of the novel the Christian message takes second place to dramatic interest and visual appeal, with Eva appearing more as an erotic object than an evangelical heroine. This is demonstrated in the People's Illustrated Edition, in which she perches on Tom's leg to decorate him with flowers (figure 1.9). With her pretty ringlets and a sideways pose that emphasizes her bust, all that remains of any evangelicalism is an attractive little bonnet that falls against her back like the wings of an angel.

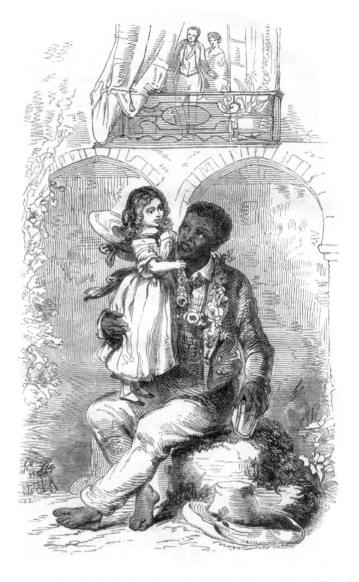

Figure 1.9 Illustration for Harriet Beecher Stowe, *Uncle Tom's Cabin; or, Negro Life in the Slave States of America*, People's Illustrated Edition (London: Clarke, 1852).

Illustrations, then, are part of a cultural network that informs their modes of representation and subject matter, and these national and ideological imperatives are often thematized in the images themselves. In several of the British editions of *Uncle Tom's Cabin,* for example, the pictures work to divorce text and image by making a distinction between the American novel and its British illustrations. This distancing effect was achieved to some extent by the subtitles, which drew attention to the American context of the novel and, in so doing,

Uncle Tom's Cabin *and Its Early Illustrations* | 39

Figure 1.10 George Cruikshank, illustration for Harriet Beecher Stowe, *Uncle Tom's Cabin with Twenty-seven Illustrations on Wood by George Cruikshank* (London: Cassell, 1852).

defined slavery as an issue that was removed from Britain and her colonies. With slavery abolished in the British Empire in 1833, and France following suit just four years before Stowe published her novel, Britain was in a position to claim the moral high ground, and it frequently did so in these editions of the book. Although the official title of the novel was *Uncle Tom's Cabin; or, Life Among the Lowly,* Clarke and Company and Routledge replaced its subtitle with "Negro Life in the Southern States of America" and on the cover of one version

included a picture of the whipping of a black woman by a black man with the appended words, "Scenes Daily and Hourly Acting under the Shadow of American Law." Ingram, Cooke and Company also modified the subtitle and made an explicitly visual link by calling the novel "Pictures of Slavery in the United States of America," while Nathaniel Cooke and Nelson and Sons added the subtitles "A Tale of Slave Life in America" and "Slave Life in America."

The illustrations signify in a similar way to these subtitles, enforcing this geographical distance, but in a specifically visual way. This is suggested in Cruikshank's picture of a slave sale, "Emmeline About to Be Sold to the Highest Bidder" (figure 1.10). The text describes the location of this scene as a "splendid dome" with marble paving, and Cruikshank highlights the incongruity between this opulent environment and the event it houses by creating a neoclassical setting complete with pillars, recesses, and sculptures. Here the motionless figure of the white-skinned and frightened girl, placed on a platform above the crowd, appears alongside three statues. On the left is a figure of blindfolded Justice holding the scales in her left hand and a sword in her right; in the middle stands a representative of liberty, one hand resting on the Declaration of Independence and the other holding a liberty cap; while on the right is a representative of Christianity, a Bible and cross encircled in one arm, as she points to heaven with the other.

These allegorical statues, like the illustration itself, have a more complex function than mere decoration or ornament and make explicit the hypocrisy of a country that extols the virtues of Christianity, justice, and freedom at the very moment that it engages in selling people (and women, moreover) to the highest bidder. The illustration also has implications for the process of viewing, for while the spectator focuses only on Emmeline, he or she takes up a spectatorial role aligned with the bidders. The viewer of this picture is implicated in the auction, positioned as part of the crowd who hungrily stare at Emmeline's body (one man even holds an eyeglass to study her more closely). This position is emphasized in the way that the auctioneer seems to look past the man who is making the latest bid and directly out to the viewer, gesturing with his hands toward the girl as if asking the spectator to assess what she is worth and to raise the stakes. Beneath the tribune a man remonstrates with a woman, recognizable from the textual description of her turban and clasped hands as Emmeline's mother, but, at this awkward juncture, his eyes roam from the scene of her appeal to fix on the spectator. The statues, however, provide another object for the gaze that allows the spectator to turn away from Emmeline, or at least to adopt a critical distance from the scene of her sale, in a way that the pictured witnesses cannot. The sculptures are offered specifically for the gaze of the viewer of the picture rather than the pictured viewers, who either stand with their backs toward them or

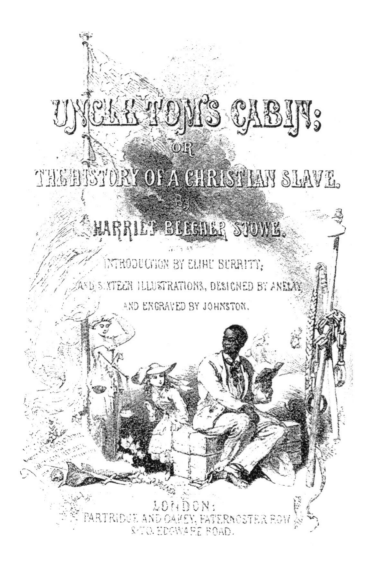

Figure 1.11 Henry Anelay, title page, Harriet Beecher Stowe, *Uncle Tom's Cabin; or, The History of a Christian Slave* (London: Partridge and Oakey, 1852).

have a partial view that is obscured by the figures of Emmeline and the auction-
eer. As the auctioneer bends down to show us the figure of Emmeline, he also
offers us a view of the representative of Christianity, who stands in the alcove be-
hind him and whose gesture toward heaven is ironically aligned with the gesture
of the bidder and inverted in the hands of the auctioneer, who points downward
to Emmeline and, in the context of this symbolism, to hell.

The viewer's understanding of the statues as critical commentaries on the
scene not only divorces him or her from the pictured crowd but suggests a real

spatial and geographical divide. There is an explicit reminder in the prominent inclusion of the Declaration of Independence not only of where this novel is set but that the problem of slavery is decisively removed from Britain and from the readers who were buying this edition of the book. This illustration is specifically addressed to a non-American viewer. It can be compared to Jewett's American illustrated editions, which, while criticizing slavery, especially within a Christian context, do not make these direct attacks on the American government itself.

Cruikshank's depiction of this scene, which came out in a weekly number in the autumn of 1852, might have inspired Henry Anelay, whose illustrations appeared in Partridge and Oakey's edition in November. The cover of this novel shows an eagle perched on a whip and fetters and uses the American flag as a backdrop, insignia carried through to the title page, on which Tom sits on a trunk, a Bible in his hand, and looks around at Eva (figure 1.11). She is flanked by the figure of Justice, while the American Declaration of Independence occupies the left corner of the image. Justice here seems to have been magically transformed from the statue represented by Cruikshank into a living figure: she has already discarded her traditional sword, which cuts through the Declaration of Independence, and is in the process of removing the blindfold that ensures her objectivity. The cups of the scales she holds are themselves colored, one black and one white. No longer equally balanced, they tip downward in favor of the white. As Justice removes her blindfold, the wind whips up around her, threatening to carry off the Declaration of Independence, and an ominous black cloud in the sky obscures the American flag.[27]

These title pages are important because they set the scene for the novel and direct its meanings in a particular way before the reading process even begins. It could be argued that this preliminary material in many ways anticipates how one reads the book as a whole. This has been suggested by Stephen C. Behrendt, who contends that images that precede the text function as an "entrapment device" that entices and arouses interest in the spectator and propels him or her forward in the narrative.[28] But this is not an innocent activity, and Behrendt's use of the word "entrapment" suggests the political import of this pictorial device, especially in a novel about slavery. In the illustrations of Cruikshank and Anelay there is an acknowledgement that slavery is a crime against Christianity (Tom reads a Bible in Anelay's title page, and the statue of Christianity appears in Cruikshank's slave sale), but whereas American versions make this the central focus, the illustrations in British editions set this message alongside one that stresses that slavery is also a crime against the American Constitution that exposes the failings of the American system and, by implication, the superiority of the British Empire.

Although the illustrations published in Britain define the text and the issues it raises as American, they also construct themselves as peculiarly British. Nowhere is this more apparent than in the pictures of the cabin itself, which take up their most prominent position in British editions of the novel. The first American illustrated version does not contain a picture of the cabin at all, and, while Billings corrected this in his designs for the 1853 edition, the room remains strikingly simple: there is no interior as such, only patches of shadow, and attention is focused solely on the three figures (Aunt Chloe, who is cooking, and George, who is teaching Tom to write). The only furniture represented is a table, the chair on which Tom sits, and a fireplace that is indicated rather than represented by the light and smoke that emanate from the side of the image and the cooking pot over which Chloe bends. In contrast to this sparsity, British versions of the cabin are highly detailed, including objects that are not described in the text but are necessary in order to make this house into a home. Anelay's design works along these lines, from its simple wooden table, its chest of drawers, and the trinket boxes and ornaments that line the shelf, to the bonnet and shawl hung up next to the window (figure 1.12). The horizontal format of this picture, by making the "ceiling" low, adds to the snugness of the interior, while the fireplace described in the text seems to have been replaced with a Victorian cooking range.

By incorporating such details, these images actually transform the Southern American "cabin" into an English country cottage familiar from Victorian paintings and engravings. One might think, for example, of the cottage interiors of Thomas Webster, William Mulready, or Frederick Daniel Hardy, with their neat ordered rooms, swept brick floors, and happy families. Indeed, this passion for representations of country cottages, present in popular magazines as well as on the walls of the Royal Academy, seems to have reached something of a peak in 1852.[29] As the first editions of Stowe's novel reached British bookshelves, the *Art Journal* reported that "cottage firesides are coming in legion upon us. A cottage-interior mania seems to have set in, insomuch that there is no exhibition without them."[30]

This coincidence between the illustrations for Stowe's text and contemporary images of cottage life is intensified in the fact that both suggest that the domestic space is indicative of moral virtue.[31] It is a connection that is also made in the novel, in which the neat, pleasant interior of the cabin described at the outset is sanctified at the end of the text, when George Shelby instructs his free slaves, "Think of your freedom, every time you see UNCLE TOM'S CABIN; and let it be a memorial to put you all in mind to follow in his steps, and be as honest and faithful and Christian as he was" (447). The British illustrations of the cabin generate these textual meanings in different ways. By drawing on a

Figure 1.12 Henry Anelay, illustration for Harriet Beecher Stowe, *Uncle Tom's Cabin; or, The History of a Christian Slave* (London: Partridge and Oakey, 1852).

pictorial tradition of rural cottages, they make a direct appeal to a spectator for whom domestic values were of increasing importance and who would make the appropriate link between a happy family, a clean domestic interior, and morality. The illustrations of Uncle Tom's cabin, like the rustic interiors found in contemporary paintings and engravings, functioned as examples of common humanity, proof that the poor could experience the same emotions, misfortunes, and joys as their wealthier counterparts. It was a common humanity, however, that was defined according to English ideals. Karen Sayer has identified the country cottage as an embodiment of England, placed at the heart not just of the community but of the nation as a whole.[32] Set in this English interior, the black figures in Stowe's novel, despite their obvious physical difference, are anglicized, made more familiar, less threatening, and more readily objects of sympathy. Because spectators were encouraged to make the connection between the idealized domestic space and moral virtue, it was more likely that they could empathize when this Negro family were separated.

But the anglicizing of the cabin also had its dangers, suggesting a similarity, however tentative, between the English rural poor and the condition of slavery. A comparison between the English factory worker and the slave is made in the

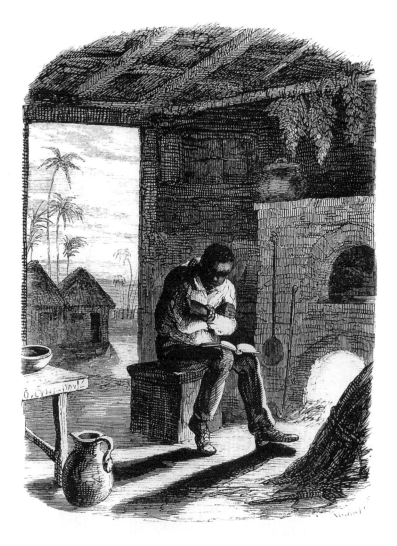

Figure 1.13 George Cruikshank, illustration for Harriet Beecher Stowe, *Uncle Tom's Cabin with Twenty-seven Illustrations on Wood by George Cruikshank* (London: Cassell, 1852)

novel itself and was fiercely disputed by some reviewers,[33] but perhaps the slave's association with the rural worker was even more appropriate because, as Douglas A. Lorimer has pointed out, they worked in similar agricultural conditions and with a similar lack of political privilege.[34] The illustrations, however, worked to neutralize this potential threat by strictly demarcating the familiar space of the cabin from the "reality" of slavery, which was designated foreign and alien. Cruikshank's illustration *Tom Reading His Bible,* which is set in a hut on Legree's plantation, signifies in its implicit allusions to, and contrast with, the scenes of the cabin that have gone before (figure 1.13). The ornamentation that adds to

the homeliness of the cabin is replaced here by simple functional items, a bowl and a jug, and Tom sits on a trunk rather than a chair. Even the fire barely lights up the hut, and Tom hugs himself for warmth. But it is the inclusion of the exterior in this scene that marks its difference from images of the cabin. Whereas the cabin appears self-enclosed, a haven that is set apart from the outside world, here the exterior encroaches on the interior space. As Tom sits alone, in sharp contrast to his earlier appearances surrounded by friends and family, his isolation is intensified in a landscape that, with its palm trees, round huts, and tropical sky, Cruikshank codifies as foreign and other.

Tom's situation on Legree's plantation is strikingly different from the experience of slavery that he has previously encountered, and is defined as such by the illustrations. Legree's ownership is contrasted with that of the St. Clare household, in which Tom and Eva seem to meet, albeit briefly, as equals. This equality is signified in the way that the images play with conventions of representing blacks. When Eva decorates Tom with flowers in the People's Illustrated Edition (figure 1.9), the position of the viewer is mirrored by that of St. Clare and Ophelia, who watch the incident from the balcony, their mutual presence emphasizing the differing reactions that they express in the text: Ophelia is initially horrified at Eva's behavior, while St. Clare's words form the title of the picture: "Your little child is your only true democrat." By privileging St. Clare's words, the picture attempts to guide readers toward a right reading of the text.

But St. Clare's attitude toward Eva's conduct has implications for the visual field too, for in the illustration of this scene Eva's "true democracy" is signified not so much in her actions themselves as in the terms of their depiction. This is suggested in the way that the picture works with and against the grain of the text: "There sat Tom, on a little mossy seat in the court, every one of his button-holes stuck full of cape jessamines, and Eva, gayly laughing, was hanging a wreath of roses round his neck; and then she sat down on his knee, like a chip-sparrow, still laughing" (184). This sentence, which seems to revel in its own temporality, mimicking the happy exuberance of a child as it jumps from one subclause to another, is replaced in the illustration with a tableau. The static nature of the picture does not necessarily suggest the limitations of the visual compared to the verbal, however. On the contrary, its very stillness, the staged poses of the protagonists, makes a connection between this representation of black and white figures and that found in the history of British portraiture, in which black children are frequently placed in the role of servants and similarly offer fruit or flowers to their white employers.[35] The illustration reproduces this iconography but reverses the hierarchy that the paintings establish: here it is the white figure who is the child/servant and the black figure who appears as a dignitary bedecked with flowers. The reversal is made even more apparent in Cruikshank's

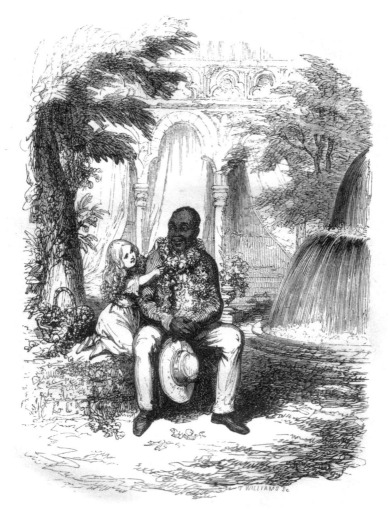

Figure 1.14 George Cruikshank, illustration for Harriet Beecher Stowe, *Uncle Tom's Cabin with Twenty-seven Illustrations on Wood by George Cruikshank* (London: Cassell, 1852)

version of the scene, in which Eva, kneeling on a seat next to Tom, is positioned physically lower than he is (figure 1.14). The politics of this situation is stressed in the fact that Cruikshank refrains from exploiting the potential for comedy and makes Tom a serious figure, who sits poised and steady. The scene is pictured as a symbolic meeting not just between the two characters but between adult and child, black and white, male and female.

Perhaps the racial politics offered in these pictures are not so clear-cut, however. While Eva and Tom seem to meet as equals, it is the equality of children. Eva does not encounter Tom as a grown woman, nor does he, despite his sobriety, appear as an adult male, but instead as a playmate, who patiently goes

along with the pranks of a little girl. Indeed, Wood has suggested that Tom is feminized in the novel, occupying the role of the ideal Victorian heroine.[36] The "true democracy" that these pictures claim to show seems to be an aesthetic rather than a social one, the blurring of the boundaries between low and high art that occurs in a black-and-white engraving for a mass-produced book that employs and challenges the conventions of portraiture.

Cruikshank's illustrations, of course, generate even more complex meanings, because they work not only with these pictorial conventions but also in the caricature tradition of Gillray, Rowlandson, and Hogarth. Cruikshank tells his stories using visual devices and symbols, and his narratives lean toward social commentary. It is unsurprising, then, that he was chosen to provide the illustrations for a book that Cassell intended to be sold by canvassers from door to door in the same way as antislavery tracts.[37] Cruikshank's pictures bring to the fore a satirical humor that is not always present in other editions and clashes at times with the moral earnestness of the book. These images, drawing on the theatricality of graphic satire, can appear more exaggerated and extreme than those found in other versions and have led critics to regard Cruikshank's representations of thick-lipped and wide-eyed Negroes as lacking in power and originality.[38] But this lack of originality is, paradoxically, precisely where their power lies—for, whether consciously or not, the pictures seem to announce their lack of inventiveness, borrowing their images from visual sources that form part of the British experience of slavery and blackness. The pages of *Punch* and the *Illustrated London News* are full of similar images, but such images are also present in texts. Cruikshank visualizes descriptions of the Negro found in evangelical and missionary reports, and his slave even bears an uncanny resemblance to Thomas Carlyle's "Quashee": "A swift, supple fellow; a merry-hearted, grinning, dancing, singing, affectionate kind of creature, with a great deal of melody and amenability in his composition."[39] Cruikshank's Negro, as Robert L. Patten suggests, is the minstrel who appeared to such popular acclaim in the theaters of the 1850s and 1860s.[40] The stereotype, according to Lorimer, is symptomatic of English attitudes toward blacks during this period, which had changed from the philanthropic construct of the suffering, Christian slave to the view of blacks as figures of fun.[41] Cruikshank's illustrations, by simultaneously employing these two types of representation, chart this shift.

The year before he illustrated *Uncle Tom's Cabin* Cruikshank had depicted the African nation dancing out of huts and across the globe to see the Great Exhibition, the Africans' plumpness emphasizing their childlike qualities and comic appeal.[42] This image is carried through to Tom's first appearance in Stowe's novel, when he dances around with the baby on his shoulder to the glee of a well-fed Aunt Chloe, who grins inanely from the table where she is preparing dinner (figure

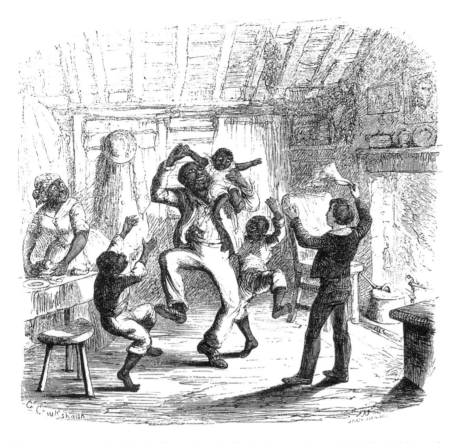

Figure 1.15 George Cruikshank, illustration for Harriet Beecher Stowe, *Uncle Tom's Cabin with Twenty-seven Illustrations on Wood by George Cruikshank* (London: Cassell, 1852).

1.15). While the family laugh and kick their legs wildly in the air, George Shelby looks on, uncomfortably waving his handkerchief, and with his two feet fixed firmly on the ground. His smart suit and collar identify him as the representative of a cultured, civilized society and contrast with the shabby, baggy working clothes of Tom and his family.[43] In another of Cruikshank's illustrations the staid Miss Ophelia discovers Topsy engaged in a similar wild dance, laughing uproariously with a turban wrapped around her head, and her eyes ready to burst from their sockets; and the Negro dance is performed again at the end of the novel, when George Shelby, in a stance similar to that of his initial appearance in the novel, gives liberty to a group of delirious slaves in comical striped outfits. The cross-referencing between images that is signaled in this dance also points outside this set of illustrations and anticipates Cruikshank's 1853 designs for *Robinson Crusoe*, in which the wild dance is used again to signify primitiveness.[44] In *Uncle Tom's Cabin* it acts as a symbol of racial difference that reveals the grotesqueness of Topsy

and the other slaves, and the distance between them and the almost-white Eliza and George, who would never behave in such a manner.[45]

The "whiteness" of Eliza and George is also indicated in their clothes. In contrast to the other Negroes, adorned in poor and clownish costume (or lack thereof) that signifies their otherness, George is shown impeccably dressed in Western suits.[46] In one edition by Clarke and Company he appears in the unmistakable pose and garb of a gentleman, his hand raised in a defiant gesture. This image appears to have been the model for John Gilbert's illustration of the former slave Frederick Douglass that appeared in *Uncle Tom's Almanack* the following year. Douglass here is covered from head to toe in a fashionable outfit; the only parts of flesh betraying his racial identity are his face and hands. His arm, also raised in a powerful appeal to the company around him, suggests a controlled and rational outlet for his passions that is far removed from the Negro dance.[47]

Cruikshank's comic exaggeration serves to undermine any threat that the Negro might pose and sets up a hierarchy of difference in which the parallel positioning of black and white characters emphasizes their alterity and the concomitant superiority of the whites. It is a device that has been identified in the novel, but is perhaps used more effectively in the visual images, in which the figures can be situated side by side.[48] To a certain extent, however, the Negro's position as foil actually removes any racial specificity, leaving only a stereotype of otherness or, as Homi K. Bhabha would suggest, of sameness. Bhabha argues that the stereotype actually disavows difference, even as it seems to acknowledge it. It covers over heterogeneity, repeatedly employing the same definitions and determinants—whether of race, class, or gender—and depending on the presence of other stereotypes for its apparent unity and fullness: "the "stereotype" requires, for its successful signification, a continual and repetitive chain of other stereotypes. The process by which the metaphoric "masking" is inscribed on a lack which must then be concealed gives the stereotype both its fixity and its phantasmatic quality—the *same old* stories of the Negro's animality, the Coolie's inscrutability or the stupidity of the Irish *must* be told (compulsively) again and afresh, and are differently gratifying and terrifying each time."[49]

Bhabha's positioning of the stereotype of the Irish alongside that of the Negro is particularly telling in the context of Cruikshank's illustrations. His *Tales of Irish Life,* published in 1824 and praised by Thackeray for its accurate representation of the Irish nation, makes use of the same stock traits that were to become an aspect of the Negro character in 1852.[50] The last image in the book depicts an Irish jig at a wedding at which the bride and bridegroom are surrounded by energetic villagers who down drinks and throw their legs and arms into the air. An invalid old woman, not to be outdone by the other guests,

attempts to dance while seated on a bench, and her weird contortions are copied by the small child who sits next to her. The carefree jollity and infantile behavior that make these characters funny are also apparent in Cruikshank's illustrations for Stowe's novel. Indeed, the connection between the Irish and the Negro slave was made explicit in an account of *Uncle Tom's Cabin* that appeared in the *English Review* in October 1852; both races were said to share "the same strong and kindly feelings, the same love of ease and comfort, the same lively apprehension of the humorous."[51]

It is not known whether the critic had any of Cruikshank's illustrations in mind when he wrote this article, but his description certainly resembles the pictures that accompanied Cassell's edition of the novel, which was being issued in twopenny weekly numbers in the same month. Perhaps their similarity lies not in any direct, or even conscious, relation, but in the fact that both texts and images are bound up in cultural values and ideologies. What I have argued in this chapter is that illustration itself plays a key role in the generation and circulation of meanings, even influencing the ways in which texts signify. I am not suggesting that Victorian books cannot be read without their pictures, but, rather, that an examination of the ways in which images and words interact opens up the possibility of different readings and viewings. In the case of a book like *Uncle Tom's Cabin,* this type of analysis seems to take on a particular urgency, with the dialogue between the engravings and the novel working to construct ideas of national and racial identity and alterity. As a genre that occupies a fragile borderline between the textual and visual, illustration is never far removed from the politics of difference and otherness that pervade Stowe's novel.

2

PICTURES, POEMS, POLITICS

Illustrating Tennyson

I

Uncle Tom's Cabin was published on the eve of a "golden age" of illustration, a period spanning roughly from 1855 to 1870, when radically different ways of illustrating texts began to emerge.[1] Yet the issues that this particular book raises and the problematic relation between word and image that it puts into play creep into "sixties" illustration and suggest that, far from idyllic, this "golden age" was, in fact, an age in crisis. This chapter aims to chart this crisis by moving further toward a politics of illustration, in the sense of identifying and problematizing an unstable set of visual practices that worked with and against the text. But I also want to emphasize how Victorian illustration is framed within a wider notion of the political. By analyzing the illustrations of the Pre-Raphaelite artist Dante Gabriel Rossetti and his less-famous contemporary Eleanor Vere Boyle, I shall suggest that the meanings of racial and national difference, so integral to the images that accompanied *Uncle Tom's Cabin,* are compounded here with meanings of sexual and gender difference. These power relations, moreover, are bound up in the power relation between words and pictures: they share the same knowledges, use the same vocabulary, and are constituted by the same values and assumptions. Indeed, the concluding part of this chapter argues that illustration generates its own gender politics. It is not a neutral mode of representation but one that participates in the ideological conflicts that make up its cultural moment.

Tennyson's poetry is central to this moment. His texts were popular not only in their own right, but in their frequent appearance as pictures, a visualization that earned the author the label of "painter's poet." Book illustrations of Tennyson's verse, however, often proved controversial, because they foregrounded the interaction between word and image in a way that was not always apparent in

paintings. Whereas the canvases hung in the Royal Academy might have quotations from the poems appended to their frames or in the exhibition catalogue, they still retained a certain distance from the text. In book illustration words and pictures appeared together, a proximity that was made more intimate by the popular technique of wood engraving, which allowed the picture and text (both printed in relief) to be placed on the same page. It was a technique that, as well as uniting the genres, could serve to emphasize the differences between them, differences that were intensified in the case of Tennyson's poetry because the illustrated versions appeared some years after the texts' original publication. The apparent disparity or fidelity between genres was more of an issue here than in texts like *Uncle Tom's Cabin,* which, in Britain at least, was illustrated at the outset, so that the pictures were in a position to play a part from the beginning in determining the reader's response to and interpretation of the words.

Tennyson himself seems to have had a negative opinion of the illustration of his works. When the publisher Edward Moxon issued an illustrated version of his poetry in 1857, Rossetti, who had contributed five designs, was convinced that the poet "loathed" his illustrations,[2] and perhaps he was justified in this view, for Tennyson later confided to a friend that "he ha[d] never seen an artist truly illustrate a poet."[3] Tennyson was certainly horrified to learn that Moxon intended to follow up this edition with an illustrated version of *The Princess* and had already commissioned Daniel Maclise as the artist. The book was eventually released in 1860, but not without some angry comments and attempts to prevent the publication on the part of Tennyson. In one letter, sent through his wife, Tennyson complained that the 1857 edition was entirely Moxon's idea and argued that plans for *The Princess* should be delayed until there was agreement on how the edition should proceed. He even remonstrated with Moxon to the effect that that the pictures should be published separately, that is, not as illustrations to the poem at all.[4]

The reasons for Tennyson's dislike of illustration are not always clear, but it does seem that he viewed the genre as in some ways threatening both to his texts and to his status as an author. With pictures appearing alongside the words, it was not always easy to control textual meanings. These concerns became manifest in an encounter between the poet and William Holman Hunt, who had also contributed to Moxon's edition. Hunt records that

> [a]fter some general talk [Tennyson] said, "I must now ask why did
> you make the Lady of Shalott, in the illustration, with her hair wildly
> tossed about as if by a tornado?"
>
> Rather perplexed, I replied that I had wished to convey the idea of
> the threatened fatality by reversing the ordinary peace of the room and

of the lady herself; that while she recognised that the moment of the catastrophe had come, the spectator might also understand it.

"But I didn't say that her hair was blown about like that. Then there is another question I want to ask you. Why did you make the web wind round and round her like the threads of a cocoon?"

"Now," I exclaimed, "surely that may be justified, for you say—

Out flew the web and floated wide;
The mirror crack'd from side to side;

a mark of the dire calamity that had come upon her."

But Tennyson broke in, "But I did not say it floated round and round her." My defence was, "May I not urge that I had only half a page on which to convey the impression of weird fate, whereas you use about fifteen pages to give expression to the complete idea?" But Tennyson laid it down that "an illustrator ought never to add anything to what he finds in the text." Then leaving the question of the fated lady, he persisted, "Why did you make Cophetua leading the beggar maid up a flight of steps? I never spoke of a flight of steps."

"Don't you say—

In robe and crown
The King stepped down,
To meet and greet her
On her way?

Does not the old ballad originally giving the story say something clearly to this effect? If so, I claim double warrant for my interpretation. I feel that you do not enough allow for the difference of requirements in our two arts. In mine it is needful to trace the end from the beginning in one representation. You can dispense with such a licence. In both arts it is essential that the meaning should appear clear and strong. Am I not right?"

"Yes," he said, "but I think the illustrator should always adhere to the words of the poet!"[5]

In many ways this conversation is a reworking of the familiar dispute between author and artist, a Victorian *paragone,* where the author argues that the image should follow the text and the artist stresses the incommensurable difference between the genres. Ironically, though, Hunt's assertion of pictorial difference comes about only in his attempts to faithfully reproduce the ideas of the poem, to condense the work of fifteen pages into a picture that takes up a fraction of that space. For Hunt, the difference between the genres is not in the stories they tell,

but the necessarily diverse ways in which they tell them. It is this very diversity, however, that works to undermine Hunt's suggestion that he can translate the poem into a picture. What the author's objections and the artist's retorts actually reveal is that these differences in modes of representation inevitably lead to multiple stories and meanings. The movement toward sameness and coincidence only intensifies the gap between the genres, a gap that revolves around Lessing's distinction between the temporality of words and the spatiality of images: the picture, argues Hunt, has one moment in which to convey events, whereas the poem is able to gradually unfold. Hunt's comments imply that this difference is insurmountable: the genres have their own distinct codes and conventions, which means that they can never be identical, while Tennyson's repeated insistence that the illustration should adhere to the text suggests that this difference can and should be overcome.

Despite Tennyson's distrust of engraved illustrations, he seems to have evinced slightly more confidence in photography as a method of illustration. Perhaps he assumed that this medium required a literal rendering of the scene, or demanded a more realist approach, and thus less imaginative input on the part of the artist. Whatever the case, he apparently requested that the society photographer Julia Margaret Cameron undertake a series of photographic illustrations of his poetry.[6] When the second volume of Cameron's edition of *Alfred Tennyson's Idyls of the King and Other Poems* appeared in October 1875, the *Times* commented on the difficulty of the attempt "to make sun-painting repeat word-painting."[7] But these difficulties were more of a practical than of a theoretical nature. The critic argued that, because Cameron had taken the photographs of Tennyson's "characters" (actually Cameron's friends, family, and servants dressed in Arthurian garb) in an unsuitable building and with little scenery and few props, she was forced to abandon an actual representation of the verses and their setting "in the hope of conveying something vague and sweet, and mythical, or of indicating by some cipher intelligible only to the imaginative a portion of the meanings which the scene recorded was itself intended to illustrate."[8] Cameron's decision to visualize the verses in the way she did is justified by the reviewer because it is seen as the only way of overcoming generic problems and of continuing to make the photographs "repeat" the words. The *Times* holds up the fidelity of the image to the text as an ideal, and, in their apparent endeavor to fulfill this aim, Cameron's illustrations are successful; or, rather, they are successful in proportion to the ways in which they are unsuccessful, to the extent that their "vague" representations are regarded as the unavoidable consequences of technical difficulties rather than as intentional or experimental. This review, then, while allowing that "sun-painting" is different than "word-painting," actually disallows the possibility that Cameron's pho-

tographs might have an agenda different from that of the text.[9] One wonders what the evaluation of her work would have been if Cameron's visual distortions had been seen as having nothing to do with technicalities. What, in other words, would be the implications of a pictorial difference that could not be reasoned away or accounted for in terms of its attempt to reproduce the text?

II

The question had, in fact, already been asked, and the answer was one that troubled the boundaries between word and image in Victorian illustration. It was provoked by those illustrations that moved away from the Hogarthian narratives produced by Cruikshank and Phiz to the more abstract designs associated with the Pre-Raphaelites. This artistic shift came to the fore in Moxon's contentious edition of Tennyson's poetry, which Gleeson White in his study of English illustration of the 1860s identified as "the genesis of the modern movement."[10] It was Rossetti's illustrations, in particular, that problematized the relation between words and pictures. Whereas the illustrators of *Uncle Tom's Cabin* might have added to the text in order to construct their own narratives, Rossetti was thought to have rejected it altogether. The artist's brother admitted as much when he wrote that in his designs for the verse, "[Rossetti] only, and not Tennyson, was his guide. He drew just what he chose, taking from his author's text nothing more than a hint and an opportunity."[11] In 1894 George Somes Layard summed up Victorian opinion by contending that out of the three Pre-Raphaelite contributors to the book, "Millais has realized, Holman Hunt has idealized, and Rossetti has sublimated, or transcendentalized, the subjects which they have respectively illustrated."[12] In the work of these artists, seemingly unified by their Pre-Raphaelite ideals, one can identify the sheer diversity of illustrative practice. Taken together, they reveal the conflicting modes of illustration that were on offer to artists and readers in the mid-nineteenth century. Rossetti's images, according to Layard, are the most radical because they not only overpower the text, but can openly contradict it. Rossetti calls into question the whole notion of what an illustrator is. As Layard comments, "The mere fact that a man's drawings are reproduced in a book, and labelled with the names of the literary productions that find place in that book, is not enough in itself to constitute that artist an illustrator in the truest sense of the term."[13]

Rossetti's position as a "true" illustrator was most famously compromised in a picture he produced for Tennyson's *The Palace of Art,* which appeared in Moxon's edition (figure 2.1). The poem recounts the isolation of a soul who is removed from the world in a palace full of treasures, but Rossetti's image proved a stumbling block for critics and for Tennyson himself, who found it impossible

Figure 2.1 Dante Gabriel Rossetti, illustration for Alfred Tennyson, *The Palace of Art*, in *Poems by Alfred Tennyson* (London: Moxon, 1857).

to work out what it had to do with his verses.[14] His bewilderment was a common response, and by the last decades of the nineteenth century the picture was being praised precisely because it was not illustrative in the conventional sense of the word but an independent creation dissociated from the poem.[15]

A viewer today, however, might be surprised by the apparent discrepancy between text and image in this illustration. The picture focuses on four lines in Tennyson's text that describe a tapestry of Saint Cecilia that hangs in the palace:

> *Or in a clear-wall'd city on the sea,*
> *Near gilded organ-pipes, her hair*
> *Wound with white roses, slept St. Cecily;*
> *An angel look'd at her.*[16]

While Saint Cecilia sits in the foreground of this picture, roses adorning her hair, the background consists of a highly detailed representation of a "city on the sea," complete with ships, battlements, and men at work. Although this illustration, in keeping with the format of the rest of the book, is placed at the head of the poem rather than next to the lines it illustrates, it does include the trappings that identify the central figure: Cecilia's obligatory organ (she is the

patron saint of poetry and music) and the angel who always accompanies her. These iconographical features would have been familiar to Victorian spectators from their frequent representation in Renaissance paintings, and it would seem, in fact, that the original viewers did recognize the saint, but they still regarded the picture as alien to the text. One probable reason for this is that, unlike most contemporary illustration, this image does not depict the narrative of the poem as a whole (Tennyson's account of the soul) or even an incident from this narrative, but extracts one of its minor details, telling a story that is alluded to within the story.

Indeed, the differences that might exist between a nineteenth- and twenty-first-century viewing are integral to this image, for what it exposes is that illustration is historically specific: the relation between word and image not only is defined differently at different moments but is seen differently too. It is the culture in which the text is read and the image viewed that determines whether the genres are seen to meet or diverge. For the Victorian viewer of *St. Cecilia,* this difference was pinned on just one word that was present in the text but not reproduced in the picture. This word rendered the image unrecognizable from the poem and raised, in itself, the problem of vision and perception: "An angel *look'd* at her." In Rossetti's image, with its extraordinary visual power and appeal, it is, ironically, this look that is absent, that evades the viewer's gaze. The angel here is doing something to Cecilia, but he is certainly not looking at her. The substitution for "look'd" of what appears to be a kiss or a bite makes the encounter between angel and saint a troubling one. Rossetti's Saint Cecilia, like Bernini's Saint Teresa, is shown in the midst of an ecstatic swoon that, to all appearances, is not merely spiritual.

The point at which the picture deviates from Tennyson's text, then, is its representation of female sexuality. It was this that in the eyes of contemporary spectators made the image completely other, an illustration that had nothing to do with the poem. So disturbing was this depiction that late nineteenth-century critics concentrated all their energies on explaining or accounting for it. In 1901 the artist and writer Joseph Pennell argued that the "kiss" was the fault of the engraver and reproduced a drawing by Rossetti in which the angel was "looking" as proof of his argument.[17] Fairfax Murray, who was of the same opinion, attempted to neutralize the sexuality of the scene even further by suggesting that the hands of the angel are wrapped in the cloak rather than touching the saint directly, as a way of showing his reverence for her.[18] The prize for the most ingenious interpretation, however, must go to Layard, whose reading of the image was based on the fact that the wings of the angel did not look at all convincing; far from pointing to Rossetti's poor design, Layard argued that they were not meant to look real, that Rossetti had conceived the picture as a

travesty of the story of Cecilia and showed a man masquerading as an angel in order to gain access to the saint![19]

Such interpretations attempt to reconcile word and image, to forge a link, however tenuous, between the two media, and at a point at which the image appears to deviate from the text. But perhaps there is a sense in which this image is not so far removed from Tennyson's poem after all. Even the sensuous aspects of the image bear some relation to the verse. William Vaughan has recently suggested that Rossetti's design brings to the fore precisely that side of Tennyson that was so admired by the aesthetes.[20] Rather than being wholly divorced from the words, the picture weaves together pictorial and textual elements, adding different dimensions to the verse but never completely rejecting it. The meanings generated by poem and picture coexist, however uncomfortably. In fact, it is precisely this sort of illustrative practice that Rossetti described when he was asked to contribute to Moxon's edition. He wrote to his friend, the poet William Allingham: "[I] fancy I shall try the *Vision of Sin* and *Palace of Art*, etc.,—those where one can allegorize on one's own hook on the subject of the poem, without killing, for oneself and everyone, a distinct idea of the poet's. This, I fancy, is *always* the upshot of illustrated editions,—Tennyson, Allingham, or anyone,—unless where the poetry is so absolutely narrative as in the old ballads, for instance. Are we to try the experiment ever in their regard?"[21] However unfaithful to the text Rossetti's illustrations seemed, this unfaithfulness does not appear to have been his intention. What the artist outlines here is a mode of illustration in which the meanings generated by the poet coexist with those of the illustrator: the artist "allegorize[s] on [his] own hook" while retaining the "hook" of the author. This type of illustration is itself "allegorical" because it contains two interpretative layers, producing a dual story, with neither story having total precedence. The aim of such an illustration is not to illuminate the poem in the sense of clarifying it, but to add to the range of its possible meanings.

Rossetti's conjunction of authors' and artists' "hooks" is primarily a conjunction of textual and pictorial ideas and devices: the literary allusion to the story of Saint Cecilia in Tennyson's *The Palace of Art* is combined with an emphasis on female sexuality that was central to Rossetti's paintings. The result is an image that illustrates a poem but also refers to its status as a work of art with its own tradition and aims. One of the most striking features of this illustration is the fact that it is instantly recognizable as Rossetti's. It seems to emphasize its own place in the artist's canon by using images and symbols that Rossetti had used before and was to use again: the familiar face of his model, Elizabeth Siddal, the sundial and dove that appear in *Beata Beatrix,* the combination of religious and sexual imagery that comes to the fore in his earlier painting of

the annunciation, *Ecce Ancilla Domini! St. Cecilia* is a patchwork of Rossetti's most common motifs. This, in fact, was underscored in the exhibition of Pre-Raphaelite art organized by Ford Madox Brown in the same year that the Moxon *Tennyson* was published. In the exhibition, photographs of Rossetti's designs for the book were displayed alongside paintings that showed his emergent aestheticism, like *Dante's Dream at the Time of the Death of Beatrice* and *The Blue Closet.*

The explicit location of the illustration of Saint Cecilia in Rossetti's artistic tradition lends some credibility to the criticism expressed at the time that his designs had more to do with schools of painting than with Tennyson's poetry. This was the conclusion reached by the *Art Journal* in its review of Moxon's illustrated edition:

> Five subjects are from the pencil of Rosetti [*sic*]; with the exception of "Sir Galahad," a vigorous and effective study, but, so far as we can make it out, without the slightest reference to any descriptive line in the poem it professes to illustrate, these designs are beyond the pale of criticism; if Millais and Hunt have shown something like an inclination to abjure their artistic creed, Rosetti seems to revel in its wildest extravagances: can he suppose that such art as he here exhibits can be admired?[22]

Rossetti's pictures are out of control, "beyond the pale of criticism," and unworthy of serious study. This wildness, however, is not the personal fault of the artist but the fault of the school to which he stubbornly conforms: Pre-Raphaelitism. The images fail because they not only are part of this school but seem to announce and celebrate their place within it. For this reviewer, it is not Rossetti's deviation from the text that is dangerous so much as his adherence to certain ideologies. According to the critic, the illustrator "must work from, as well as up to, his model; but then we look for his own ideas of the subject before him, expressed in the true language of pictorial art, and not in that of any particular school or creed."[23]

What is good advice for the artist, however, is not necessarily so for the art critic. Paradoxically, it is these very "schools" and "creeds" that the *Art Journal* is eager to foster. Sandwiched between articles on the "Private Galleries of the British School" and the "Style and Character" of such a school, the review participates in the construction of a national artistic identity. This is intensified in an account of another illustrated book, *The Farmer's Boy,* by Robert Bloomfield, which shares the same page as the review of *Tennyson's Poems* and alludes to it, encouraging the reader to make the appropriate connections between the texts: "There is scarcely an author whose works take sufficient rank

in literature to entitle them to such distinction, and are of a nature to admit of illustration,—from Shakspere [*sic*], Milton, and George Herbert, down to the living Laureate,—who has not been made still more popularly known through the genius of the artist."[24] Illustration here is a "distinction," a way of signifying the worth of great literature, an accolade conferred on canonical authors. In its ability to popularize texts, however, the genre also has a certain power: it can play a part in constructing this canon in the first place. The reviewer goes on to argue that the pictorialization of *The Farmer's Boy* has prevented it from falling into obscurity or being subsumed by the mass of poetry in circulation. The review begs the question of how far literary worth is constituted, rather than reflected, by illustration, to what extent it is less a "distinction" than a determinant of value. As David Blewett has asserted, the number and variety of illustrations that accompany a work keep it alive "in much the same way as a great play or an opera is renewed through successive productions."[25]

This potential power of illustration is accentuated and problematized in its nationalist import, for, according to the critic in the *Art Journal*, it is specifically British authors who are canonized by British illustrators. *The Farmer's Boy*, written by a British writer, is set in the British countryside and illustrated by the unmistakably British artists Myles Birket Foster, Harrison Weir, and George Elgar Hicks. The "highest Art-genius of a nation," eulogizes the critic, "[has been] engaged in strewing with flowers of beauty new pathways for the triumphal progress of her literary heroes."[26] Such a national "triumphalism" is evident in other contemporary accounts of illustration. The French illustrator Gustave Doré, although "virtually an Englishman by adoption" during this period, frequently fell prey to such definitions.[27] The *Times* saw his edition of *Idylls of the King* as significant because it was the first instance of a living Frenchman illustrating the works of a living Englishman:

> Much has been done of late to popularize Gustave Doré in England;
> but we question whether Doré has not done even more to popularize
> Tennyson upon the Continent, and so to spread abroad a taste for our
> modern English literature. For instance, it is no secret that since Doré
> first tried his pencil at illustrating them, the *Idylls of the King* have
> been translated into French, Spanish, German, and Italian, and even
> into Swedish, and, helped on by Doré's illustrations, have found a
> ready sale wherever those languages are spoken.[28]

The increased popularity of Tennyson's poetry that came with its illustration serves here as a thinly veiled metaphor for the expansion of the empire, with the genre functioning as a means of colonizing even those European countries that

compete with Britain for imperial dominance. And it is no accident that it is a Frenchman who is placed in the role of imperialist, fighting for the progress of English ideals. Doré, whether he knows it or not, is an ambassador for English poetry and, by implication, for the concepts of Englishness to be found in such poetry.

Like Doré, Rossetti is also frequently enlisted in this colonial mission. Gleeson White argues that this artist's popularity abroad allowed for the progress of his "entirely English" artistry, with the traditional enemy, France, again most under threat, his style spreading "over that Continent which one had deemed inoculated against any British epidemic."[29] But there is always a question mark over such expansionism. Ruskin used a similar image of disease to condemn Doré's illustrations to Tennyson's *Elaine,* seeing them as "a sign of what is going on in the midst of us, that our great English poet should have suffered his work to be thus contaminated."[30] Perhaps it was easier to view a Frenchman as a corrupter of English ideals than it was an artist whose father was Italian but who had been brought up in England. Rossetti occupied an uncomfortable borderline between Englishman and foreigner that seems to have contributed to the way in which his work was received.[31] White concedes that, to the native Englishman, Rossetti's images seem more "exotic and bizarre" than British,[32] and even Millais described his fellow Pre-Raphaelite as "mysterious and un-English."[33] In relation to a "nationalistic" text like Tennyson's *Poems,* written by the laureate and opening with a dedicatory poem to Queen Victoria and her empire, Rossetti's difference is thrown further into relief.[34] Perhaps there are more pointed meanings in Layard's accusation that in Rossetti's designs for the book the artist "ignored the allegiance which, as illustrator, he owed to the text," a description of the divide between word and image that is couched in the language of imperial subject relations.[35]

Rossetti's inability to occupy the role of a "proper" illustrator, to unite the image securely to the word, is bound up in his inability to occupy the role of a "proper" Englishman. Indeed, it was this imperialist discourse that set the tone for discussions of illustration in general. Luke Fildes described illustration as "a Branch of Art singularly and peculiarly English in which our supremacy was unquestioned from Hogarth," and Edmund J. Sullivan, writing in 1921, describes the medium of wood engraving itself in terms of empire and Englishness.[36] Analyzing the artists working in the 1860s, Sullivan writes:

> The art of the Sixties had been the most British—even the most English—expression yet found since Hogarth, although of the Pre-Raphaelite leaders Millais, John Bullyish as he was in appearance, being a Jerseyman, was presumably predominantly French in blood—

Rossetti was half Italian. The influences they had first chosen were medi-
aeval and foreign. But Pinwell, Houghton, Pettie, Keene, Lawless, Ma-
honey were all British, and, with the exception of Sandys, submitted to
no influence in art that was not already rooted in England.[37]

This interweaving of illustration and Britishness constitutes the divergence
of image from text as a threat to national identity, but it is also curiously reac-
tionary, a way of asserting what the "proper" relations between society and art,
texts and pictures, should be, and of displacing political problems and anxieties
onto a seemingly other, artistic realm. This paradox is ingrained in the Moxon
edition itself. Tennyson's homage to Victoria's empire at the outset alludes to the
"care" that attends the queen's role, a reference that must have had particular
resonance in the year in which the book was published, for, on May 10, just
two months before the review of *Tennyson's Poems* in the *Art Journal,* the "In-
dian Mutiny" had erupted. The *Art Journal*'s discussion of the appropriate re-
lation between word and image and its concomitant attempt to glorify the
nation takes place at precisely the moment when the nation was most under
threat. The mutiny is a subject, however, on which this particular periodical re-
mains eerily silent; aloof from political events, it stands as the last bastion of
aesthetic isolation, a Tennysonian palace of art in which war and peace make
no difference. But, despite the journal's apparent lacunae, there is a sense in
which the cultural and ideological context is always already there, present in
that place, both elusive and overdetermined, where Rossetti's pictures fall so
short of the illustrative ideal.

III

The May Queen, originally published before Victoria's accession, was one of the
most popular nineteenth-century poems, Tennyson adding the "Conclusion" in
1842. There were some fifteen paintings of the poem and it was also set to
music.[38] Its appeal can be attributed not only to the haunting and catchy repe-
tition of the verse, but also to the Victorian values that it was seen to embody.
With its dying young heroine, the text presents what one contemporary re-
viewer called "a touching picture of filial affection, conjoined with a spirit of
piety and resignation to the Divine will."[39] The poem also served as a metaphor
for a dying way of life; the rural customs and traditions it describes were nos-
talgic reminders of a lifestyle that had all but disappeared.

In 1851 the May Day festival, traditionally held on village greens through-
out the country, was replaced by a very different event: the opening of the Great
Exhibition in Hyde Park, a symbolic reminder of both the progress of industry
and the dissolution of rural communities. This was not lost on commentators.

In the *Dublin University Magazine,* Tennyson's *The May Queen* represented the legacy of the past and punctuated an account of this new "May-Day Feast": the flower that blossomed in May 1851 was that of mechanical skill, the Morrice dance was replaced by the "March of Nations," and it was not some country maid but Victoria herself who might have repeated the words of the laureate to the Duchess of Kent: "I'm to be Queen of the May, mother, / I'm to be Queen of the May!"[40]

The inclusion of *The May Queen* in this account of the opening of the Great Exhibition is not quite as incongruous as it first appears, however, for although text and event celebrate different, and even opposing, lifestyles, they are both celebrations of Englishness: the Crystal Palace epitomized English ingenuity and industrial superiority, and Tennyson's poem described the beauties of the English countryside and the value of its traditions. One critic described *The May Queen,* alongside Tennyson's *The Miller's Daughter,* as "true pictures of English character and customs."[41]

Illustrated editions of *The May Queen* rework these ideas. Versions published in 1861 and 1872 took advantage of the development of chromolithography, a method of color printing, and appeared like medieval illuminated manuscripts, with the flowers described in the verse enclosing the text and entwining the letters in a blaze of color.[42] The 1872 edition added to the English flavor of the poem by including two vignettes that appeared at the end of the text's first and second sections, the first showing a group of villagers dancing around a maypole, a custom that Tennyson alludes to in his poem, and the second depicting an English rustic cottage in winter with its wooden beams, lattice windows, and well-ordered garden. These colored editions of *The May Queen* juxtaposed the Victorian technology that was to shape the destiny of the illustrated book with an idealized vision of a preindustrial age.

To a certain extent, however, they were exceptions. The mid-nineteenth century was characterized by the resurgence of wood engraving, a practice that was described in terms of a return both to nature (the designs were made on the ends of boxwood) and to the past (it was a modern version of the medieval woodcut). Wood engraving constituted an ideal vehicle, then, for picturing Tennyson's poem. The first illustrated versions of the text were wood engraved and appeared in 1857, J. C. Horsley designing three pictures for the poem when it appeared in Moxon's illustrated edition, and Thomas Dalziel (of the famous engraving firm) producing four drawings to accompany the poem in Robert Willmott's *The Poets of the Nineteenth Century.* The artistic styles and techniques of these editions are strikingly diverse, and each posits a different relation with the text: Dalziel uses alternate rectangular and arched blocks that are predominantly dark and framed by a black borderline that separates them

Figure 2.2 Thomas Dalziel, illustration for Alfred Tennyson, *The May Queen*, in *The Poets of the Nineteenth Century*, ed. Robert Aris Willmott (London: George Routledge, 1858).

from the text, while Horsley has light unbounded scenes, largely devoid of engraving.

In terms of subject matter, there is also little resemblance between the two versions. Horsley opens the poem with the crowning of the May queen, whereas Dalziel adheres more strongly to the chronology of the narrative, showing the young girl destined to be queen of the May urging her mother to "wake and call me early." Dalziel goes on to picture the May Day celebrations, the sick bed attended by the mother and sister, and a meeting outside a churchyard between the mourning mother and sister and a young man. Horsley includes two scenes of the dying girl, one in which she is sitting by a window being read to by her sister as her mother weeps, and another in which she lies in bed. Even the common scene of the May Day celebrations is pictured very differently in each edition. For Dalziel, the event comes at the top of the page that begins "New Year's Eve" (figure 2.2). It therefore closes the first section of the poem and provides a sorry reminder to the reader of a happiness and health that is now gone. While Dalziel packs his small rectangular block with scores of cheering people, the heroine almost indistinguishable from the crowd, Horsley's illustration is much more grand and stately (figure 2.3). His May queen is placed in the center with a crown on her head and scepter in her hand and is raised above the country courtiers who stand around her, an evocation of the coronation of the young Victoria.

Of these two editions, Horsley's is the more detailed and symbolic. In the opening scene the maypole rivals a church spire, an anticipation of how the story will end, and the artist frequently includes elements that point backward and forward in time. In the last picture this is a clock itself; with its pendulum caught midswing it suggests that time might be running out for this May queen, whose spring bonnet hangs forlornly on the other side of the bed.[43] On

Figure 2.3 J. C. Horsley, illustration for Alfred Tennyson, *The May Queen*, in *Poems by Alfred Tennyson* (London: Moxon, 1857).

a table a candle flickers next to bottles of medicine. It was this edition of the story that proved the most influential for later illustrators, despite the fact that one critic saw his version as proof that Horsley "knew only one facial type and only one mode of arrangement."[44] His scenes of the crowning of the May queen and the dying girl sat in a chair are repeated almost exactly in the illuminated edition of 1861 and in some early twentieth-century versions.[45]

Where Horsley and Dalziel differ in technique and subject matter, however, they do share one important characteristic: they depict concrete incidents and events, telling the story of the poem rather than interpreting its significance. This does not mean that they do not add to the text: Dalziel's last scene of the churchyard meeting is not described in the poem, and neither are the symbolic details that adorn Horsley's pictures. But they do not step outside the storytelling framework itself; if anything, they are immersed in the narrative. Their additions are additions to the story, not extensions or allegories of its themes or ideas. Indeed, this narrativity, as Rossetti implied, seemed the only option for an illustrator of such a narrative poem, which gave little scope for any "allegorizing." It was left to an "amateur" female artist to offer an alternative reading of *The May*

Queen. By conjoining the storytelling of Horsley and Dalziel with the imaginative brilliance of Rossetti, she not only interpreted Tennyson's text in multiple ways but also offered a radical rethinking of the role of the female illustrator.

Eleanor Vere Boyle, or "EVB" as she signed herself,[46] described by Rodney K. Engen as the "only competent woman illustrator, draughtsman to emerge before 1860"[47] and by Gordon N. Ray as having "as unmistakable a style as that of any Victorian illustrator,"[48] published her version of *The May Queen* in December 1860 (it is dated 1861).[49] It was eclipsed in terms of reviews by the illuminated edition of the poem that appeared in the same year, but it was extremely popular throughout the century, running through several editions and issued in America. A close friend of Tennyson, Boyle approached the poet with the suggestion of illustrating the verse and received what was from him a relatively encouraging response: "I would rather you than any one else should do it."[50] Tennyson's blessing on the project was less surprising considering that this "amateur" artist was already accomplished, having published two successful children's books, *Child's Play* (1852) and *A Children's Summer* (1853). She was advised by Boxall and Eastlake and had a close correspondence with the Pre-Raphaelites. Millais planned to include her in a sketching club in 1854, and Rossetti asserted that she was "great in design."[51] Indeed, Rossetti decided to illustrate "The Maids of Elfen-Mere," one of the most influential designs of the century, for William Allingham's *The Music Master,* only because the poem that Allingham initially suggested he should draw had already been so well illustrated in *Child's Play.*[52]

EVB was in many ways the perfect choice as an illustrator for *The May Queen,* a text that was regarded as a "sweet, simple, touching little poem" that would not have been out of place in a young person's poetry book.[53] The focus on the natural elements in Tennyson's poem was very much a concern of the artist. A follower of Ruskin, she asserted that "[n]ature is creation's picture-book,"[54] and her illustrations demonstrate the attention to detail that Ruskin and the Pre-Raphaelites espoused. Like Tennyson, Boyle was fascinated by an older, simpler way of life that was fast disappearing and that she regarded as closer to nature and the truth of art.

Taking these shared concerns into account, it comes as something of a shock to see the extent to which these pictures refuse to be fixed, veering dramatically between reality and fantasy, an immersion in the homely world of the narrative and an exploration of the spiritual beliefs and ideas that inform it. The diversity of these images is apparent in the different types of illustrations on offer, from heavily engraved images, with sharp definitions and borders and a range of tonal effects, to simple, unframed vignettes. There are also variations in the positions of the pictures on the page. They are placed above and below

the text as well as sandwiched between the lines. The result is an illustration of the verse that is both a parallel version and a creative, interpretative layer that works to redirect or intensify certain meanings. These pictures do not reject but supplement the text, forming a symbiotic relation that is intensified by the fact that the pictorial movement between themes and styles is not random but determined largely by the tripartite division of the verse. EVB moves from storyteller to interpreter to creator or visionary in accordance with the movement of the poem itself.

The first section of *The May Queen* is characterized by bold wood engravings that depict the events of the poem and tell the tale in a similar way to Horsley and Dalziel: there is the girl's initial appeal to her mother, the spectacle of her coronation, and the obligatory English country landscape. All these pictures gain a heightened realism from the fact that they were drawn from life: the May queen was modeled on Boyle's consumptive daughter, and the scenery was that of Marston Bigot in Somerset, where the artist lived. Even in this section, however, the narrative is invaded by fantasy, just as the more fantastic elements in the later sections are interspersed with narrative detail. The flowers that EVB has sprouting up throughout the book call to mind William Blake's mystical and organic images in *Songs of Innocence and of Experience*, while her representations of cherubic children incite comparison with Victorian fairy painters. Angels populate this edition: they are depicted curled up in the petals of flowers, flying through the sky, and in the graveyard of a country churchyard. Their presence directs the Victorian reader back to EVB's other popular works, especially *Child's Play*. On the title page of *Child's Play*, where the illustrations accompany snippets from nursery rhymes, an angel prays over the cradle of a newborn baby; the last scene contains four large angels standing over the bed of a child, with the lines:

> *Four corners to my bed,*
> *Four angels round my head,*
> *One to watch,*
> *Two to pray,*
> *One to bear my soul away.*[55]

The picture seems to have provided the inspiration for a scene in *The May Queen* in which an angel sits on the girl's bed, its wings almost spanning the width of the engraving (figure 2.4).

In the context of Tennyson's poem, EVB's angels serve a specific purpose, transformed from the disembodied sound that they represent in the conclusion of the text, in which the heroine hears them "call," to a real bodily presence, visual proof of the existence of the divine in the human world. The scenes of

Figure 2.4 EVB (Eleanor Vere Boyle), illustration for Alfred Tennyson, *The May Queen* (London: Sampson Low, 1861).

death throughout the book are combined with angelic reminders of immortality that intensify the text's religious message and make the poem a symbolic vision of the afterlife. The final page of "New-Year's Eve" sets the tone for the mystic scenes that follow (figure 2.5). The engraving appears underneath the lines:

> *Good-night, sweet mother: call me before the day is born.*
> *All night I lie awake, but I fall asleep at morn;*
> *But I would see the sun rise upon the glad New-year,*
> *So, if you're waking, call me, call me early, mother dear.*

The depiction of a shadowy figure, standing in the mouth of a cave that looks onto the sea, and engulfed in a shroud that sweeps around its head and clings to its skull, seems to bear little relation to the words of the poem. The move away from illustration that serves a simple narrative function is made explicit in the fact that it follows just such a picture, in which Effie, on the instruction of her sister, arranges roses around the parlor window (figure 2.6). The only reminder of this previous scene is the rose that the mysterious figure clutches, a symbol of life in death. This illustration does not have a direct relation with the lines that it pictures on the level of the story—it does not show the girl lying in her bed and waiting for the dawn. Rather, it attempts to convey the *implications* of the words, to represent the thin line between life and death that is in-

Figure 2.5 EVB (Eleanor Vere Boyle), illustration for Alfred Tennyson, *The May Queen* (London: Sampson Low, 1861).

herent in the girl's desire to see in the new year. The image is a shocking one, coming as it does between more conventional pictures, but it is also a conciliatory emblem of eternity: the sun sets on the horizon, but it will rise again, and the sea will continue to crash against the rocks.

The images throughout this edition of *The May Queen,* drawn, after all, by the wife of a rector, serve as a post-Darwinian assertion of Christianity that is in sharp contrast to the fake religious ideals that Ruskin identified in the illustrations to *Uncle Tom's Cabin* and, indeed, to the doubt expressed in many of Tennyson's texts. The importance of Christianity is central to the final section of the poem, but the pictures communicate this message not so much in their presentation of a visual version of the story as in their extraction of details from the poem in order to construct a separate and distinct spiritual meaning. The depiction of the heroine's submission to her death works in this way (figure 2.7). This image is placed between lines of the text that tell of the stoicism and comfort she has found in the words of a clergyman and is a remarkable visual embodiment of this faith, the girl kneeling at the foot of the crucified Christ, her arms wrapped around the cross and her lips touching the savior's feet. Lilies, symbols of purity, stretch up the picture space toward a fortified medieval castle

Figure 2.6 EVB (Eleanor Vere Boyle), illustration for Alfred Tennyson, *The May Queen* (London: Sampson Low, 1861).

on a hill, and vine leaves and grapes flourish behind the cross, a reminder that it is the blood of Christ, shed here, that leads to everlasting life. Even while it assumes a textual function, this image is steeped in artistic traditions, drawing on medieval and Renaissance iconography and, closer to EVB's own time, on the work of the Pre-Raphaelites. The symbolic lily and vine appear in Rossetti's paintings of the Virgin Mary, and the young girl kneeling at the feet of Christ is reminiscent of his design for "Mariana in the South" in Moxon's edition of Tennyson's poems.

EVB's illustration cannot be said to deviate from the text. Rather, it tells a tale that is both absent and present in the verse: the "words of peace," presumably the story of the crucifixion and resurrection that the priest has told the dying girl. The image visualizes this implied narrative rather than displaying the facts of the text itself: the conversation between clergyman and heroine. It tells not the story of the verse, but the story that the verse evokes yet leaves unsaid. Unlike Rossetti's illustrations, which coexist with the text as a second (potentially conflicting) story, Boyle takes the text at its word, collaborating with it in order to intensify and isolate certain meanings. There is a sense, however, in

Figure 2.7 EVB (Eleanor Vere Boyle), illustration for Alfred Tennyson, *The May Queen* (London: Sampson Low, Son, 1861).

which the illustrations do come to dominate the text, turning this apparently "simple" poem into something more complex and philosophical: a tale of the supernatural and of Christian theology. And this is a tale that should not be told by a woman.

IV

The complication of illustrative roles that EVB undertakes is caught up in a complication of gender roles. Boyle's pictures, which modify and rework textual meanings, threaten contemporary accounts of illustration that define the interaction between word and image in terms of a gendered hierarchical relation, in which the text and picture are "married" or "wedded together" and the image is "faithful," "loyal," "subordinate," or "subservient" to the words. As the *Illustrated London News* proclaimed on its launch in 1842, art is the "bride" of literature.[56] Such metaphors, common throughout the nineteenth century, have been questioned by Lorraine Janzen Kooistra. For Kooistra, the illustrated text does not simply juxtapose a masterful and authoritative "male" text and an inferior "female" image. Rather, it combines the characteristics of two bodies, like the hermaphrodite; it is "bitextual."[57] This dualism is apparent in EVB's edition of *The*

May Queen, with its curious mixture of the domestic and the philosophical, the "feminine" pictures of flowers and children and the "masculine" designs of scriptural figures and the resurrection of the soul.

Of course, there is nothing natural about the gendering of these modes of representation, but the apparent obviousness of this gesture stems from their frequent construction in Victorian books that set out the parameters of the female artist, like the popular *Elegant Arts for Ladies,* published in 1856. Although this book prided itself on the belief that women should aspire to knowledge and accomplishment as well as men, the actual forms of this knowledge served to enforce rather than undermine contemporary gender roles: artistic endeavors, comments the author, "keep a household together, while they also purify and exalt the minds of its members."[58] Predictably, the favored arts for women here are watercolors of flowers and genre pictures. Oil paintings of historical, classical, and scriptural subjects are defined as the highest form of art but, as more intellectual, have few successful female practitioners.[59]

It is not simply the "intellectual" aspect of these genres that explains the relative absence of women artists in Victorian culture, however. In an unpublished account of the life and work of EVB, her great-great-granddaughter explains how Boyle's aspirations to paint in oils and model in clay were thwarted by family and friends, who regarded these activities as unsuitable for women.[60] Book illustration might have been a lesser evil, but it was still a problematic pursuit for females. *Elegant Arts for Ladies* makes no mention of illustrative drawing or design, and, in terms of published illustration, there is a distinct lack of female artists in the mid-nineteenth century, despite the fact that among middle- and upper-class women it was a favorite artistic pastime, a factor demonstrated in their highly pictorial diaries and letters. These private texts, however, rarely emerge in the public arena, making Victorian illustration a practice dominated by relationships between men.

While EVB adhered to Victorian ideologies by relinquishing her higher artistic ambitions, there is a sense in which she continued to transgress gender roles, both by invading the male sphere of illustration and by daring to illustrate in a "masculine" way. Perhaps most telling is the fact that contemporary reviews exclude the more troubling aspects of her work—the imaginative pictures of dreams, death, and omens found in *The May Queen* and developed in *A Dream Book*—in favor of her representations of fairy children, which could more readily be assimilated into a "feminine" model. These images of dimpled toddlers were widely praised. Ruskin called them "inestimable treasures,"[61] they were compared with those of Raphael,[62] and poems appeared in EVB's honor in magazines. It seems that the role of the woman illustrator was acceptable, but

only if it was combined with and seen in the light of conventional female iden-
tities. As Ellen C. Clayton remarked, EVB's "lines are drawn, not alone with the
heart and hand of an artist, but also with a mother's tenderness."[63]

Boyle's work, like that of her female contemporaries, was analyzed not on
its own merit but in terms of her position as a woman. A similar review had
greeted the publication of her friend Lady Waterford's illustrations to *The Babes
in the Wood* over a decade before: "[T]hey have the look of such gentle parent-
age," remarked the critic, before going on to assert that the best pictures were of
children, while the men were especially "ill-drawn."[64] The trouble was that there
was no independent "merit" for such illustration, no criteria for evaluation that
was divorced from gender. In "A Few Words on 'E.V.B.' and Female Artists,"
Francis Turner Palgrave addressed the problem of how women's work could be
evaluated and what a "just criticism" of it might entail, but even his discussion
depends on the gender of the artist: a woman's art, he argued, had to be seen in
terms of the artist's limited training and the fact that it was often produced for
pleasure rather than financial gain.[65] The works of male artists, however, could
be judged by a more universal standard of art. Palgrave's suggestion that there is
a difference not just in the images created by men and women but in the way
that they can be assessed is intensified in the case of illustration, in which the
focus on the sex of the artist comes to replace the more conventional vehicle for
evaluation: the interplay between picture and text. In discussions of female il-
lustrators written by Palgrave and Clayton, the relation between word and image
is subsumed by an account of the relation between image and gender.

EVB's designs for *The May Queen* not only testify to the diversity of illus-
trative practice in the 1860s but also assume a feminist significance, even if this
is due to the fact that they are constantly described in gendered terms. Boyle
herself was attentive to Victorian sexual politics, and one wonders to what ex-
tent the use of her initials rather than her full name to sign her works might
have been intended, in the beginning of her career at least, to render her sex in-
determinate. She must have been aware, while she was working on Tennyson's
poem, of the furor that was erupting over Laura Herford, who was begrudg-
ingly allowed to enter the male enclave of the Royal Academy Schools when she
submitted work to the selection panel signed only with her initials.

With contemporary discourses evaluating illustration according to the sex
of the artist, EVB's designs can be viewed as an attempt to question these defi-
nitions, to intersperse complex and abstract pictures with images that conform
more readily to a feminine ideal. These conflicting urges—on the one hand, to
play the "proper" woman and, on the other, to question what a woman's role
might be—are suggested by a paper that the artist wrote on art education in
1870, almost a decade after the publication of *The May Queen*. More revealing

than the content of this paper, which solidly adheres to Ruskinian ideals, are the factors surrounding its delivery, or, rather, nondelivery, for although Boyle wrote this lecture for the Frome School of Art (it was later published by Macmillan), she never actually read it. A talk she gave in 1899 explained the reasons why: "[I]n 1870 it had hardly begun to be thought at all right that women should let their voice be heard in public,—or perhaps only just for a word or two. So well understood was this at the time, that I recollect it was considered incorrect for me on the evening in question to read myself, the address I had prepared. It had to be read aloud for me. There's a strong contrast between then and now, and we women are not any longer careful to keep silence."[66] EVB, like the pictures that she produced, is full of contradictions, and it is these contradictions that characterize mid-Victorian illustration and anticipate the future of the "picture book." Indeed, Boyle was always ahead of her time. As an author and an artist, she was never entirely "careful to keep silence," but gave women a voice by making them visible, and it seems only fitting that she undertook this role in the politically charged arena of the illustrated text.

CRINOLINEOMANIA

Punch's *Female Malady*

I

"Crinolineomania," *Punch* informed its readers in 1856, is "essentially a female complaint, although many of the other sex—husbands in particular—are continually complaining of it."[1] A potential remedy is suggested by Dr. Punch, who, in this article and the illustration that accompanies it, takes on the case of a tearful young crinolineomaniac, laying bare her symptoms and their mental origin before concluding that the cure is to keep her away from those places of infection—the milliner's and Regent Street—and to place her on a strict diet of pin money. If all else fails, then the only option is to ridicule the lady out of her insanity, and this particular medicine Dr. Punch will dispense in weekly doses.

While Eleanor Vere Boyle's inroads into the male-dominated world of the illustrated book served to make women more visible in mid-nineteenth-century culture, there is a sense in which they were already *too* visible, their bodies and clothing dominating the pictures and texts in popular periodicals like *Punch*. Thus, even as this satirical magazine promises to prevent a serious outbreak of crinolineomania, it is itself infected with the disease, obsessed to a fetishistic degree with the cage that supported the skirts of mid-Victorian dresses. Far from quashing crinolineomania, *Punch* not only exacerbates but invents it. It is no wonder that two years after this article, when the popularity of the crinoline skirt still showed no sign of diminishing, *Punch* was less optimistic about its laughing cure: "It is no use trying to laugh or reason women out of it," a reporter unhappily conceded. "In all matters of dress, and in that of crinoline especially, the female mind is impervious to ridicule and reason."[2] The solution he recommends is to make husbands pay an excess baggage duty when their crinolined wives travel on trains!

For all its protestations to the contrary, *Punch* went on laughing at the crinoline, even, and especially, when it professed that the crinoline was no laughing matter; it laughed, indeed, for almost a decade, by which time the crinoline cage had all but shrunk away into the bustle. But jokes, as Freud has warned, are never simply jokes: they mark the return of what is repressed in the unconscious, and in *Punch*'s unconscious is what lies beneath the layers of crinoline: the female body and all that it represents. The use of the term "Crinolineomania" is, after all, resonant with Victorian stories of madwomen in attics, of females driven insane by the constant and terrible demands of bodies and minds that are out of control. In mid-nineteenth-century medical discourse there certainly seems to be a mania for female manias. Sally Shuttleworth points to the example of a doctor in the 1860s, who identified, among other forms of female insanity, hysterical mania, amenorrheal mania, puerperal mania, mania of lactation, climacteric mania, ovarian mania, and postconnubial mania.[3] Shuttleworth argues that this medical classification was intertwined with the gender division of labor: the female body, defined as irrational and disabling, both validated women's position in the home and allowed men to be constructed as rational and autonomous, even as they were positioned in an industrial marketplace that made this self-control an impossibility.

Punch's representation of the crinoline participates in these ideologies, forging the link between politics and clothing that Carlyle had identified in *Sartor Resartus*. The crinoline, I shall argue, was bound up in anxieties about the role of women in Victorian society, the same anxieties that followed EVB's advance into the art world, but its meanings were radically unstable: it was a metaphor for female emancipation, literally enabling women to occupy a wider sphere, but it was also a way of checking this freedom, of emphasizing women's frivolity and irrationality and, by implication, their unsuitability for public life. *Punch* took the size of the crinoline as symptomatic of the silliness of the women who wore it and their status as fashion victims. On its pages the crinoline is a political and paradoxical weapon: a signifier of female empowerment and entrapment, a symbol of a slackening and tightening control over the female body, of a free and restricted movement. This slippage is testament to the emergence of the crinoline at a time when female identity was under negotiation and suggests that this undergarment actually played its own part in this debate. The crinoline adds weight to Fred Davis's argument that "fashion has repeatedly, if not exclusively, drawn upon certain recurrent instabilities in the social identities of Western men and women."[4] It was "woman" herself and what she signified that was increasingly questioned in mid-Victorian Britain. In the shadow of the crinoline's expansive skirts were the first rumblings of the feminist movement, with calls for greater legal rights for women and an improvement in education and employment opportunities.[5]

Despite its cultural and political import, the crinoline as it appears in *Punch* does not necessarily tell the truth about female costume: it is a representation and, as such, is subject to the laws and conventions of a particular type of comic journalism. But neither is it simply a *fabric*ation. Indeed, its ideological significance works against the idea that there is ever such a simple truth. The crinoline here is exaggerated for pictorial and polemical reasons, assuming proportions that it is hard to believe were ever really adopted. In fact, the magazine's frequent reports of crinoline accidents, of women stuck in doorways, blown into the air like balloons, or catching fire (it was, as *Punch* gleefully announced, a "killing fashion"), seem to have infected "reality." Perhaps there is more than a touch of a *Punch*-line in newspaper headlines that appeared in the 1850s like "Suicides Attempted. Martha Sheppard, in the Serpentine, but Saved by Her Expanded Crinoline,"[6] or the less fortunate Ann Watts, "Dashed to Pieces from her Crinoline being drawn on by the Machinery in Guest's Button Factory, Sheffield."[7]

Punch's crinoline was never a "real" item. However, the fact that numerous fashion history books and even the psychology of clothing still use its images as historical evidence in support of their descriptions of this piece of female attire suggest the ways in which these pictures actually worked to construct reality and to firmly establish the cultural status of the crinoline.[8] This construction was determined in part by the genre of illustration itself, the dialogue between word and image that *Punch*'s cartoons put into play. Roland Barthes has analyzed this relation between different modes of representation, arguing that when a single item of clothing is described in a newspaper or magazine, the description actually incorporates three garments: the written garment, which is described in the text, the image garment that is pictured by the photograph or drawing, and the real garment to which both refer and which has its own set of relations that make it distinct from the words and picture.[9] *Punch,* by juxtaposing word and image in its formulation of the crinoline, signifies in the way Barthes describes. This is not to say, however, that its three garments are ever fixed or stable. While the textual and visual representations of the crinoline are reliant on the actual object, the real item of clothing and how it is viewed in the social world are determined by the plural meanings that the crinoline acquires on the pages of *Punch*.

These generic devices, the mechanisms by which the crinoline is produced as a representation and the implications of this for the meanings of illustration, are the focus of the second half of this chapter. What I want to suggest is that the threat to hierarchical gender roles that the crinoline embodies is paralleled by an overturning of the conventional hierarchical distinction between text and image. In *Punch* it is the image that assumes priority and even directs interpretation. The

particular brand of journalism and the techniques that *Punch* employs, then, are never distinct from their subject matter: the layering and overlayering of meanings that the crinoline generates—its association with female freedom and constraint—is inseparable from the interaction between stories and pictures that the magazine so brilliantly performs.

II

For many critics the crinoline is regarded as just another mechanism of control over women's bodies in the strict patriarchal regime of the nineteenth century.[10] Frequently analyzed in relation to the corset and debates about tight-lacing, the crinoline cage is blamed for physically hampering women's movements and thwarting their intellectual pretensions. R. Broby-Johansen, for example, suggests that the main reason for the eventual rejection of the crinoline was that its shape was "undemocratic." Subsequently, "the greatly improved education of women," remarks Broby-Johansen, "made the splendid isolation of the crinoline no longer appropriate."[11] More recently, Rachel Weathers has analyzed the crinoline as a foil to the "Aesthetic" dress favored by the Pre-Raphaelites. The crinoline, she contends, was the costume of the angel in the house, an item of clothing that kept women sheltered and untouchable within the domestic sphere and enforced ideas of female passivity, vulnerability, and chastity.[12]

Such views of the crinoline, however, tell only part of the story, marginalizing those aspects of the crinoline's construction and reception that offer very different readings. For a start, the crinoline actually offered a certain freedom rather than restriction of movement, replacing layers of heavy petticoats that clung to the body with a comparatively lightweight dome within which women could move their legs more freely. On a more theoretical level, it is hard to reconcile the crinoline's seeming control over women with the fact that *Punch*, a staunch antifeminist magazine, along with other antifeminist tracts, so fervently argued for its eradication.[13] Indeed, *Punch* seems to have perceived the crinoline as a threat, and one, moreover, that was never separate from questions of female education and emancipation. The "splendid isolation" that the crinoline embodies and that Broby-Johansen identifies as its defining feature was constructed largely on the pages of this magazine and worked to cover up and expose the ways in which this skirt allowed women, both metaphorically and literally, to occupy a larger space in the social world.

On June 28, 1856, when the crinoline was making one of its first appearances, *Punch* reported:

> Public attention is being painfully called to the state of isolation in
> which fashionable females are placed by the extraordinary amount of

crinoline which they wear about them, and which renders it impossible for any one to approach within some feet of them. If a lady in the full dress of the period were to faint, it would be quite out of the power of any benevolent being to get sufficiently near to her to catch her, or tender his support. We cannot understand the cause which induces the ladies of the present day to raise up such a barrier around them as to compel everybody to keep at a respectful distance, and to place themselves in, as it were, a state of blockade. Everybody knows the fair sex to be rather encroaching, but the mode in which ladies encroach on the space which ought to be equally free to all is becoming so great an evil that a gentleman taking a stall between two ladies at the Opera is sure to find his place occupied by a quantity of tulle or other material, in the recesses of which his seat is so completely buried that he seeks for it in vain.

Really, if this system of over-dressing continues, we shall call upon SIR RICHARD MAYNE to issue police regulations for the prevention of obstructions in the thoroughfares by means of crinoline.[14]

This account, however humorous, shifts almost apprehensively between containing the female and voicing her threat, on the one hand resorting to stereotypes of women that keep them in their place (ladies are "encroaching" and likely to faint), and, on the other, suggesting the problems that the crinoline poses: to be blockaded off is to be untouchable, unapproachable, uncontrollable. The crinoline is troubling because it prevents access to the woman's body, a point that was reiterated in numerous *Punch* illustrations, in which men are pictured in the hopeless situation of trying to make physical contact with crinolined females. To some extent these women *are* isolated from the social world, but their skirts also render them a part of it: not only does *Punch* itself turn them into a public spectacle, but within its pictures and stories they attend parties, go to the opera, and walk in the thoroughfares; and it is here that they tread on men's toes, for, despite the assertions made in this article, space is never "equally free to all." There are places in the Victorian world where female entry is barred, and the crinoline infringes on this prohibited space, invading male territory, just as it invades the man's seat in the opera.

The representation of the crinoline in *Punch* is directly concerned with the female's relation to her social environment and the amount of space she should or should not occupy. The illustrations of crinolined women show men literally forced into the margins in a way that women threatened to force them in the public and professional world. As J. C. Flugel has argued, such clothing, by adding to the apparent size of the body, gives an increased sense of power, "a sense of extension of our bodily self."[15] With their billowing skirts, women appeared huge

and autonomous, able to colonize alien spaces as their own. It is no wonder that the conclusion of *Punch*'s narrative appeals to the law with the wry warning that Richard Mayne, the chief commissioner of the metropolitan police, will be called on to control the situation.

And if the police do not remedy these circumstances, there is always recourse to Parliament. One of the most popular Victorian pamphlets dealing with the crinoline was the mock Act of Parliament, which sought to introduce sumptuary laws and curb female rights. One such "act" stipulated that the prerogative of women to choose their own dresses was being withheld and they would be required to take a signed certificate from their husbands/fathers to the dressmaker before being allowed to purchase garments.[16] As these "acts" suggest, women's consumption and the dangers of their increasing purchasing power were at the forefront of discussions about the crinoline. *Punch* aggravated this threat by suggesting that the crinoline was indicative of a female inability to make "sensible" purchases. The crinoline, it argued, was pure spectacle; it had no use value (a factor demonstrated by the crinoline's frequent pictorial transformation into useful, functional objects—a Christmas tree, bathing machine, or children's roundabout); and women's love of such finery was proof of their frivolity and poor judgment. So effective was this association between the female intellect and the crinoline that it became cultural currency, reproduced in countless texts and even feminist tracts.[17] Harriet Martineau, writing in the *Westminster Review* in 1857, argued that, as far as dress was concerned, Victorian women were no wiser than their great-grandmothers: "Their feelings have carried them away into a fanaticism of fashion which *Punch* may expose, but can hardly caricature."[18]

Punch, as Martineau implies, seems to tell the truth about women and their clothes, and it is in this apparent veracity that ideology is at work. The idea that it was only common sense to view the crinoline as embodying aspects of the female character made the gender divide that it imposed also appear self-evident: women's construction as irrational served to define men as rational and authoritative.[19] Whereas women could not be trusted with money because they would waste it on elaborate dresses, men were warned to exercise their control and keep the purse strings away from their wives and daughters. In August 1856 *Punch* reported a "Melancholy Accident." A woman walking up and down a shopping arcade in a crinoline had caused so much damage that her unfortunate husband, a struggling clerk, who was unable to pay for the damaged merchandise, had been locked up in either a jail or an asylum. The article includes a bill of the objects that she destroyed (including "25 Noah's Arks—not one animal saved"), while the illustration underneath functions as a Victorian version of a closed-circuit TV camera and captures the woman in the act: with

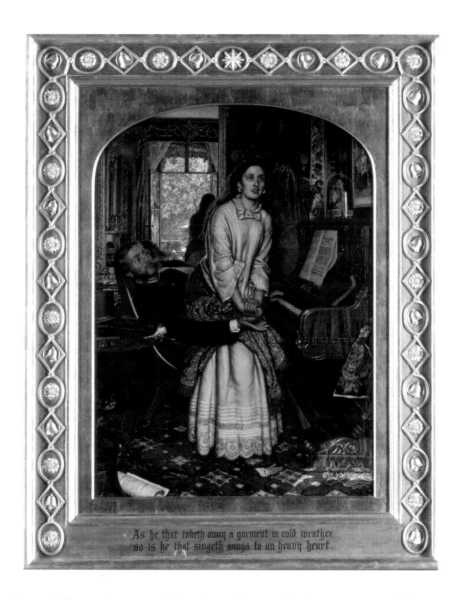

Plate 1 William Holman Hunt, *The Awakening Conscience* (1853). Image courtesy of Tate Britain, London.

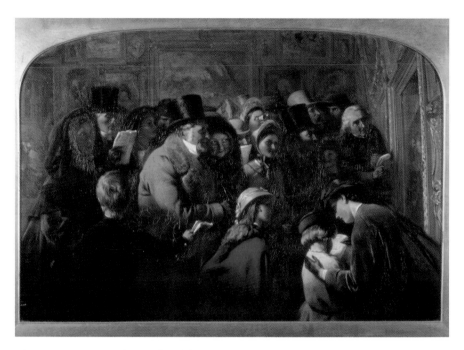

Plate 2 George Bernard O'Neill, *Public Opinion* (1863), Leeds City Art Gallery. Image courtesy of the Bridgeman Art Library, London.

Plate 3 Thomas P. Hall, *One Touch of Nature Makes the Whole World Kin* (1867). Image courtesy of Richard Green, London.

Plate 4 Joseph Noel Paton, *In Memoriam* (1858). Reproduced by kind permission of Lord Lloyd-Webber.

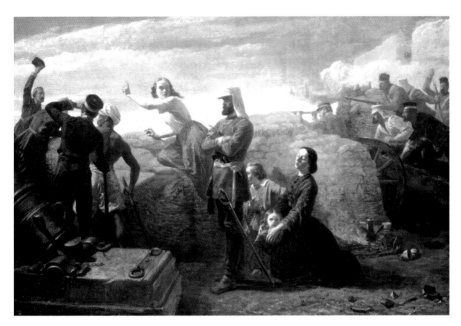

Plate 5 Frederick Goodall, *Jessie's Dream (The Relief of Lucknow)* (1858), Sheffield Galleries and Museums. Image courtesy of the Bridgeman Art Library, London.

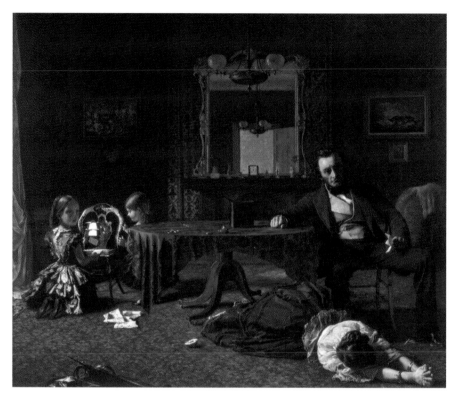

Plate 6 Augustus Leopold Egg, *Past and Present* (1858). Image courtesy of Tate Britain, London.

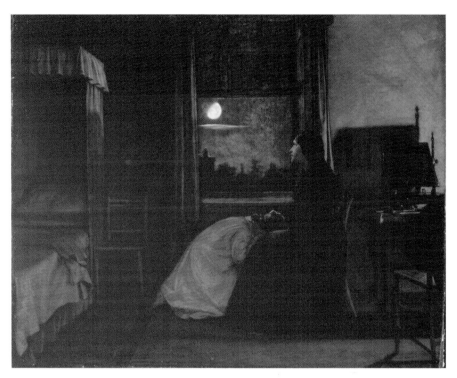

Plate 7 Augustus Leopold Egg, *Past and Present* (1858). Image courtesy of Tate Britain, London.

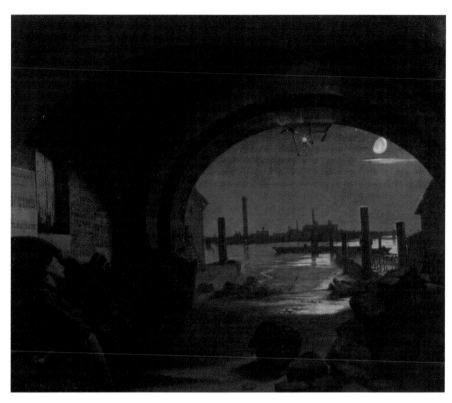

Plate 8 Augustus Leopold Egg, *Past and Present* (1858). Image courtesy of Tate Britain, London.

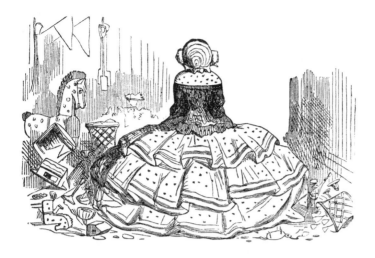

Figure 3.1 "Melancholy Accident!!!" *Punch*, August 16, 1856.

her back to the viewer, she walks through a toy shop, blissfully unaware as the huge flounces of her polka-dot dress knock over everything in sight (figure 3.1). The scene is, of course, highly amusing, and it is precisely this comedy that masks and reveals insecurities and anxieties about gender, hinting at the dangerous—because feckless and wasteful—mass consumption of women. The implication is that this female ruins her husband, not just in this act of destruction but in the fact that she is a "lady of fashion," who spends the hard-earned wages of a "struggling clerk on a rising salary" on crinoline and flounces.

By representing women as extravagant consumers, determined to deplete their husband's wages, *Punch* was responding to and participating in contemporary debates about women's rights to control and own their own property and money. English law endorsed a system of coverture in which a wife's legal identity was subsumed under her husband's. This prevented her from possessing property or any wages she might earn in her own name.[20] The injustice of the system had been made public by Caroline Norton, who wrote numerous pamphlets on women's place in the law; and by Barbara Leigh Smith, Bessie Parkes, and Mary Howitt, who presented a petition to Parliament in 1856, arguing that a married woman should be regarded as single in relation to property and earnings.[21] At the same time, the Law Amendment Society issued a report on the laws relating to married women's property and held an open meeting to discuss the subject. The debate over married women's property in the 1850s culminated in 1856 and 1857 when a bill, based on the arguments put forward in the petition, was introduced into the House of Lords by Lord Brougham and the Commons by Sir Thomas Erskine Perry. The issue also got

caught up in the discussions over the bill for marriage and divorce, later to become the Matrimonial Causes Act of 1857.

Punch often referred directly to these legal debates in its discussion of crinoline. On May 23, 1857, it reported:

> SIR ERSKINE PERRY'S Bill for the better security of the rights of married women, has met with so favourable a reception that, should it not pass during the present session, it may pass in the next century. We, however, hope for immediate legislation upon the subject. There are two clauses in the present Bill that no man, at least no husband who is not an absolute brute, can object to. The first makes a married woman answerable for her own tongue; and therefore relieves the husband of a responsibility that, since the invention of marriage, no man has known how to grapple with. . . . The second right about to accrue to married women is, the right to pay their own debts. We do not know, for a surety, whether this portion of the amended law will tend to make the shops of bonnet-makers and milliners less attractive, less seductive; but we should think it not unlikely. As the injustice of the existing law operates, a woman loses nothing in yielding to the temptation of dress, seeing that the husband must pay for it. But with women fully possessed of their rights, it will be otherwise. Thus, a woman who cannot pay for her own dress will, upon her own account, go to gaol for the debt. We understand, however, that the benevolence of the legislature will lend itself to the allowance of the following amendment:—"That whereas, every woman committed to prison upon a judgement debt contracted for her own gowns and petticoats, shall not be confined within the walls, but be allowed to live 'in the rules' of her own Crinoline."[22]

The link between the crinoline and women's rights is made explicit here (the article is actually entitled "The Rights of Women"). By resorting to stereotypes of women as gossips and slaves to fashion who cannot be trusted to walk past a bonnet-maker's, it suggests that the consequences of women's having control over their own money, while extremely beneficial for milliners, would be disastrous for society at large. This article also indicates the ways in which the issue of married women's property was becoming increasingly involved with other issues of female emancipation and, indeed, with feminist activism in general. As the petition was discussed in Parliament, the *Times* contained reports of women's rights conventions that were being held in America. In Britain there was a simultaneous call for improvement in female education and a widening of woman's sphere in the workplace. Barbara Leigh Smith's "Women and

Work," which contended that middle-class women should loosen their dependence on men by taking up paid employment, was published in 1857, and a year later Bessie Rayner Parkes discussed the growing number of females in the workplace in the *English Woman's Journal.* Throughout the mid-nineteenth century female education became a major political issue, with the setting up of Royal Commissions paving the way for women's entrance into the professions. The first female doctor qualified in America in 1849 and, if this example was not so quickly adopted in Britain, the outbreak of the Crimean War suggested that there might be other roles for females within the medical establishment.

The crinoline in *Punch* is a vehicle for discussing and amalgamating these different aspects of female emancipation, from women's control over money to their increased presence in the workplace. Members of Parliament (MPs) saw a similar link between legal rights for women and women's participation in public life. Just over a week before *Punch's* article on "The Rights of Women," Alexander Beresford Hope spoke in Parliament, linking the question of married women's legal identities with female activism. He argued that if politicians agreed that wives should be independent in the eyes of the law, they would be giving in to the "rather extravagant demands of the large and manly body of 'strong-minded women'" who were advocating all sorts of female rights.[23] *Punch* itself, along with other discourses, went some way toward cementing this association. Perhaps Beresford Hope had been frightened into his remarks by an article that had appeared in the magazine two months previously and that also referred to "strong-minded women," envisaging the logical conclusion of female rights: not just enfranchisement, but the possibility of female politicians. The article asserted that one of the grievances of those "strong-minded women," who "lose their time and temper in talking of their Rights," was their inability to become MPs. Starting with the predictable objection that female politicians would never cease talking, *Punch* goes on to state why, fortunately, women will never enter Parliament:

> But it seems to us that were the memberesses properly returned, it
> would still be quite preposterous for more than one in twenty of them
> to expect to have a seat, for the simple reason that, unless their num-
> bers were extremely limited, it would be impossible to find a room to
> hold them. In their present state of Crinoline, ladies on average require
> at least a dozen yards of sitting room a-piece; and were they to return
> as many members as the gentlemen, it has been estimated that the
> space which would be covered by above six hundred petticoats would
> considerably exceed a couple of acres.[24]

In *Punch* the crinoline is not only a mechanism for voicing concerns about the emancipation of women but a way of putting them firmly back in their

place, a place that is definitely not Parliament. The crinoline showed women expanding into the public and social arena, but it also became a means of curbing that expansion. Never willing to discard a good joke, *Punch* tried it again a year later, asserting that because the Ladies' Gallery in the House of Commons could accommodate only a certain number of full-skirted females, "strong-minded women" should observe that the issue of women MPs "all turns upon a question of Crinoline."[25] Such articles, it seems, had a lasting influence on Mark Lemon, the editor of *Punch* through the crinoline years, who wrote a play about female Members of Parliament which was performed in 1867. Written during the militant activities of the suffragettes, Lemon's play was an awful vision of what might happen if women ever came to Parliament. After discussing trivial things like needles that cut thread and a tax on rouge, the female politicians find themselves unable to agree on anything and finally submit to the men. And the title of this play is *Woman's Suffrage; or, Petticoat Parliament.*

The bill giving married women the right to own their own property was not made law, although the separated and deserted wife was treated as a single woman in the Matrimonial Causes Act of 1857. It was rejected because politicians regarded it as a threat to domestic happiness and the separate gendered spheres of public and private on which that happiness depended.[26] An independent legal identity meant that there would be two people in a marriage, not one, and this would undoubtedly lead to disharmony and disunity. The crinoline, implicated in these issues, was similarly construed as a threat to domesticity. The huge skirts, which prevented access to the woman's body, posed a serious threat to a husband's social and sexual control over his wife. This is implied by Dr. Punch in his diagnosis of crinolineomania. The disease, he asserts, is "destructive to domestic comfort; for when a married lady is afflicted by the malady, her husband is compelled to keep at arm's length from her. Whether, as the mania thus leads to virtual separation, it might not be regarded as sufficient grounds for a divorce, is a point for the consideration of the Doctors' Commons perhaps more fitly than of *Dr. Punch.*"

The crinoline's disruption of the domestic ideal, however, is not wholly the fault of the British women who wear it, but the result of foreign—or, more specifically, French—corruption. The blame for the whole crinoline craze, although the mania was in part set up by *Punch* itself, was laid at the door (and "what a very wide door it must have been," *Punch* joked[27]) of the French Empress, Eugénie.[28] The crinoline, according to *Punch*, had already had a drastic effect in France, where it was described as a "depopulating influence" because it disallowed physical contact between the sexes and required so great an expense that a family could no longer be financially supported. French ladies had to choose between finery and family and, unsurprisingly, went for the dress, a situa-

tion that the magazine was quick to condemn: "We cannot think it in good taste to show more love for finery than affection for a family: nor can we regard it as becoming in a wife so far to forget her nature, and distort her duties, as to ruin her husband by the richness of her dresses, and in the blindness of idolatry to even sacrifice her children to the Juggernaut of Fashion."[29]

The domestic threat of the crinoline, then, was also more specifically a national threat, with the home a microcosm for the country at large. In 1857, barely a week after the outbreak of the "Indian Mutiny," *Punch* attempted to instill some reason into its female readers by including a letter, written by a fictitious female correspondent, Jane Matilda, that criticized the crinoline and appealed to women to adopt their proper spheres and renounce their intellectual pretensions. According to Jane Matilda, woman's love of finery not only prevents her from being taken seriously, but also presents a threat to national security. Women in Britain, unable or unwilling to protect or fortify their country, had allowed a French invasion:

> Some time ago, they talked of the French coming over and invading us. *Mr. Punch, we have been* invaded, and nobody knows what trouble and anxiety carried among tens of thousands of people. To be sure, we haven't had our house-tops knocked off by bomb-shells; and haven't had to pack dragoons into our best bed-rooms, as I have read NAPOLEON always insisted upon, carrying fire and bayonets into the bosoms of peaceful families. But, I don't know if we haven't had a much worse invasion than this; for we've been invaded and carried right off our feet by the French Empress and an army of milliners. Don't tell me; band-boxes may be worse than bomb-shells.[30]

The crinoline's association with France also rendered it a signifier of the lax morals and excesses of Paris. Henry Mayhew describes the French prostitutes who promenade the Haymarket, dressed in crinolines so wide that they look like pyramids.[31] *Punch* made the link between Frenchness and immorality explicit when it staged a dialogue between a crinoline and a hooped brocade from the time of Queen Anne.[32] The Queen Anne hoop speaks for English morality, of a time "When no slip-shod slatternly nature intruded / In manner or morals, deportment or dress." For the brocade, the crinoline is an embodiment of "blunted manners," or worse, and this licentiousness is associated specifically with France:

> *If folks will trust nature, in all she inspires them,*
> *In her good as her bad do give nature a chance:*
> *Let our women be seen, not the stuff that attires them:*
> *And leave Crinoline and air-jupons to France.*

The irony, of course, is that the brocade, which is the mouthpiece for *Punch* itself, appeals not on behalf of the dress of her own time but on behalf of the figure-clinging dresses favored in the Romantic period, which exposed the "true" contours of the female body.

The implication is that the crinoline is on the side not of nature, but of duplicity and artifice. Under her skirts, the female's body was hidden from view, and this unsettled the power relations that positioned her as an object of the male gaze. The crinoline was in many ways a pure spectacle, but it also harbored something unseen and secret, a paradox that came to the fore in the way that it was often pictured as an object of concealment. One edition of *Punch* shows a crafty suitor hiding behind the billowing skirts of his lover when their clandestine meeting is interrupted; another depicts a man taking advantage of a walk with Lady Crinoline and her daughter to wear a comfortable but ridiculous pair of short trousers. And then, of course, there was the ingrained duplicity of the French, *Punch* reporting that French women had been smuggling goods into and out of the country under their crinolines. The "real" garment also offered the opportunity for concealment. Costume historians have identified beneath the flounces of the dress secret pockets that disappeared when more tight-fitting dresses came into vogue. This duplicity, however, came at a price. There were dire consequences for women who strayed from the ideal and attempted to conceal things within their skirts. Oskar Fischel and Max von Boehn report the case of a duchess who burnt to death when she tried to hide a cigarette that she was smoking under the folds of her crinolined gown.[33]

But there was something else hidden underneath the crinoline: the lower half of the female body itself. The Empress Eugénie was reputed to have worn the crinoline to hide her pregnancy before the birth of the prince imperial, and Queen Victoria was said to favor it for the same reasons. The crinoline covered up the facts of reproduction that determined women's identity in the mid-nineteenth century. And there was the even more disturbing possibility that it concealed a deformed and monstrous body. *Punch* commented that "the dresses at present in vogue not only cover a certain number of square feet. They cover two other feet, which may be square for aught anybody can tell; or which may be splay, or clubbed; and whilst we find fault with wide and draggling skirts, we should not forget that they are a great blessing to those otherwise fair damsels whose lower extremities are clumsy or deformed."[34]

The crinoline's dangerous concealment is counteracted by *Punch*'s persistent attempts to make it visible. Despite the fact that it was said to appeal only to the female eye, it was also an object of male desire. There was a simultaneous repulsion at the sight of it and an irresistible need to look: "Who can resist

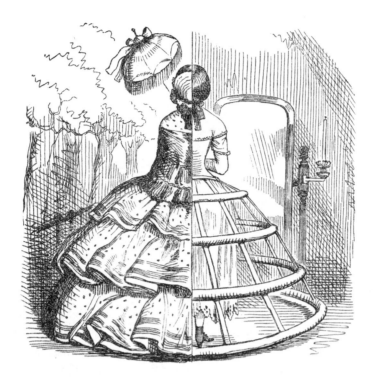

Figure 3.2 "Dress and the Lady," *Punch*, August 23, 1856.

the terrible fascination, the very natural curiosity to inspect minutely the instrument of torture and discomfort from which we have long suffered . . . ?" asks one writer of his male readership.[35] Placing this object of clothing under the gaze also masters it: the crinoline is looked at, regulated, and controlled, even as it is constructed as unseen and out of control.

The contradictory status of the female who wears this garment, who is at once spectacular and concealed, was suggested in *Punch* in the issue following that of the "Melancholy Accident" in the shopping arcade. Here the polka-dot dress makes another appearance, or rather half of it does, for this woman, like a biological specimen, is sliced in two, the left side of the image showing her outdoors and dressed in all her finery, a fringed parasol making her ornamentation complete, while the right side pictures the "lady" in her dressing room and stripped of her flounces; all that remains is the crinoline cage, which dispels the illusion of her magical skirts (figure 3.2). A mirror here replaces the trees in the background and makes the appropriate connection between the crinoline and female vanity, but it also suggests the uncomfortable voyeurism of this scene. The image becomes a metaphor for the way that *Punch* as a whole attempts to lay the crinoline bare, to reveal its secrets to the uninitiated. It panders to fantasy, giving

spectators the illusion that they are able to see through a woman's clothes, even as she takes a stroll through the park.

This attempt to show what cannot be shown is, in fact, a frequent device in *Punch,* in which women in crinoline walk past shops that display the contraption in the window, or have their dresses turned inside out by a sudden gust of wind. In one illustration two street urchins point to the *broderie anglaise* petticoat that can be seen when a woman lifts her skirts. "My eye, Tommy, if I can't see the old Gal's legs through the peep holes!" exclaims the "dreadful boy" to his friend, but more is revealed in the shop behind them, which displays several crinolines and, hanging above the boys' heads, a pair of striped stockings.[36] Such images make the crinoline an object of knowledge, something accessible to those who would otherwise have no such knowledge. And with knowledge comes power. The woman's body is no longer concealed by a dress that keeps her at arm's length, but is controlled and possessed by those who look at and judge her.

While the illustration of the woman in the park/boudoir appears to show all, however, it also draws attention to what cannot be seen and the implications of this for vision itself. This lady's crinoline is, after all, another layer of clothing; what lies beneath is only hinted at in the woman's porcelain back and shoulders and the flash of leg beneath the frilled edges of the petticoat. The all-seeing and powerful vision that this image seems to offer is only ever an illusion. Perhaps even more troubling is the suggestion that there is nothing underneath the crinoline, no "real" female who is separate from her clothes. The picture seems to present a simple dichotomy between "Dress and the Lady," a physical divide that cuts up the words as well as the woman, but there is no simple opposition. The "dress" in the left half of the image invades the territory on the right, so that "the lady" is still a "dress"; she is still seen only through the hoops of the crinoline. The illustration implies that this "lady" (the signifier itself suggests the more social and decorous aspects of womanhood) is always determined by the significations of dress. As Charles Baudelaire proclaimed, woman and costume are an "indivisible unity": "Everything that adorns woman, everything that serves to show off her beauty, is part of herself."[37] The crinolined woman as she is displayed in *Punch* is, in effect, all dress, and this might explain why she is so often pictured with no face or features and with her back to the spectator. In Dr. Punch's account of crinolineomania the dress is even described as an extension of the body, a growth that assumes the appearance of a white swelling. And the implications of this fusion are more disturbing than the disorder itself: if female identity is something put on like layers of clothing, then it follows that there is no natural reason why women should be placed in particular roles.

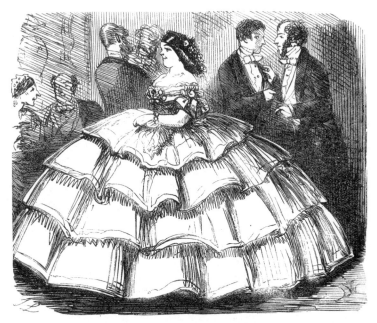

EASIER SAID THAN DONE.

Master of the House. " OH, FRED, MY BOY—WHEN DINNER IS READY, YOU TAKE
MRS. FURBELOW DOWN STAIRS ! "

Figure 3.3 "Easier Said Than Done," *Punch*, July 19, 1856.

III

The meanings of the crinoline, its empowerment and containment of the fe-
male, are generated by and depend on its representation as a visual object,
whether the emphasis is on its enormous size (signifying power), its lack of use
value (frivolity, superficiality), or its ability to conceal (foreign corruption).
Punch puts this dress on display; it does not just write about the crinoline and
set it up textually as a thing to be looked at, but shows it, visualizes it, makes it
into a picture. *Punch*'s wood engravings demarcate how much space the crino-
line takes up, setting its parameters in a way that demonstrates a technical ver-
satility that the magazine was at pains to contrast with that of other visual arts
and publications. With the emergence of the crinoline, *Punch* joked, illustrated
books of fashion had been forced to enlarge their plates to more that twice their
original size; the plates would soon be as large as dinner tables.[38] Even in the
Royal Academy a "full width" portrait of a crinolined lady would take up one
side of the three large rooms.[39] While the *Belle Livres* and Royal Academy were
grappling with this problem, however, *Punch* was more than able to display
enormous crinolines within the small space of its illustrations. In the few square
inches of the woodblock the crinoline is hemmed in, confined, and mastered,

even as it is represented as beyond the containment of the picture. The skill required in making these crinolines appear huge within such a tiny space is beautifully rendered in a picture designed by John Leech that appeared in *Punch* in July 1856 (figure 3.3). As the crinolined skirt of this woman is inflated across the lower half of the image, its dimensions seem to dictate the size of the picture rather than the other way around. It is hard to believe that this female is actually framed by the illustration, made to fit into its square like a doll packaged up in a box.

The meanings of this picture, however, are not confined to the engraving, but are generated in the relation between the image and the text that accompanies it. Underneath this female, whose skirt spreads like an umbrella across the width of the image, are the words and thoughts of the two men eclipsed behind. The maturity and authority of the whiskered man and his physical motioning to his younger companion suggest that he is the "Master of the House," who says, "Oh Fred, my boy—when dinner is ready, you take Mrs. Furbelow down stairs!" The worried glance of the younger man implies that the title of the scene, presented to the viewer in large block capitals, constitutes his own thoughts on the matter: "EASIER SAID THAN DONE." Whereas the picture makes its meanings in the visual impact of the huge dress and the miniature men who are pushed behind, the text signifies by adding the words that the older man is saying and the younger man (or the voice of *Punch*) thinking, and referring these back to the image. The woman's very identity is bound up in her dress: a "furbelow" is a flounce or pleated border, but the name also suggests what remains invisible in this vibrant spectacle that seems to offer all, invoking the horsehair petticoats that were the precursors of the crinoline, and perhaps even functioning as a more indecent double entendre for the sexually enlightened reader.

Punch's humor in the illustrated joke relies on the spectator assuming a link between text and image and understanding the convention of seeing each in the light of the other. This reciprocity is emphasized in the page layout, with the illustrations and caption occupying their own self-enclosed unit, although this is not to say that the reading of word and image is a straightforward one that proceeds down the page in the way that one reads a text. The layers of inscription in this particular illustration complicate the convention by placing the punch line before the explanatory text. In *Easier Said Than Done* the comedy comes about in the fact that the picture and caption seem to coincide perfectly. The laughter is that of recognition, a self-satisfied laughter that is generated because the viewer's interpretation of the scene corresponds with the punch line.

Even this type of joke, however, depends on a gap between the visual and textual; an awareness that the punch line is so apt can occur only if there are

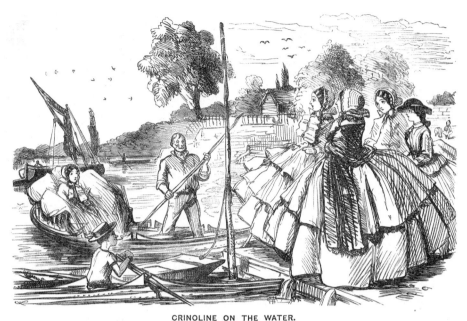

CRINOLINE ON THE WATER.

Waterman. "YOU'VE NO CALL TO BE AFEARD, MISS; WE'RE LICENSED TO CARRY SIX!"

Figure 3.4 "Crinoline on the Water," *Punch*, June 12, 1858.

other possibilities, if there is the realization that the joke could have been different. It is the arbitrariness, the very fragility, of the connection between picture and caption that makes *Punch's* illustrated jokes so effective and appealing. In fact, the most common type of humor relating to the crinoline is one that functions in the very disjuncture between media. In another of Leech's illustrations, *Crinoline on the Water,* a lady in her voluminous skirt fills up half the space of a rowboat (figure 3.4). As she sits, unable to move and looking decidedly grumpy, the folds of her skirt gathering around her like a large cushion, the oarsman looks toward four other crinolined women who wait on the bank; the text that accompanies the picture is "You've no call to be afeard, miss; we're licensed to carry six!" The joke here depends on an open disparity between the visual and verbal, the incongruity of the text in relation to the picture. The words do not fit with the scene that we see before us, and it is precisely this difference that makes the illustration funny.

All of these illustrations suggest the ways in which text and image function together to produce a comic effect, but, in its representation of the crinoline, *Punch* privileges the visual in a way that deviates from many Victorian illustrated texts. Gleeson White asserts, "Unless an engraving be from a painting, or a topographical view the rule in English magazines then, as now, is that it must illustrate the text."[40] This "rule" sets up a hierarchical relation between text and image that gives primacy to the textual: the picture "must illustrate the text" in

the sense that it follows a text, whose meanings it enforces. The picture, in other words, is not central to the meanings of the work but gains its value in relation to the work. As I have already argued, however, things were never this simple. The illustrators of *Uncle Tom's Cabin* might have "followed" the story, but they also generated new meanings. When Boyle and Rossetti produced designs a few years later, the image, far from dependent on the text, could take its cue from the text's absences and gaps.

The pictures of the crinoline in *Punch* subvert White's idea of illustration in another way. Unlike the majority of *Punch*'s illustrated jokes, in which the humor lies primarily in the words—a verbal misunderstanding or pun—and the image assumes a secondary and sometimes even superfluous position, the visual representation of the crinoline is integral to its meanings. Jokes about the size of the crinoline need to be seen; "Easier Said Than Done" is itself a phrase that refers to and depends on the image—it is amusing only in its reference to the picture, to what the spectators inside and outside the engraving can see. These images of crinolines determine the meanings of the text: they make the words signify, and this applies not just to the caption that accompanies an image, but also to those crinoline jokes that appear in textual form, without an accompanying illustration. The humor of men unable to locate their opera seats because of the preponderance of flounces, or women too large to sit in Parliament, derives from *Punch*'s visual images of the crinoline, images that were able to direct the comedy of such text-based features because of their frequent appearance and iconographical similarity. The meanings of the crinoline generated in *Punch,* then, relied on the magazine's own pictorial representations, on what it chose to emphasize or marginalize, rather than assumptions or knowledge about how things "really" were.

Or, perhaps the way things really were was itself determined by *Punch;* the magazine constructed a knowledge about the crinoline that came to be accepted as truth. *Punch*'s mode of representation dogged the decade and informed people's perceptions about this item of clothing. The marketplace was inundated with pamphlets, tracts, stories, articles, poems, and pictures that reproduced the meanings of the crinoline found on the pages of *Punch,* rehashing the same old jokes, but in startlingly different contexts. Illustrated stories included the familiar scenes of women unable to get through doors or fit in carriages, and hindered by all sorts of obstacles and dangers. One tale, aimed at children, but with a stern warning in the preface to mothers to steer their daughters away from such idiotic clothing, tells of an egotistical little heroine, determined to wear a crinoline, who comes to her senses only when she is almost burnt to death at a party.[41] Another text, more troubling because it does not announce itself as a work of fiction, blames the crinoline for an increase in seduction, prostitution, and in-

fanticide among the servant classes, citing a doctor, who "impartially" observes that the murder of children has doubled in the period since the introduction of the crinoline. This fashion, asserts the author, originates "in the temporary weakness of female caprice" and is "inimical to good and social order, and pregnant with immorality and death."[42]

Such arguments, although stripped bare of any humor, take *Punch*'s representation of the crinoline to its logical conclusion, but with the difference that they reproduce as fact and medical evidence what the satirical magazine only ever shows as a representation. Indeed, *Punch*'s mode of representation, the overturning of the "proper" relation between word and image, is integral to this magazine's gender politics and also has implications for those images that draw on it. Among *Punch*'s most celebrated intertexts is an illustration by John Everett Millais for Anthony Trollope's *Framley Parsonage*, which was serialized in the *Cornhill Magazine* from January 1860 to April 1861. The picture, which came with the caption "Was it not a lie?" was a scene taken from chapter 16, in which Lucy Robarts tells Lord Lufton that she cannot love him and retreats to her room, throwing herself on the bed in anguish and despair (figure 3.5). When Trollope saw this illustration he wrote angrily to George Smith, the publisher and owner of the *Cornhill:*

> I can hardly tell you what my feeling is about the illustration to the June No. of F. parsonage. It would be much better to omit it altogether if it be still possible,—tho I fear it is not—as the copies will have been sent out. The picture is simply ludicrous, & will be thought by most people to have been made so intentionally. It is such a burlesque on such a situation as might do for *Punch,* only that the execution is too bad to have passed muster for that publication.
>
> I presume the fact to be that Mr. Millais has not time to devote to these illustrations, & if so, will it not be better to give them up? In the present instance I certainly think that you & Mr. Thackeray & I have ground for complaint. . . . Even the face does not at all tell the story, for she seems to be sleeping—I wish it could be omitted.[43]

Millais' image has been the focus of much critical attention, with opinion divided as to its merits, but it has not been interpreted in relation to the illustrations of the crinoline in *Punch,* a surprising omission considering that Trollope himself made this connection.[44] It would seem, however, from its reception by the author and other contemporary critics, and in terms of the subject matter and style of its composition, that this picture is intimately related to the images of crinolined females that were appearing each week in the magazine. Millais, of course, would have been familiar with *Punch*'s representation of this item of

Figure 3.5 John Everett Millais, illustration for Anthony Trollope, *Framley Parsonage, Cornhill Magazine*, June 1860.

clothing and understood the techniques employed in its illustrated jokes—he was himself to contribute to *Punch* and the *Almanac* in 1863 and 1865, and counted John Leech, an artist responsible for many a crinoline picture, as one of his closest friends. Unlike many of Millais' other illustrations, which are recognizable in their generous use of white space, sharp definition, and tonal contrasts, here the image is constituted by the scratched and scrambled lines typical of *Punch*'s illustrations, giving the impression that they have been drawn in haste (hence Trollope's remark about Millais not having the time to devote to

them).[45] This effect might have been produced by the process of engraving rather than determined by the original design, although Millais' practice of drawing his images directly onto the block reduced the possibility of variations between his drawing and the engraved version. But, stylistic issues apart, the illustration's subject matter is itself too close to *Punch* for comfort. With its impossibly large crinoline and mass of frills and flounces, it refers directly to those illustrated jokes that depend on the dress's expansion across the picture space. The setting is also familiar from *Punch:* as in *Dress and the Lady,* the crinolined woman appears alone and in her bedroom, the solitary subject of the image, along with a mirror, a conventional signifier of female vanity.

So effective is this interpictorial allusion that, according to Trollope, the image seems more fitting for *Punch* than for *Framley Parsonage.* The crinoline, appearing in this highly recognizable form, is something discordant and extraneous that eclipses its textual analogue and refers instead to other pictures. It is the crinoline's association with a brand of comic journalism that Trollope seems to object to most: *Punch's* sometimes farcical humor is at odds with his story, and its manifestation in the picture substitutes comedy for the specificity of the scene, the despair of Lucy Robarts. The image is a "burlesque" rather than a scene of emotional crisis. But perhaps there is a more serious objection to the illustration lurking in Trollope's criticism, one that is intertwined with the way that pictures of the crinoline in *Punch* overturn the conventional relation between word and image, for, seen in the light of this picture, the textual event itself becomes comical, an illustration of the image, a punch line. Trollope must have been acutely aware of his own unfortunate choice of caption. "Was it not a lie?" which the author had chosen as a title without seeing the proofs of the picture, now becomes a disturbing indictment of the novel as a whole and the failure of its claims to truth.

The text illustrates this image more than the image illustrates the text. Even the face, complained Trollope, "does not at all tell the story," or, rather, it does not tell the story that the writer intended. The image of the crinoline generates its own narrative and carries the text along with it. Indeed, this picture stood apart from the rest of Millais' illustrations, which were highly praised by Trollope, and in direct opposition to the "proper" function of illustration that the author outlined in his autobiography:

> Writers of novels know well,—and so ought readers of novels to have
> learned,—that there are two modes of illustrating, either of which may
> be adopted equally by a bad and by a good artist. To which class Mr
> Millais belongs I need not say; but, as a good artist, it was open to him
> simply to make a pretty picture, or to study the work of the author

from whose writing he was bound to take his subject. I have too often found that the former alternative has been thought to be the better as it certainly is the easier method. An artist will frequently dislike to subordinate his ideas to those of an author, and will sometimes be too idle to find out what those ideas are. But this artist was neither proud nor idle. In every figure that he drew it was his object to promote the views of the writer whose work he had undertaken to illustrate, and he never spared himself any pains in studying that work so as to enable himself to do so.[46]

Trollope espouses the relation between word and image that White was later to identify as the "rule" of illustrated magazines. The image here should be subordinate to the text; it should not be "pretty" in its own right but should gain its aesthetic value to the extent that it represents the text and the author's intention. This type of illustration, Trollope acknowledges, takes its place in a hierarchical relation in which the text is superior and anterior. Although such images are difficult to produce and require the artist to study the words on the page, there is no incommensurability in the project itself: a picture is able to reproduce the text, while the writer's views are similarly identifiable and reproducible.

Trollope, then, like Tennyson before him, implies that a word and picture *can* work in the same way and generate the same meanings, that the two genres should share the same aims and objectives. It is a view that is compromised in Millais' use of the *Punch* motif, which privileges the visual to the extent that the picture comes to determine how the words are read. This was recognized by contemporary reviewers, who went on to interpret the novel in the context of Millais' picture. After describing Lucy's crinoline, the critic in the *Saturday Review* remarks:

> The tableau is in all respects worthy of the novel. Mr. Millais, in a congenial moment of social inspiration, has been so fortunate as to hit off in this one illustration the whole spirit of the book. None of Mr. Trollope's figures in their wildest grief could be drawn except in their every-day dress. . . . All are ordinary men and women, and their sayings and doings are neither above nor below the level of what we see in common and everyday life. Mr. Trollope himself nowhere pretends to do more than to write down what he sees going on around him. He paints from the outside.[47]

The critic in *Sharpe's London Magazine,* while much more negative in his evaluation of the novel, agrees that it is illustrative of the image:

Surely, Mr. Millais, when he drew that personification of crinoline representing Lucy Robarts in a state of woe, was in an humour of grim satire. There could not be a better emblem of the book than this picture. The pretty woeful face and clasped hands and little pendant foot (though this must be booted in horse-breaker fashion) squeezed into odd corners to give due prominence to that mountain of flounces, are as the touches of real human nature which Mr. Trollope has sparsely scattered on the outskirts of his huge mass of conventionalism.[48]

The remarkable similarity between these reviews, even while they have different opinions of Trollope's novel, lies in the prominence that both give to Millais' image of the crinoline. As in *Punch,* this huge skirt is bound up with social identity and superficiality, the way things appear on the outside, and the novel, in turn, is also interpreted in these terms: as a story about social manners, conventions, dress codes. It is the picture itself that suggests this interpretation and directs the meanings of the text; it stands as the privileged signifier.

This visual primacy might not be characteristic of Millais' illustrative output as a whole. According to Trollope, Millais' other pictures demonstrate a willingness to subordinate the image to the text. Nevertheless, there is evidence that, as an illustrator, Millais does exhibit a certain tendency to assert the independence of the image from the text. The artist made a lucrative business out of selling replicas of his designs and, as Allan R. Life has pointed out, this could explain why he did not attempt renditions of characters and situations that would be meaningless without the words.[49] Millais' pictures are often capable of standing alone, without written accompaniments. Indeed, this illustrator, so often lauded for his fidelity and sensitiveness to the text, would occasionally reuse designs, a factor that further undermines the apparent unity of text and image in his work. The image of Lucy Robarts in her crinoline bears a striking resemblance to an illustration that Millais had drawn to accompany Tom Taylor's poem *Magenta* in *Once a Week* in 1859. This picture shows a young woman lying on her bed and grieving for a loved one who has perished in the Battle of Magenta in the Italian War of Unification (figure 3.6).

While the iconographical features of these two images are virtually identical, *Magenta* is illustrated in a way that weakens its association with *Punch* and suggests another reason why Trollope might have disliked the *Framley Parsonage* picture. Gone are the masses of fussy frills that accentuate the size of the dress, in favor of less elaborate and more somber flounces; gone are the scrambled lines, to be replaced by smoother, more precise hatching and a careful rendering of tones and shadows. The way that this picture is drawn makes it appear less like a burlesque and more like a representation of a real event, and this encourages the emotional response to the scene that the poem demands. It

Figure 3.6 John Everett Millais, illustration for Tom Taylor, "Magenta," *Once a Week* 1, 1859.

was precisely this realism that Trollope expected in illustrations, the same realism that could be found in his novels. Not only were his characters carried through from book to book, but he encouraged his illustrators to strive for continuity, directing them, whenever necessary, to appropriate descriptions of figures. Michael Mason has argued that it is around the issue of this characterization that Millais' images and Trollope's texts are most at odds, the artist adopting a style that showed dignified, almost classical figures, but failing to distinguish between them or sufficiently render their individuality.[50] This variance is accentuated in the case of Lucy Robarts, who was described by Trollope as "the most natural English girl that I ever drew"; "I doubt whether such a character could be made more life-like," he wrote in his autobiography.[51] Her disappearance under the folds of her skirt comes to symbolize the loss of this identity; the real human life that Trollope had created becomes a *Punch* caricature in Millais' drawing; or, rather, she is eradicated altogether in favor of a dress and all the contradictory meanings of female identity that it brings with it: in her crinoline, this "natural" and "good" girl is silly, frivolous, superficial, or perhaps even duplicitous.

The threat this image represented to Trollope's realist project is further emphasized when one compares it to the pen-and-ink and watercolor drawing of the same scene that Millais produced the following year (figure 3.7). The differences between these two images mark the fine divide between an illustrated joke and a more naturalistic mode of representation, with the media themselves playing a part in this distinction. The move away from engraving to the softer lines and tones of pen, ink, and watercolor erases the jagged markings that characterize the original illustration and incite comparison with *Punch's* pictures. The size of the crinoline is also noticeably diminished in the reproduction, stopping well short of the edge of the drawing and thus lessening its comic potential. The result is an image that appears more realistic than its counterpart in the *Cornhill.* As N. John Hall remarks, this drawing "is markedly superior to the wood engraving; the face is that of a real woman whereas by comparison that of the print resembles a figurine."[52] In fact, Trollope became reconciled to the illustration only when he saw the dress in "real" life: "I will now consent to forget the flounced dress," he wrote to Smith; "I saw the *very pattern of that dress* some time after the picture came out."[53] The word "pattern" suggests that Trollope encountered this crinoline in the form of a fashion plate, or perhaps adorning an actual lady, but, either way, this "reality" is far removed from the representations of the crinoline on the pages of *Punch.*

Punch's portrayal of the crinoline, then, had implications not just for the construction of female roles, but for illustrative practice, giving the image a centrality and prominence that was often at odds with its position in other illustrated books and magazines. In 1863 the *Cornhill Magazine,* having previously published Millais' illustrations for *Framley Parsonage,* followed *Punch's* lead and included an article on the vagaries of women's fashion, coming to the conclusion that the ridiculousness of female dress was an apt signifier of women's stupidity: "in nothing does the female intellect more markedly betray its weakness than in this matter of costume," scoffed the critic.[54] Another condemnatory account of the crinoline is offered by Trollope himself, albeit through the voice of Miss Jemima Stanbury, in *He Knew He Was Right* (1868): "In the days of crinolines she had protested that she had never worn one,—protest, however, which was hardly true; and now, in these later days, her hatred was especially developed in reference to the head-dresses of young women. 'Chignon' was a word which she had never been heard to pronounce. She would talk of 'those bandboxes which the sluts wear behind their noddles'; for Miss Stanbury allowed herself the use of much strong language."[55] For Miss Stanbury—and perhaps even for Trollope, who might still have been haunted by Millais' image—the crinoline and the fashions that follow in its wake are symbolic of a lapse in female morality, but neither Miss Stanbury, nor Trollope, nor *Punch* could repress

Figure 3.7 John Everett Millais, "Was it not a lie?" (1861), pen-and-ink and watercolor. Image courtesy of Agnew's, London.

such fashions. When *Once a Week* asked the question "Who Killed Crinoline?" in 1869, the immediate response—"*Punch*"—was soon discounted, for, as the writer observed, that magazine had been railing against the fashion for almost a decade but to no avail. Nor was its demise due to patriarchal intervention: "Paterfamilias was alternately funny, indignant, and argumentative over this monstrous thing, which was burlesquing the natural shape of his prettiest daughters, besides subjecting them constantly to the risk of being burned alive; but wife and daughters alike received the sarcasm carelessly, and the wrath

meekly, and continued wearing crinoline as before."[56] Staged, as this extract makes explicit, as a battle of the sexes, the right to wear the crinoline was one in which women emerged victorious and men were quite literally battered and bruised. The female's "meekness" is questioned in her very ability to ignore such chastisement, her "careless" dismissal of sarcasm and anger. Paradoxically, the crinolined woman was never a fashion slave or a fashion victim. On the contrary, her very labeling as such may be taken to suggest a quite different possibility: that the wearing of the crinoline cage was an act of resistance, and was recognized as such by Victorian women every time they set eyes on the pages of *Punch*.

4

NATION AND NARRATION

The Englishness of Victorian Narrative Painting

I

Roland Barthes's assertion in "The Death of the Author" that a text is a "tissue of quotations," "a multi-dimensional space in which a variety of writings, none of them original, blend and clash," seems the most appropriate beginning, with the reservation that it actually undermines the notion of an origin or beginning, for a chapter that discusses how art has been discussed and, in its very title, draws on other titles that refer to a title.[1] The phrase "The Englishness of English Art" was coined by Nikolaus Pevsner as the subject of the Reith lectures that he delivered in 1955 and published in book form a year later.[2] Two essays appeared in 1990 that drew on and took issue with Pevsner's theory of art: William Vaughan's "The Englishness of British Art"[3] and John Barrell's "Sir Joshua Reynolds and the Englishness of English Art,"[4] which was included in Homi K. Bhabha's anthology, *Nation and Narration,* the other pre-text for my chapter heading.

Perhaps one cannot judge a book by its cover, but titles are a different matter. The modification Vaughan makes to Pevsner's original bears out his argument that at the center of Pevsner's account is a slippage between "English" and "British" that the historian shares with art critics of the eighteenth and nineteenth centuries, while Barrell's allusion to Sir Joshua Reynolds declares his thesis that the idea of a national art emerged in the shift in Reynolds's *Discourses* from a civic humanist ethics, which was bound up in the ideals of history painting and promoted universal values over local ones, to a discourse of the "customary" that, by reversing this hierarchy, stressed the distinctiveness of the nation's art and constructed a national community. Pevsner's own title brings together a number of assumptions about the status of art and national identity that inform the text as a whole. In pinpointing the qualities that make

a particular piece of art "English," he suggests that "Englishness" is not just the mark of a geographical location, and does not simply emerge with an object's country of origin, but is a set of identifiable characteristics and values that are capable of being realized or embodied in art. His title assumes a direct correlation between this ideological domain and canvases, sculptures, or buildings. Such a linkage, however, is itself ideological: it not only establishes "Englishness" as a privileged signifier but also implies that it is somehow anterior and exterior to art. For Pevsner "Englishness" exists in a context that lies outside the art object, and that the art object comes to reflect. Art represents the society in which it is produced, but it is also curiously divorced from it and unable to affect it. While he intertwines art and ideology, therefore, Pevsner actually denies the contribution of art to the ideological fabric of culture.

I want to argue, however, that art is one of the signifying practices that make up culture, and there is a sense in which it is constitutive rather than reflective, actually constructing ideas of what "Englishness" is. This construction comes to the fore in the illustrated books and magazines that I have analyzed here, whether it takes the form of the creation and propagation of "English" values (the ideals of family and morality embodied in the country cottage motif in *Uncle Tom's Cabin,* for example; or the "correct" modes of female dress and behavior implied in *Punch*) or encounters with the other that establish notions of national identity in their very deviation from them (American slavery, the "foreign" quality of Rossetti's designs, French immorality). The construction of ideas of "Englishness" is also at work, as the next three chapters will suggest, in Victorian paintings. Even art criticism, the way that art is viewed and written about at a particular historical moment, is not politically neutral or objective, existing in an aesthetic vacuum, but is the product of its time and one of the discourses that make that time what it is. What is most revealing in Pevsner's construction of the Englishness of English art is that his search for a national art is displaced onto the art object's apparent assimilation of national values. In this way it comes to seem obvious and natural to view art as an embodiment of national characteristics rather than seeing this very gesture as an imperative generated by art criticism itself.

It is this aspect of Pevsner's analysis that Barrell brilliantly subverts by suggesting that the notion of a "national art" is a theoretical concept rather than a truth about painting. However, his emphasis on the origin of such a concept, on the moment it first became possible to formulate the idea of an "English art," in some ways elides its plurality and instability. The "Englishness of English art" is not a unified or fixed notion but one that is constantly in process, and this is also the case with the ideas of nation and national identity on which it depends.

This chapter, then, jumps both from illustration to painting and from the eighteenth-century focus of Barrell's discussion to the middle decades of the nineteenth century, with the qualification that this was just one moment in which an arbitrary link was made, and then made to seem natural and true, between the blocks of color on a canvas and a geographical and ideological space. For Raymond Williams the glue that held together these distinct realms was the notion of culture that was emerging in this particular period. According to Williams, "culture" came to signify a "whole way of life," a merging of art and society that can be identified in the writings of Ruskin, Morris, and Pugin, who regarded aesthetic, moral, and social judgments as indivisible. Embedded in this notion of culture, art was seen to evolve from society, and society, in turn, was judged and characterized by its art.[5]

This idea of the social significance of art was not without its critics, however, and the reaction came in the latter half of the nineteenth and beginning of the twentieth century with the notion that art was distinct from the social world, its values located in plasticity and painterliness, qualities that were regarded as apolitical. Among the proponents of "art for art's sake," Roger Fry stands out as a writer who provides a different way of thinking about the Englishness of English art, and does so by proclaiming the need to divorce painting and nationalism. From the opening pages of *Reflections on British Painting* Fry embarks on a scathing attack on those who view painting as patriotic:

> However valuable patriotism may be in certain fields of human activity, there are others from which it should be rigorously excluded. And assuredly one of those is art-history and the critical appreciation of works of art. Even the historian of his country's political development should endeavour to discount his patriotic bias, but we tend to judge his failure to do so with a certain leniency because his very subject-matter is so deeply tinged with patriotic feeling. But in the art-historian such a failure of detachment is far less excusable since the artist's allegiance is towards an ideal end which has nothing to do with the boundaries between nations.[6]

Fry's invective is addressed to the descendants of those mid-nineteenth-century art critics who emphasized, as Pevsner did a century later, the connection between painting and national identity. As such, it echoes the words of the artist James Whistler, who, having suffered at the hands of Victorian reviewers, also railed against the contemporary association of painting with nationalism. Whistler's objections were directed at the comments of writers like J. B. Atkinson, the respected art critic for *Blackwood's Edinburgh Magazine,* who in one review argued that a "nation's art ought . . . to be a mirror to a nation's greatness,"

a "mirroring" that could be achieved if painting were to take its themes from English history, religion, literature, or the glorious imperial progress that was currently underway: "Ours is the supremacy of the sea and the dominion of the land," he eulogized, and "an empire upon which the sun never sets is sketching-field wide enough."[7]

For Fry and Whistler the problem with an analysis such as Atkinson's was not simply that it evaluated painting according to the extent of its nationalist zeal but that it misinterpreted the meanings of individual pictures by viewing them in these terms. But these reviews did not always constitute a misreading of the image. Fry's attack on the critics detracts from the fact that painting *could* be concerned with questions of national identity and that it was not always a matter of reviewers making an artificial connection. This is a possibility that he firmly excludes: the artist, he confidently asserts, works toward an ideal end that has nothing to do with nations. The possibility is glimpsed, however, in something that is missing from this story of nation and painting: the *story* itself. What connects Fry and Whistler is the contention of both artists that, along with nationalist fervor, narrative should be eradicated from painting and art history. These two elements, indeed, were virtually inseparable. While Atkinson sees national art epitomized in the "pictorial romance" depicted by the genre painter and didactic images that recount more serious tales, Fry's and Whistler's discussions of a misplaced patriotism take place in the context of assaults on narrative art, pictures that presume to tell a story.[8] Where Whistler argues that art is "degraded" by the assumption that it functions in a literary way,[9] Fry takes issue with the narrative painter par excellence, William Hogarth. According to Fry, there is much to admire in Hogarth's delicacy of tones, but such painterly qualities are let down by his insistence on telling stories.[10] And the same is true of that other great narrative painter, David Wilkie, who shows considerable promise until "the story-telling aspect of the picture . . . become[s] too prominent."[11]

In Fry's account the popularity of narrative painting has serious consequences for British culture as a whole, resulting in tragedy for "the whole temper and character of our civilization." In the nineteenth century, he remarks, "we became slaves to Philistinism, Puritanism and gross sentimentality."[12] Indeed, it is here, in this evocation of the national crisis that narrative painting instigates, that Fry's own narrative begins to crumble. The text's direct address to, and embracing of, a British audience, along with its description of a calamity that affects them all, works to reassert rather than eradicate patriotism. Ultimately, *Reflections on British Painting* does more to consolidate and define the "boundaries between nations" than to abolish them.

In Fry's analysis it is genre paintings, narrative images that tell stories of everyday Victorian life, that most encourage nationalist or patriotic readings.

This is not to say, of course, that these pictures were actually "national" or that they really did constitute a discernible group. What is most significant is the fact that they were *constructed* as such, and not just by Fry. Ironically, his argument is dependent on the link between narrative and nation that was instigated by those very mid-Victorian critics whom he was so eager to denounce. The most emphatic identification of narrative painting as specifically "English" came in the wake of the Exposition Universelle, which opened at the Palais des Beaux-Arts in Paris in May 1855. Fine art had not featured in the Great Exhibition of 1851, but the exhibition in Paris four years later contained the largest display of British paintings ever shown abroad. The British contributed alongside twenty-six other countries but came second only to France in terms of the numbers of canvases on display, with 231 oil paintings and 143 watercolor pictures by 295 artists, including established narrative painters like William Mulready, John Everett Millais, Edwin Landseer, and William Holman Hunt, all of whom showed several pictures apiece, while the art of David Wilkie was prominent in the engraving section.

The Exposition Universelle, like the other international exhibitions, was a space where different crafts of the world not only were displayed but could be compared and contrasted. Baudelaire, who had been commissioned to write a series of articles on this exhibition for *Le Pays,* described it in exactly these terms: "There can be few occupations so interesting, so attractive, so full of surprises and revelations for a critic . . . as a comparison of the nations and their respective products."[13] The whole format of the exhibition was conducive to the construction of national identities and the identification of differences between one nation and another.[14] By bringing together the works of various countries, the exhibition encouraged a viewing of these objects in terms of shared national characteristics, while the hanging of the countries' works in separate halls or even buildings suggested their insularity and position as distinct schools. Any national or geographical difference became a very real spatial one: spectators might have to walk up several flights of stairs in order to cross from France to England. According to Richard Redgrave, who organized the British section of the 1855 exhibition, the British paintings were placed in one of the most inconvenient galleries and partitioned off from the French exhibits by curtains. The allocation of this disappointing venue, however, was justified in terms of the high percentage of British narrative art, with its characteristic small canvases that were ideal for hanging along the side hall of the main floor.

Whatever the actual criteria for selecting the British works to be shown at this exhibition, the layout implied a continuity between the paintings similar to Pevsner's formulation of the Englishness of English art. Spectators, forced into viewing the pictures of one country as an independent entity, were also

encouraged to identify a common thread, the quality or characteristic that
made the works distinctly national. The paintings, then, were always already
determined by a notion of "Englishness" or "Britishness" (the two terms being
more or less interchangeable at the time) that set them apart from other works,
but they were also seen to evince certain qualities that, in turn, came to define
what Englishness or Britishness was. The display and interpretation of these
paintings played with and between ideas of what "England" signified, from a
definite geographical space to a complex set of values and ideologies, and these
meanings came together in the construction of the "Englishness" of narrative
painting. Identified initially by the French, this national difference was one
that critics in Britain were eager to foster, and throughout the months of the
Exposition Universelle and well into the following year the press published nu-
merous translations of French articles that pointed to the originality and
uniqueness of English painting.

It was, indeed, this individuality that came to be regarded as English paint-
ing's defining characteristic. The *Art Journal* cited a critic in the *Journal l'Union,*
who had commented that the English school was "the most unique in its char-
acteristics" and went on to locate this uniqueness in the English character itself:
"Every eye is at once struck with its originality—originality of thought—origi-
nality of tint—originality of treatment. England is eminently national, and she
is too proud to imitate others."[15] The *Moniteur* was reported to have made a
similar remark: "The present English school has no guide but its own caprice;
each one ranges as his individuality prompts—without, however, for an instant
losing the British stamp."[16] "The artists of England," argued one French reviewer
in the *Athenaeum Français,* "belong to the school of England—quite uncon-
nected *with the schools of the continent,* they are themselves alone."[17] Moreover,
it was paintings that told stories that were identified as representing an essence
of English art. *La Patrie* agreed, "It is in this *genre* anecdotical . . . that the artists
of England should seek their inspiration, and anticipate success."[18] One French
review was described by the *Art Journal* as particularly favorable because it as-
serted that the power of English painting lay in the fact that

> It is English—purely English. It must be sought for where alone it ex-
> ists—in works of its own creation. . . . [N]o artist, of whatever country
> he may be, has carried farther than they have, truthfulness in *genre* and
> the poetry of reality in landscapes. The actors whom they introduce
> into their familiar scenes of life, have a living power of visage and ac-
> tion; they think aloud—they move, and you become one of them,
> while dwelling on the scene, before which the artist stands with his
> palette and his pencils.[19]

In January 1856 the *Art Journal* was still faithfully transcribing the remarks of the French press on English painting. Its justification for doing so was that these foreign reviews might prevent British artists from developing bad habits, but this justification might also have had something to do with the fact that in these accounts English paintings personified the English character: the English were fiercely independent, proud, and worthy of their imperial domination.[20] One of the last reviews to be translated was from Maxime Du Camp's *Les beaux-arts à l'exposition universelle de 1855*. Du Camp, having looked in some detail at the paintings of Millais, Webster, and Mulready, concluded, "In truth, our neighbours across the Channel have carried into Art the essential originality which segregates them, and enables one to recognise them at a glance, amongst all other people. There is in their painting, as in themselves, a something original, especial, *eccentric*, which attracts attention. It has the flavour of their soil. It is neither Flemish, nor Spanish, nor Italian. It is English, Protestant, methodistical, and, up to a certain point, is adapted for them alone."[21]

Du Camp's account, coming a year after the exhibition in Paris, suggests how effective the construction of a specifically English art had been. These canvases speak their own national difference, embodying those characteristics inherent in the country from which they emerge and seeming to spring from the land itself. But there is also another possibility, of course: that it is the critics themselves who construct this national difference, who forge the link between art and nation. After all, the "Protestant" and "methodistical" culture of England that Du Camp sees the paintings as displaying was precisely what "England" signified to the French. Indeed, Patricia Mainardi has argued that the French response to foreign art at the 1855 exhibition reveals more about France than about the paintings themselves. The favorable reviews of English art certainly might have owed something to the fact that the English were fighting alongside the French in the Crimea. Mainardi alludes to a cartoon that appeared in *Le Charivari*, the French equivalent of *Punch*, in June 1855: a woman who claims to have spotted an error in an English picture is rebuked by her male companion, "'Madame, the English are our allies, I will never admit that they could err in one of their pictures, I ought not and will not!'"[22] According to Mainardi, comments on the rise of British genre scenes and the analogous decline of history painting, which was frequently blamed on Protestantism and the British constitution, were a vehicle through which the situation in France could be compared and contrasted.[23] In this context, English narrative paintings, defined in French criticism as a mirror of England, might well have reflected the political situation across the Channel.

The effects of the Exposition Universelle on the reception of narrative painting in Britain were far reaching. The reviewers suggested not only that

narrative painting might be peculiarly English but that it constituted a distinct school.[24] After 1855 it became common practice to group together British paintings in terms of their storytelling. For the first time at the Manchester Art Treasures Exhibition in 1857 the paintings of Wilkie, Mulready, Webster, and the Pre-Raphaelites were placed alongside works by Hogarth, who was increasingly recognized as the founding father of the genre. So pervasive and compelling was this "history" of narrative pictures that when Sacheverell Sitwell wrote his classic account of these images in 1936 he not only pointed to Hogarth as the predecessor of the Victorian narrative artist but saw the genre in terms of a national school.[25]

In a sense, however, Sitwell's task had already been performed for him. Samuel and Richard Redgrave's *A Century of British Painters* devotes considerable space to Victorian narrative painters and is itself part of a nationalist agenda. The book appeared initially in 1866 as *A Century of Painters of the English School; with Critical Notices of their Works, and an Account of the Progress of Art in England.* In 1947, however, another version of the text appeared under a title that was to become more familiar: *A Century of British Painters.* Ruthven Todd, who edited this version for Phaidon, does not refer to this postwar modification, which replaces "English" with "British" and erases the possibility that these artists from different countries constitute a national "school."

If the Redgraves might have been less than enthusiastic about this latter change, they probably would not have questioned Todd's appellation "British," for the shift from "English" to "British" that takes place in the publishing history of the book is integral to the story that it tells. Todd might have been influenced in his amendment by the Redgraves's own attempts to bring together the countries of Britain under the common aims of art and to differentiate them from other nations. Their main strategy in achieving this end is to identify the mutual interests of three representative narrative painters: the English Leslie (who is appropriated as such despite the fact that he was actually raised in Philadelphia), the Irish William Mulready (who was described by F. G. Stephens just a year later as "thoroughly English"[26]), and the Scotsman David Wilkie. It is a rather dubious construct of Britishness, then, especially considering the notable absence of any Welsh painter, but this does not deter the Redgraves from their nationalist project: "It is noteworthy that these three artists, whom all will admit to have attained the highest eminence in this class of art, should at the same time represent the three sections of our countrymen; that in Wilkie, Scotland, in Mulready, Ireland, and in Leslie, England, have reason to be proud of men who have left behind them pictures so varied in manner, so original in treatment, and so characteristic of British art as to be wholly different from those of any other country."[27] By choosing these three particular exponents of narrative painting, the Redgraves

make what appears to be a natural link between British nationalism and narrative art, one that might be "noteworthy" but comes to seem coincidental rather than politically motivated. The move in some way excuses the constant slippage in the text between "Britain" and "England," but it also allows the authors to make more forcefully the point that the art produced in the different regions that make up the British Isles is united in its difference from art produced in other countries.

Moreover, according to the Redgraves, this difference lies not just in a national penchant for narrative art but in the specific story that British painting tells: whereas the French depict the horrors of war, the British show the pleasures of domestic life. This national and artistic difference was also identified by Baudelaire, who in his *Salon* review of 1859 looked back at the English paintings that had been on display in France in 1855 and saw their "intimate glimpses of the *home*" as reflections of the English mind.[28] It was thus not pictorial narrativity in general that came to be defined as specifically "English" in this period, but a particular *kind* of narrative.

For the Redgraves it required only a shift of emphasis to assert that the ideal space for displaying such domestic pictorial stories was the middle-class home itself. Unlike French paintings, British images were not made for grand public buildings but required a different space for exhibition and appealed to a different market: "It was soon found that pictures to suit the English taste must be pictures to live by; pictures to hang on the walls of that home in which the Englishman spends more of his time than do the men of other nations."[29] While the Redgraves address the English reader as one who is familiar and will sympathize with this love of the domestic, they actually go some way toward *creating* this link between pictures, Englishness, and home. Their authoritative mode of address and suggestion that this association has already been proven ("It was soon found") masks the almost frantic repetition of these three terms. This successful juxtaposition is necessary for their final and most definitive assertion: that the Englishman spends more time in his home than the men of any other nation. It is this factor that is used to differentiate the English from other races, to define England as a nation, and to cement the position of narrative paintings in this nationalism. Narrative pictures here do not simply "suit" the English taste but work to define, display, and categorize it, playing a part in *producing* this idea of Englishness and venerating the private sphere of the home so that the ideal of domesticity comes to seem natural, obvious, self-constituting—an essential characteristic of Victorian life.

English genre painting, as the Redgraves were at pains to point out, was everything that history painting in the grand manner was not: its canvases were tiny and it focused on trivial rather than momentous events, on realism rather than the ideal, on the present as opposed to the past, and on the private rather

than the public world. For some critics, however, these characteristics were interpreted not as a sign of the superiority of British art, but as indicative of its inadequacy and inferiority. When he visited the Exposition Universelle, Charles Dickens, like the Redgraves, also compared English and French paintings, but came to the very different conclusion that English paintings were "small, shrunken, insignificant," with narratives that were not always successful. Even in its failings, however, the genre was bound up with ideas of national identity: "There is a horrible respectability about most of the best of them—a little, finite, systematic routine in them, strangely expressive to me of the state of England itself. . . . Don't think it a part of my despondency about public affairs, and my fear that our national glory is on the decline, when I say that mere form and conventionalities usurp, in English art, as in English government and social relations, the place of living force and truth."[30] The suggestion here that English art comes to embody the contraction of the empire ("our national glory is on the decline") seems only too apparent in canvases that focus on the insular, domestic space. What is not acknowledged, however, is the part that these ideologies of the "home" had to play in the construction of the empire in the first place, to what extent, for example, the gender roles they frequently displayed served to constitute an idea of "Englishness." Paradoxically, Dickens's account works against itself, functioning to suggest not the "insignificance" of narrative art but its importance for ideas of national identity. The humble genre painting is, after all, situated as part of the body politic, symptomatic of the condition of the country.

The analogy is important for ideas of nation as well as for the images themselves. With art and society so closely interlinked, nation can itself be seen as a series of (pictorial) stories, a view that recently has been voiced by Homi K. Bhabha. According to Bhabha, nation is a linguistic construct, constituted by competing discourses, political tracts, and literary texts that refuse closure: "To encounter the nation *as it is written,*" Bhabha writes, "displays a temporality of culture and social consciousness more in tune with the partial, overdetermined process by which textual meaning is produced through the articulation of difference in language."[31] I would suggest, with Bhabha, that the link between narratives and nation is not simply a metaphor but a real cultural and linguistic process that produces nation as a signifier and marks it with the workings of difference. But, unlike Bhabha, I contend that this has implications not only for the textual but for the visual too. In the mid-nineteenth century the "articulation of difference" that produces and disrupts meaning and constitutes national identity can be found in the hybridity that the narrative painting shares with illustration: the difference between something "written" and something pictured. And part of this difference is embedded in a spectatorial process that

is also a "reading," an interpretation. Victorian narrative paintings are made for an English audience: they address a collective group, who can understand the tales that they tell and share their cultural references. When Maxime Du Camp recognizes that English art is adapted for the English alone, he glimpses the disturbing possibility that even the act of looking at the narrative picture is never free from nationalist politics.

II

In the viewing position that it encourages, the Victorian narrative picture stands as a curiously postmodern form of art. It holds its own in a world of interactive technology and hands-on museum exhibits because it allows the spectator to work on the painting, to actively trace its meanings. The viewer here is not a passive recipient, but one who pieces together the clues of the painting in order to construct its story. To look at the narrative picture, then, is to question the very premises of looking. Here sight and interpretation merge in a way that denaturalizes vision and suggests that it is not simply a biological process but one that involves the generation of meanings, a cultural awareness of what is seen. The narrative image, in other words, depends on the spectator's understanding of and location within a signifying system and its concomitant social conventions.

The recognition that there is not a natural or neutral way of seeing paintings also suggests a link between Victorian and poststructuralist theories of visuality. The cultural critic bell hooks describes a mode of seeing that is determined by race and gender, arguing that black female spectators have adopted an "oppositional gaze" in their viewing of white cinema that allows them the critical distance to interrogate films and the images they present.[32] The context and political agenda of hooks's analysis are, of course, very different from those of Victorian accounts of narrative painting, and this is only exacerbated in her focus on racial and gender specificity, but the two accounts do share certain premises, with the relation between culture and vision also playing a part in mid-nineteenth-century paintings. The viewing position that pictorial narratives demand, for example, has implications for the construction of national identity.[33] In a seeing that is also a reading, the spectator must be able to understand the many references that the painting uses to tell its tale, whether these are the individual details on the canvas, or the wider ideological codes that regulate how the figures and their actions are to be interpreted. The narrative picture addresses a community of viewers who share and participate in its assumptions, and this community frequently comes down to national and racial determinants.

But there are also, of course, "outsiders," spectators who, as hooks so persuasively argues, do not see in the same way. In the mid-nineteenth century these were foreigners, viewers from other countries who were regarded as particularly prone to misreading the British narrative painting. The editor of the *Art Journal* intervened in an unfavorable French review of the Exposition Universelle to assert that the French may well have misunderstood the British images on display.[34] Even Du Camp fails to read correctly. His description of Edwin Landseer's narrative animal picture, *The Sanctuary*, was greeted with derision when it was translated in the *Art Journal* because the Frenchman was unaware of the picture's meanings and did not understand that it was about that quintessential English tradition: hunting. "All that he has made of one of the most charmingly poetic and touching compositions that ever came from the hand of artist," wrote the critic, "is simply a stag taking a bath. . . . It quite escapes his critical eye, that the noble animal, like his fellow in the forest with the melancholy Jaques, has just won his life from the remorseless hound and huntsman."[35] The apparent French ignorance of English customs is intensified here in the elevated mode of address that the reviewer uses to deflate Du Camp's views (this is not "a stag taking a bath" but a "noble animal"), while the distance between the Frenchman's matter-of-fact interpretation and the reviewer's grandiose one is compounded in the literary allusion to Shakespeare, the ultimate signifier of Englishness. The French, however, were also aware of the cultural gap that could lead to misinterpretations of the narrative picture. Commenting on Edward Matthew Ward's *The South-Sea Bubble,* a historical genre painting that followed closely in the tradition of Hogarth, one French critic remarked that it "represents one of those comic scenes which can only be well understood by those who know what a joke is in England."[36]

In 1902, when William Sharp wrote a history of the art of a previous century, the link between narrative painting and its English spectators was conventional, although by now it had become a cause for lamentation rather than celebration:

> There is a radical tendency in the English art-world to value and certainly to care above all else for the work of the literary painter. Let a man tell a story well in illustration, or be obviously dramatic or humorous or fantastic, and he will be popular. It is the episode told or suggested in a graphic way which pleases the crowd. This native tendency—which merely indicates untrained appreciation, the indifference of ignorance—was flattered and enhanced by the influence of so enormously popular an artist as Sir Edwin Landseer. The painters who have been most popular since are those who are story-tellers or painter-illustrators—

literary painters, in a word; as, for example, Mr Marcus Stone with his picturesquely unreal or fatally pretty love-scenes.[37]

The narrative painting, although consumed and perpetuated largely by the middle classes, was marketed as a democratic genre that would appeal to all, regardless of education or training. But, while this type of painting might have been popular across classes, its attraction was not necessarily universal. Sharp identifies not only the Englishness of pictorial stories but the English way in which they are viewed: it is a "native tendency," he asserts, to appreciate such images. Indeed, unlike hooks's viewers, these Victorian spectators do not hold a critical distance from the works but are characterized by the fact that they "care" for them, a signifier that suggests not only a value judgment but also an emotional investment.

It was this "emotional" way of looking, the adoption of an empathetic gaze, that was seen to define the British way of viewing the narrative picture.[38] Thus, while Du Camp can write dispassionately about a stag taking a bath, the critic in the *Art Journal* invents a story for the scene that adds to its pathos and poetry: the stag "has made his way through the calm lake—*leaving his trail upon the face of the waters*—to this island Sanctuary, whither he cannot be pursued."[39] The "gross sentimentality" that Fry and others associate with Victorian narrative images, then, is not simply isolated on the canvas but is a product of the viewing process itself. Moreover, this emotional response does not merely cause the spectators of the narrative painting to "melt away in a deluge of blubber," as Thackeray once commented, but serves an ideological function, breaking down the barriers between the inside and outside of the painting and enabling viewers to "enter" the picture and take on board those "proper" Victorian values that they saw there—such as the joys and virtues of family life— or a warning of what might happen if one strayed from these ideals.[40]

In this context, the "right" emotional response to the image is a test of one's nationalism as well as virtue, proof of one's place in a society of viewers that understands the picture's story and shares its ideals. It is not surprising that the working classes, in particular, were encouraged to view such images, with employers organizing trips for their workers to exhibitions like the one in Manchester in 1857. The argument, which Sharp takes for granted, was that even the illiterate could understand pictures that told stories (a debatable notion considering the complex literary, historical, and biblical allusions that some of the paintings make), but, closer to the surface, was the apparent ability of narrative paintings to inculcate middle-class values in working-class viewers.

The social bonding that occurred between the viewers of the narrative painting, as well as between the spectators and the canvas, was described by Henry James, who visited the Royal Academy exhibition in 1877:

> [I]f there is something irritating in the importunately narrative quality
> of the usual English picture, the presumption is generally that the
> story is very well told. It is told with a kind of decent good faith and
> *naïveté* which are wanting in other schools, when other schools at-
> tempt this line. I am far from thinking that this compensatory fact is
> the highest attribute of English art. It has no relation to the work of
> Gainsborough and Reynolds, Constable, Flaxman, and Turner. But in
> some of the things in the present Academy it is very happily illus-
> trated.
>
> I found it illustrated, indeed, in the spectators quite as much as in
> the pictures. Standing near the latter with other observers, I was struck
> with the fact that when these were in groups or couples, they either, by
> way of comment, said nothing at all or said something simply about
> the subject of the picture—projected themselves into the story. I re-
> member a remark made as I stood looking at a very prettily painted
> scene by Mr. Marcus Stone, representing a young lady in a pink satin
> dress, solemnly burning up a letter, while an old woman sits weeping
> in the background. Two ladies stood near me, entranced; for a long
> time they were silent. At last—*"Her mother was a widow!"* one of them
> gently breathed. Then they looked a while longer and departed. The
> most appreciable thing to them was the old woman's wearing a
> widow's cap; and the speaker's putting her verb in the past tense struck
> me as proof of their accepting the picture above all things as history.[41]

The ladies who are so fascinated by this painting and in turn fascinate the criti-
cal gaze of James are presented as characteristically naive. In Sharp's terms they
represent the untrained masses who appreciate any picture that tells a good
story. Marcus Stone's painting *Sacrifice,* which is alluded to here (although
James seems loathe to mention its typically melodramatic title) is particularly
effective in generating the desired response because it allows the viewers to be-
come part of the story in a sentimental reaction that mirrors the emotions of
the two females in the image. These spectators view the events that the paint-
ing depicts as "history," a real event that has actually occurred in the past, and
a past that is set in their own temporal space ("Her mother *was* a widow").

 This articulation of a mutual history for the painted figures and the spec-
tators is itself important for ideas of national identity. John Stuart Mill had ar-
gued in 1861 that the greatest inducement to nationalism was the possession of
a shared history and "community of recollections," that nation, in other words,
depends on possessing those collective feelings associated with a common
past.[42] Mill's ideas were taken up by Ernest Renan in a lecture delivered at the

Sorbonne in 1882. According to Renan, it is precisely this invocation of a shared history that is crucial to the formation of a nation. Nations are determined not just by geography, race, language, or religion, but by a legacy of memories and the common will to perform great deeds in the future. And it is grief rather than joy that occupies the most important place in the national memory, because it indicates a shared suffering.[43] Renan's comments seem to describe the feelings of the two women who stand wistfully and sorrowfully in front of this painting by Stone, their emotions and knowledge of what widowhood signifies bringing them together and blurring the distinction between them and the figures on the canvas.

This empathy with the picture, then, is the linchpin for national identification, and this comes to the fore in James's discussion, in which the politics of looking is not natural but national: it is an English viewing that is intertwined with the English genre of the narrative painting. And the most "English" aspect of this mode of spectatorship is the fact that it is primarily a "reading," an ability and willingness to get involved in the pictorial story. No wonder this projection of Victorian spectators into the picture space became a favorite subject for narrative painting itself. William Powell Frith's *A Private View at the Royal Academy in 1881* depicts a crowd of engrossed famous spectators, while a less well-known audience show no less enthusiasm for the "Picture of the Year" in George Bernard O'Neill's *Public Opinion* of 1863 (plate 1). As Kate Flint points out, by placing their emphasis on gatherings of people, depictions of exhibitions show the viewers taking part in a social ritual.[44] But in these particular scenes this communal "ritual" also allows for what seem to be a highly personal and individual responses to the images. Often "entranced" by the painting, rooted to the spot, these pictured spectators are unable to take their eyes from it, while their interpretation of the picture, in typical narrative style, is written all over their faces.

One Touch of Nature Makes the Whole World Kin by Thomas P. Hall enacts this meeting of spectator and spectacle that is indicative of the genre as a whole (plate 3). The assortment of city dwellers who gather in front of this art dealer's window are themselves transformed into a narrative picture, framed by the pane of glass through which they peer. Their viewing of a picture that lies upright on the edge of the painting draws attention to the fact that they too are objects of the gaze, connected in the very act of looking with the viewers on the other side of the canvas. Hall's image is all about looking, a mirrored/doubled looking, an internal and external gaze, that renders the figures both seeing and seen and draws attention to the painting's own status as a painting. The "external" spectators are an integral part of this image; we look from inside the art dealer's shop, the position that should be occupied by the proprietor and, although we are unable to see

the image that our counterparts stare at, three prints, suspended from the ceiling, are offered specifically for our sight. For a Victorian audience this painting must have presented a curious reciprocation of the gaze, as these painted figures, dressed in contemporary fashions and situated in a contemporary setting, repeat the audience's own activity of looking at a picture. The actual image that is central to the painting's meanings might be a landscape, one of the rural scenes that had become increasingly popular with city dwellers, or even a genre painting itself. But in a sense it makes no difference. The "touch of nature," Hall's title seems to announce in an almost self-congratulatory way, is not the unseen canvas but the representatives of human life who gather in front of it, hypnotized for a moment before they return to daily business.

The emotional response of Hall's viewers, both inside and outside the canvas, is achieved because the image seems so realistic, in spite of the fact that it draws attention to itself as a painting. Perhaps, indeed, its very "staging," its status as a picture that tells a story, adds to its verisimilitude. Norman Bryson locates painterly realism in the relation between word and image, the very relation that defines both illustration and the Victorian narrative picture.[45] He contends that the figural aspects of an image, the features like perspective or visual details that are apparently independent of language, work to construct the illusion of reality and to substantiate the truth of the discursive elements, the linguistic coded "messages" such as the title or the story the image tells. Made up of components that seem trivial or excessive compared to the discursive message, the figural masks its role in meaning production because it seems to come from a realm of knowledge outside the canvas, including elements that appear semantically neutral, such as posture, costume, and the location of objects in space. Far from innocent, however, the realm of the figural generates the meanings of the image, meanings that are all the more convincing because they seem so incidental:

> These new meanings . . . are felt as having been *found,* and this confirms exactly the natural attitude, where the meanings of gestures, clothing, physiognomy, body-typing, and the other "subtle" semantic codes are felt to inhere in the objective world and are not understood as the product of particular cultural work. Because the "subtle" meanings are hard to prise out, they are valued over those meanings which, as it were, fall into the hand of their own accord; and because the meanings are discovered in neutral territory, amidst the innocent, perspective-based spatial information, they seem immaculate.[46]

The viewer "discovers" these meanings, and it is this that makes them seem so natural and persuasive. Indeed, according to Bryson, this "discovery" works to confirm the truth of the discursive aspects of the image, giving the impression

that they are part of the same signifying system. In *One Touch of Nature* it is the figural elements of the image, the visual appearance of the protagonists, their clothes, and facial features, that naturalize and validate the textual "message" that "one touch of nature" does, in fact, "make the whole world kin." The spectator outside this canvas is doubly involved in this image—in "finding" meanings and participating in the painting's "reality," becoming a part of it. The picture appears as a snapshot of life, encouraging the viewer to work out the relation between this seemingly random group of people and to construct an imaginary existence for them. What will be the fate of this poor crossing sweep? What is the history of the serving girl? Is she a country maid, perhaps, who has been forced to try her luck in the city? Even these imaginary stories, however, are never totally subjective or personal: they do not emanate from the canvas, but depend on the spectator's other cultural references, other stories and pictures.

However trivial such figural details appear, they are highly political, and precisely because they seem so neutral and self-evident. It is the neutral and self-evident aspects of Hall's picture that work to enforce contemporary ideas about national identity, gender, and class. On one level, this image, with its community of spectators drawn from different walks of life, seems hopelessly idealistic. Caroline Arscott has read the painting as an example of the power of art to unite people regardless of class, a picture that shows the "miraculous abolition of the social differences that make the modern world so dangerous."[47] But there is a sense in which this painting, far from unifying, is extremely divisive, erecting what Susan P. Casteras has identified as the "invisible barriers" that Victorian art uses to separate persons of different classes.[48] In *One Touch of Nature* these barriers are symbolized by the window frames that isolate and exclude as much as they incorporate and unite. Even the commercial setting of the scene, its focus on a shop window, is a reminder that, despite its promise of solidarity, this art is never free for all. The divide between rich and poor is rendered more acute in the quotation from Shakespeare's *Troilus and Cressida* that forms the title of the painting and directly addresses an educated audience who are far removed from the little crossing sweep. This is a "kinship" that is divided by class.

There is a way, though, in which these spectators *are* united, even in their differences, for, however disparate they appear, they are not a random group at all but a set of national stereotypes, representatives of English life, who could have stepped straight from the pages of Hippolyte Taine's *Notes sur L'Angleterre*. There is the fresh-faced maid, the dandy who leers at her, the crinolined gentlewoman, attired in the huge bows and garish stripes that *Punch* liked to ridicule and Taine saw as indicative of English bad taste.[49] The focus of the image, of course, is an impossibly clean crossing sweeper, whose doleful expression and

wide eyes set him apart from the crowd and who incites comparison with the "street-boy," similarly susceptible to the power of art, described by Charles Kingsley later in the century: "[I]t is delightful to watch in a picture-gallery some street-boy enjoying himself; how first wonder creeps over his rough face, and then a sweeter, more earnest, awe-struck look, till his countenance seems to grow handsomer and nobler on the spot, and drink in and reflect unknowingly, the beauty of the picture he is studying.[50]

The crossing sweep was, in fact, one of the most familiar English types in the mid-nineteenth century, a figure who had fast become a symbol of the London destitute, interviewed in Henry Mayhew's *London Labour and the London Poor*, immortalized as Poor Jo in Dickens's *Bleak House*, and appearing on a weekly basis in *Punch*. He was also a common figure in narrative painting and occupied a sentimental role similar to that found in Hall's painting in Augustus E. Mulready's *Remembering Joys That Have Passed Away* (1873) and *A London Crossing Sweeper and Flower Girl* (1884). In both of these scenes, as in *One Touch of Nature*, the crossing sweep is inseparable from the city, a signifier of London itself. *Remembering Joys* is set in Drury Lane, while Blackfriars Bridge is the location of *A London Crossing Sweeper*. Indeed, the "whole world" that Hall's picture claims to represent is, in fact, London, a metonym for the nation at large and a microcosm of English types.

Hall's spectators are part of the same nation, and this "kinship" is offered to the viewers on the other side of the canvas, who, in the very process of looking at and understanding the image, are also enlisted as English subjects. The identification that is extended to both sets of viewers is suggestive of what Antony Easthope describes as the formation of a "collective identity," an identity that is bound up in class, race, and ethnicity. According to Easthope, this identification is generated in the focus on an external object: "National unity, nation as unity, is an effect. It is an effect, first of all, of the process of collective identification with a common object which is accompanied by identification of individuals with each other."[51] In Hall's painting the "common object" that brings together this seemingly disparate group of people is the hidden canvas itself. But its obscurity, the inability of the viewer outside the canvas to see it, problematizes the unity that the image presents. There is a reminder here that not everyone has access to this "common" object and that a national identity founded on it is always lacking.

Even as it focuses on visibility, then, Hall's image draws attention to what cannot be viewed; as it suggests the possibility of a unified vision, it simultaneously exposes that there might be other ways of seeing, an "oppositional" gaze. These contradictory meanings come together in a menacing-looking figure who is excluded from the main frame of the picture but occupies a central position

from its margins: a man who holds a monocle to his right eye and gazes not at the picture in front of him but at the pretty serving girl with the milk jug. At once an insider and an outsider, part of yet set apart from the crowd, this man emphasizes the whole problem of looking, throwing into disarray the "kinship" that the painting seems to offer. His look lays claim to power and authority, slicing through the triangular composition of the main frame and positioning woman as the object of the male gaze.

The serving girl does not return his look. Perhaps she cannot. For this look is also a look across frames, into another pictorial space, a gaze that is so unnerving precisely because it seems to mimic our own. The glance of this man is bound up in definitions of gender, class, and national identity, yet it cannot quite be contained by them. It is what Slavoj Žižek has defined as a look "awry," a look from an angle, which might suggest a blurred, distorted sight, but can also mean the very opposite: "[I]f we look at a thing straight on, i.e., matter-of-factly, disinterestedly, objectively, we see nothing but a formless spot; the object assumes clear and distinctive features only if we look at it 'at an angle,' i.e., with an 'interested' view, supported, permeated, and 'distorted' by *desire*."[52]

The "desire" motivating the man in Hall's picture might seem self-evident. His glance, writes Lynda Nead, renders the maidservant "subject to the sexual exchanges of the city."[53] But the desire that motivates the painting as a whole is more complex and problematic, a desire for "kinship" that remains unfulfilled. The "look awry" is the symbol of this lack and suggests the very problems of a national identity that is also a narrative. For Bhabha, it is the linguistic structure of nation that makes nation heterogeneous and fractured: "[T]he problematic 'closure' of textuality questions the 'totalization' of national culture."[54] Translated into visual terms, this open-endedness and multiplicity is also apparent in Victorian narrative painting, and precisely in that look elsewhere, a deviant glance from the sidelines that suggests the possibility of other ways of seeing, and questions, even as it upholds, the Englishness of English art.

A TALE OF TWO STORIES

Joseph Noel Paton's In Memoriam

I

The plurality of the narrative picture, as well as of national identity itself, is the subject of a painting exhibited in the Royal Academy in 1858. *In Memoriam,* by the Scottish artist Joseph Noel Paton, is a tale of two stories (plate 4). Based on the massacre of women and children in the so-called Indian Mutiny of 1857, the image was originally displayed with bayoneted Indian soldiers advancing on the fugitives who huddle together in the dingy cellar. Unsurprisingly, the picture caused some controversy when it was first shown. The *Athenaeum* commented that it should not have been hung because it was cruel and in bad taste,[1] and the *Illustrated London News* called it a "horrible picture" with a "revolting" subject matter.[2] Such reactions incited the artist to make changes to the scene, and when it was taken down from the academy walls Paton painted over the mutineers with a group of Highland soldiers on a rescue mission. Even Queen Victoria was said to have breathed a sigh of relief.[3]

There are two versions of this pictorial story, then: one that presents itself to the viewer today and one that caused a ripple of horror among its original Victorian spectators. But there is a sense in which Paton's story is not a "story" at all, for its narrative, based on an actual event, and the painterly devices it employs, lay claim to historical realism. And this, in fact, was part of the problem. Paton attempts to construct this picture as a history painting: the triangular composition of the central group and the effective use of chiaroscuro draw on the tenets of this genre, while the stoicism of the women, their courage in the face of adversity, situates them as classical heroes.[4] Ironically, however, what this history painting lacks is any historicity. The fact that the events of the Indian Mutiny had occurred so recently (circumstances in India were still not resolved,

and the siege of Lucknow had been lifted only two months before the painting was exhibited in May 1858) removes the historical distance usually associated with such images and adds to the painting's shock value. This was the main criticism leveled at the painting in the *Art Journal*:

> The appalling details of the murder of our countrymen are yet so fresh in the memory that any mere allusion to these fiendish atrocities cannot be borne without a shudder. What, then, must be the feeling on contemplating a picture like this, representing, with all the subtlest cunning of Art, a party of these poor ladies and children awaiting their fearful doom? . . . And it is entitled "In Memoriam"—be it so; it is not painted for the present generation,—half a century hence, when the dreadful subject has become matter of history, it will then more becomingly—though not even then regarded without a shudder—serve the purpose for which it appears to have been painted.[5]

According to this review, the horror of the painting lies in its immediacy, the fact that the massacres are still fresh in the minds of the spectators, but this is also what makes the image so powerful. I want to suggest that *In Memoriam* plays a part in scripting the events of the Indian Mutiny and influencing how they were viewed in Britain. If history, as Norman Bryson has argued, "is a fusion of event with writing"—not simply what has taken place, but what has been re-presented—then Paton's image participates in this formation of the past; it is a narrative picture that "writes" history, and, as such, is inextricable from the politics and ideologies entrenched in this textual activity.[6] *In Memoriam* is made for future generations, who, as the *Art Journal* suggests, can view the Indian Mutiny as history, but it is also precisely one of the mechanisms by which the mutiny is historicized. It is a painting in process, history in the making, and with history comes truth, or so the story goes.

Paton's striving for pictorial accuracy is embodied in the figure of the little child asleep in the foreground, modeled on a boy who had actually gone through the events in India with his mother. The painting's photographic realism and impressive detail work alongside the faithfulness of its reportage (the specific Highland regiment that it depicts featured prominently in the Indian Mutiny battles) and brings to life newspaper reports of the events.[7] Paton, painting his image far away from the atrocities of India in a studio in Dunfermline, found his inspiration in these texts, producing a narrative painting that is constituted by other narratives.

Most critics agree that the image represents a specific incident: the slaughter at Cawnpore, where some two hundred women and children were hacked to death and their dismembered bodies thrown into a well. Paton seems to have

had in mind an evocative description of the British troops' arrival in Cawnpore that was written by a soldier and originally appeared in the *Times* on September 30, 1857, although it was frequently cited and elaborated in contemporary accounts of the mutiny:

> I was directed to the house where all the poor miserable ladies had been murdered. It was alongside the Cawnpore hotel, where the Nena lived. I never was more horrified! The place was one mass of blood. I am not exaggerating when I tell you that the soles of my boots were more than covered with the blood of these poor wretched creatures. Portions of their dresses, collars, children's socks, and ladies' round hats lay about, saturated with their blood; and in the sword-cuts on the wooden pillars of the room long dark hair was carried by the edge of the weapon, and there hung their tresses—a most painful sight! I have often wished since that I had never been there, but sometimes wish that every soldier was taken there that he might witness the barbarities our poor countrywomen had suffered. Their bodies were afterwards dragged out and thrown down a well outside the building where their limbs were to be seen sticking out in a mass of gory confusion. Their blood cries for vengeance, and should it be granted us to have it, I only wish I may have the administration of it.
>
> I picked up a mutilated Prayer Book. It had lost the cover, but on the flyleaf is written, "For dearest Mama, from her affectionate Tom. June, 1845." It appears to me to have opened at page 36, in the Litany, where I have but little doubt those poor dear creatures sought and found consolation in that beautiful supplication. It is here sprinkled with blood. The book has lost some pages at the end and terminates with the 47th Psalm, in which David thanks the Almighty for his signal victories over his enemies, &c.[8]

In its original manifestation in the Royal Academy *In Memoriam* represented the moment before these murders were committed, and the outrage of its spectators suggests that they too were haunted by the memory of this and other newspaper accounts that so vividly described the conclusion of Paton's narrative. But the painting, even as it attempts to re-present the truth, also exposes the dangerous possibility that history is itself a narrative that is subject to writing and rewriting. The soldier who wrote the letter in the *Times* is, after all, constructing a story for these women, setting up the scene of their death in a way that derives from other stories of virtuous women and Christian martyrs. His "eyewitness" account is always dictated by such narrative conventions, and by the cry for vengeance. The author's assertion that the spilt blood of women

and children demands an equally violent response, a retribution that is given a Christian justification in the allusion to the forty-seventh psalm, recalls the false inscriptions reputedly made on the walls by the first soldiers who arrived at the house in which the victims were slaughtered. Apparently written by the women and begging for deliverance, these graphic marks create historical events, not only by presenting their own account as reality, but by fuelling the emotions of the soldiers who came after and regarded them as genuine.[9] The Indian Mutiny was in many ways a textual war, played out in conflicting reports of the incidents that were unfolding, a battle in which each side made its own truth claims and fought for a verification of its stories. Such was the extent of this myth making that in 1859 a book appeared that was devoted to the various fictions that had grown up around the events of 1857.[10]

If spectators did not recognize the fictionality of Paton's original image, they could not fail to be aware of the conflict between image and "reality" in the overpainted version, for, as everyone knew, at Cawnpore the troops had arrived a day too late to save the women and children from massacre. Or perhaps this was something that the viewers chose to forget. *In Memoriam* turns the Highland (read "British") soldiers into national heroes, effacing the Indian soldiers and the inadequacies of a campaign that was riddled with fatal mistakes. Paton's alteration of the picture's conclusion ultimately subverts its historical realism. It is this act that exposes the status of the image as a narrative painting rather than a true record of events.

Not all commentators were satisfied with this overpainting, however. The *Times* praised the picture in its original form, asserting, "Nothing in the exhibition shows truer feeling of the end and aim of art,"[11] while the French critic Ernest Chesneau criticized the introduction of the Highlanders:

> I think every one will agree with me when I say that, in obedience to dramatic feeling in its most rudimentary sense, the sight of these men ought to add to the excitement. "The sepoys!" is naturally the cry which should escape from every mouth. But such is not Sir Noel's idea; doubtless he was anxious to spare the nerves of his fair and tender-hearted spectators, and so instead of sepoys he has introduced the red coats of the Scottish soldiers. A pleasant but a decidedly commonplace conclusion; by which the work is both enfeebled and stunted; all the terror therein depicted is a mere delusion, and the drama terminates in the happy and paltry manner of a trashy three-volume novel.
>
> This is a gross mistake. What shall we say of the circumstance, that when this picture was first exhibited at the Royal Academy in 1858, the sepoys were represented in the place that they ought to oc-

cupy? So far from exculpating the artist, does not this rather serve to deepen his error? Sir Noel Paton reduces his noble tragedy to a melodrama by this unfortunate modification.

It would not require more than two days' work on the part of the artist to restore his picture to its former tragic greatness, by the alteration of the figures in the background, and we should strongly advise him to follow this course, if the opportunity presents itself, by his again becoming possessor of the painting. The whole interest of the appalling subject rests on this important centre.[12]

Chesneau's criticism stems in part from his own artistic background. Richard Redgrave might have argued that he demonstrated the typical French taste for bloody battle scenes. But his discussion does have implications for narrative painting as a whole, a genre that Chesneau identified as an essential component of the "English school." Paton's "gross mistake" is seen in the light of the image's storytelling: he has turned the painting from noble tragedy to melodrama, from classic realism to a trashy novel. The painting, whether it shows the mutineers or not, is barely a painting at all but a text: its errors, Chesneau contends, are in the tale it tells, not in its execution.

With the image as text, the viewers are positioned as readers, who have to unravel the painting's clues in order to piece together the story. The gaps in the painting, then, are filled by the spectator in a way that depends on a whole range of cultural references, a knowledge and understanding not just of pictorial stories but of social conventions. In this respect, the narrative painting always refers outside itself, even in the case of those images that do not draw so explicitly on actual events. A "right" reading of *In Memoriam* depends on this cultural awareness and, in particular, on a familiarity with contemporary reports of the atrocities that were being carried out in India. How else would the spectator be able to recognize the Highlanders as coming to the rescue of the women? Without a knowledge of what they signify, the entire narrative could be reversed: they could have acted out the "conclusion," the threatened violation of the women, and could now be closing the door on the scene of desolation (the appearance of the girl in white and the articles of clothing scattered on the floor would, in fact, support such an interpretation).

It is, therefore, the "reading" process itself that renders the narrative picture most political. It is hard to believe, for example, that, even in its original form, the women's fate is uncertain. The Indians are shown entering the door of the cell, but they might as well be pictured in the act of rape and slaughter. It seems common sense to view the mutineers as murderers, especially if the picture is interpreted as a truthful representation of the events at Cawnpore, but

this reading actually demands a leap in the story, a bridging of the gap between the Indian soldiers' entry and their following actions. The ease of jumping to such a conclusion, even today, suggests that Victorian racist assumptions, like the mutineers themselves, have not been so easily erased. Perhaps this is another example of the persuasive yet unreliable narrative of history, for according to many reports, the Indian soldiers actually refused to kill the women and children at Cawnpore, and the task was carried out instead by two Muslim butchers, a couple of Hindu peasants, and the lover of the female overseer of the house in which the women and children were imprisoned.

Like the conclusion of the story, its beginning also remains a matter of conjecture, although the spectators are encouraged to forge together the missing links. A typical description comes from Chesneau: "Invaded in the midst of their luxurious life, [the women and children] have fled from massacre, hunted from one street to another, until at last they have blindly thrown themselves into the shelter of these four crumbling walls."[13] But even the most successful narrative painting does not fit easily into the Aristotelian definition of a story as having a distinct beginning, middle, and end. The problem with narrative pictures is that they are pictures, not texts, and in order to create their stories, they have to present several aspects of the tale simultaneously, to overcome their own temporal limitations and point forward and backward in time. In some paintings this is achieved by symbols, letters, or pictures within the picture that refer either to what has gone before or to what might occur in the future. In another Indian Mutiny painting, Edward Hopley's *Alarm in India,* the occupants of a British officer's quarters in Lucknow nervously await the inevitable Indian attack, while the music on the piano, *The Campbells are Coming,* anticipates the relief of the city by Colin Campbell in November 1857.[14] *In Memoriam* does not rely on such symbolic devices but does represent the present and future together by juxtaposing the distressed group of women with the figures who can be seen through the window and in the doorway and who signify how the tale will end.

Louis Marin associates this simultaneous representation of episodes with pictures of historical events:

> The historical painting is a painting whose "tense" is present, whose time is the present moment when it is seen, and the only possible way of making the story understood by the viewer, or "read," is to distribute, all around his central represented moment, various circumstances that are logically connected to it by implication or presupposition. This is the reason why historical painting is considered the most difficult and also the most prestigious genre of painting, because in the present presence of the pictorial representation, it has to express di-

achrony, temporal relationships, yet can do so only through the net-
work of a whole that generates its parts logically or achronically by its
own signifying economy.[15]

The pictorial "signifying economy" that Marin identifies, however, is very dif-
ferent from that of a text, in which the reader moves down or turns over the
page. In narrative pictures, whether in the form of history paintings or genre
scenes, the "pages" are viewed together.

This has some striking implications for Paton's image. According to Ches-
neau, the alteration of the projected end of the story radically modifies its pres-
ent, the situation of the women and the spectator's response to them. The
introduction of the Highlanders makes the women's fear seem exaggerated, a
"mere delusion." The viewers can see that the women and children have no rea-
son to be afraid, and their reaction to the scene changes. The work as a whole
is affected by this transformation—it is "enfeebled and stunted" because of it,
a factor that exposes quite forcefully the interdependence of the compositional
elements of the narrative picture. As Chesneau remarks, the "interest of the ap-
palling subject rests on this important centre."

The narrative painting highlights, and with more direct impact than a text,
the interrelation between its various elements. *In Memoriam,* however, compli-
cates this interrelation because its elements are not necessarily what is visible on
the canvas. While the viewer is required to fill in the pictorial gaps and absences
in order to construct the story, the story itself is determined by what is missing:
that other conclusion to which it silently refers. The narrative of this painting and
the consequences of its reception alter forever the tale that it tells: once we know
about its reconstruction, the picture is never the same. Even Chesneau, con-
fronted by the appearance of the troop of Highland soldiers, refers to and inter-
prets the painting according to the original presence of the Indians. These two
contradictory endings coexist within the picture space and generate a plurality
that is both liberating and disconcerting, undermining any search for a definitive
meaning of the image, a "correct" version of events. *In Memoriam,* perhaps more
than any other mid-Victorian painting, warns the viewer that the canvas does not
tell the whole story, or, rather, it tells too many stories. Despite its irrevocable
metamorphosis, this image always contains the trace of that other ending. The In-
dian soldiers are present, even in their absence; they haunt the margins of the can-
vas, seeming almost to possess the kilted men, who open the wooden door and,
like their counterparts on the other side of the canvas, take in the scene before
them. The specters of the Indian mutineers and all that they represent are there,
in those blazing eyes and erect bayonets; no over-layering of color, no hasty alter-
ations, can ever wipe them away or eradicate the possibility of a climax too awful

to contemplate. The two versions of the story exist uncannily side by side, one visible, the other seemingly invisible, but engrained into the terrified faces of the three women in the foreground and the black servant, who, having heard the creaking of the door, or glimpsed the widening chink of light as it hits the hard stone steps, turns now, wide-eyed, to meet her fate.

II

The fate that does await these women, whether death or salvation, or both, will never, of course, come to pass, despite the seductive illusion of the picture's story-telling. Frozen in time, the child with the tangerine dress will always remain blissfully asleep, while the mother, Bible in hand, prays for eternity. There is a sense, then, in which the generic characteristics of the painting, its status *as* a painting, determine the inertia of the female figures, their position as static objects of the gaze, and this passivity extends to the narrative itself and the sexual politics it generates. Because the women's future is decided by men—the Indian mutineers, the Highland soldiers, or the whims of a male artist—the story goes on without them. They are an essential part of the narrative, but they do not determine how it proceeds. Their heroism, in fact, lies in this acceptance of what will happen to them, the silent acknowledgment that they are not in charge of their own destinies, but are powerless in relation to the men, who will either rescue or massacre them.[16]

The image not only tells the story of the Christian bravery of British women and children in the Indian Mutiny but also defines what the proper behavior of all Victorian women should be. This group of females, far away from the comforts of the middle-class home, epitomize the ideals of the angel in the house: they are pious, self-sacrificing, and passive. The figure in the center as she looks to heaven, and the woman who kisses the baby and holds tight a little girl on the right, are painted as Protestant Madonnas. In this construction of femininity *In Memoriam* directly addresses its contemporary female viewers, increasing the impact of this address by situating the spectators in the cellar itself, where they are invited to position themselves in relation to these pictured women, as subjects who suffer with them. Henry James would, no doubt, have been horrified at the empathy that this particular picture inspired in its viewers. According to Paton's granddaughter, "thousands identified with that pitiful group of women and children, huddled together in a cellar, waiting for death."[17] It was an empathy that, despite the *Art Journal*'s criticism, could be most effectively generated by its contemporary audience and is weakened by our historical distance. Not only would the pictured women have been familiar in terms of their fashionable dress, but they embodied those virtues to which

the middle-class female viewer was also encouraged to aspire. The women in *In Memoriam* were reflections of their counterparts outside the canvas and one of the cultural mechanisms that shaped their identities, providing an ideal picture of what they should be and how they should behave. As I suggested in the previous chapter, a suitable response to such a picture was proof of the viewer's own investment and participation in these ideals.

There is a sense, then, in which *In Memoriam* can be seen to work alongside other Victorian accounts of the massacre of women and children to endorse a stereotype of females who are defenseless and innocent. This is the conclusion reached by Pamela Gerrish Nunn, who argues that such representations of female victims of the Indian Mutiny reasserted the notion that women were reliant on men and temporarily "erased" the image of the "strong-minded," independent woman who was emerging in contemporary culture.[18] In this context *In Memoriam* served to reinforce the belief that women should not play a part in war but should be protected from its atrocities within the confines of the middle-class home. The events at Cawnpore, however horrible, were in a way fortunate in that they allowed this construct of womanhood to be asserted at the very time that it was threatened, with the calls for more legal and political rights for women and an expansion into the workplace that was the target of so much ridicule in *Punch*.[19]

But this idealized femininity was, by necessity, placed at a geographical distance. The divide between the angelic slaughtered memsahibs and the active female campaigners at home became apparent in one of *Punch's* large double cartoons that appeared following the outbreak of the mutiny. On the left page an army recruiting officer approaches a man serving behind a counter, while on the right, even before he has left his post, a marching band of women descend on the shop, waving a banner inscribed "Women for Women's Work."[20] War, it seems, despite assertions to the contrary, is never far from the question of female rights.

Perhaps, then, the gender politics of *In Memoriam* are more complex than Nunn's analysis suggests. After all, the females that it depicts play a prominent part in the painting, even standing as embodiments of the British nation. Moreover, although these women seem willing to allow themselves to be murdered, their inner strength at this time of crisis has some surprising feminist implications. In an article that appeared in *Fraser's Magazine* five years after the painting was first exhibited (the author seems to have in mind William Henry Simmons's popular engraving of the picture, which appeared that year), *In Memoriam* was read not in opposition to those "strong-minded women" who fight for female emancipation and flout an intelligence deemed inappropriate for women, but as a justification of them. The argument here is perhaps not as radical as one might hope. The writer is preoccupied with rebutting the pejorative meanings of the

label itself, arguing that "strong-minded" females do not have to be ugly old spinsters: they can be "feminine" as well as clever. This does not necessarily mean that they have to adhere to typical roles, though. On the contrary, they are encouraged to adopt a more active lifestyle and to cultivate their intellectual powers rather than superficial accomplishments. It is this intelligence and independence that the author sees embodied in the group of women in Paton's image:

> We saw but the other day a truly suggestive picture, by that well-known Scottish artist, Mr. Paton, representing a group of our countrywomen and their children awaiting a fearful doom in the shambles of Cawnpore. . . . It is a wonderful picture. The seal of suffering, physical and mental, protracted to the utmost verge of human endurance, is set on every countenance, however varying in feature and natural expression. Each tells its retrospective tale of agony, while it embodies that passive, yet inflexible courage, which is rather the offspring of religion than despair. There is no yielding in the mute, helpless defiance of the stony eye—not a quiver in the wasted features or the parched, discoloured lips. . . .
>
> These English women, prepared for death, and worse than death, had need of all the training of their English education and the vigour of their English natures to preserve their sanity under such appalling circumstances. There are cases of female heroism on record, arising from that awful crisis, unrivalled by the exploits of the stronger sex at any period of the world's history. What must have become of the few who survived those trials, had they not possessed that indomitable strength of mind which proceeds from habits of self-restraint and self-reliance, grafted on the principles of strong religious faith? They must have sunk from sheer mental incapacity under the ordeal, and the plumed bonnets, and the bonny tartans, and the kindly Scottish faces beneath the glancing bayonets, would have come too late![21]

This account is in many ways reactionary, a reworking of the stereotype of the "suffering," "passive," and "helpless" female in the context of a nationalist pride in England's religion and liberal education system. The women here embody those domestic ideals that the Redgraves associated with English narrative painting. But they are also bold and unyielding, demonstrating a "self-reliance" and "defiance" that renders them "strong-minded." They do not sink under the weight of their anguish but remain mentally, if not physically, alert, a strength that comes from their superior intellect as well as their religious faith.

It might not be enough to say that the females in *In Memoriam* embody a stereotypical Victorian frailty. Rather, they are the product of a complex set of power relations that are constitutive of the specific cultural moment in which they appeared. These women actually undermine the idea that there is ever a clearly defined or stable image of "femininity" or, indeed, that there is ever a clearly defined or stable interpretation of Paton's painting. Even if they *are* regarded as simply "passive" or "frail," this is not necessarily stereotypical. With calls for changes in women's legal status, suggestions of female sexual deviance in public discussions about adultery (Egg's *Past and Present* was displayed in the same Royal Academy exhibition as *In Memoriam;* see chapter 6), and the apparent frivolousness of women who wore the crinoline cage, Paton's apparently idealized females were starting to look more like the exception than the rule. There is certainly a contrast between this painting and other depictions of the Indian Mutiny. The writer in *Fraser's Magazine* alludes to female acts of bravery that surpassed the heroism of the "stronger sex," and stories of these acts, as well as being extremely popular in textual form, were often visually represented, like the enduring picture of the young and beautiful Ulrica Wheeler firing a gun at her tormentors, which was printed in Charles Ball's *History of the Indian Mutiny* (1858). Even the more sedate images that were displayed on the walls of the Royal Academy placed women, however outwardly angelic and maternal, in the center of the action rather than waiting for death. In Hopley's *Alarm in India* a young female, with a baby at her breast, grabs a revolver; in Abraham Solomon's *The Flight from Lucknow* a group of women are pictured escaping from the scene; and in *Jessie's Dream* by Frederick Goodall the heroine has broken away from a kneeling woman to climb above the barricades and point to the approaching soldiers (Plate 5).

In Memoriam is not typical in its representation of the women caught up in the Indian Mutiny but strikingly different. And the reasons for this difference lie in the painting's constant reference outside the canvas, the truth claims it makes, which allow the writer in defense of "strong-minded women" to slip so easily between describing Paton's females and their historical counterparts. To a certain extent, these painted heroines are not even the subject of the image but substitutes for those real females caught up in the Indian Mutiny, to whom the engraving of this picture is dedicated and whose stories were eagerly read by the British public. *In Memoriam* might appear, as Jane Robinson has suggested, as part of the "gaudy surfeit" of pictures that dealt with the Indian Mutiny, a painting that epitomizes the values of domesticity, but this in itself is highly political.[22] As a reminder of the atrocities of Cawnpore, which became the battle cry of the British soldiers, Paton's image participates in contemporary discussions about how the captured mutineers should be dealt with and stirs up the

cry for retribution.[23] The emotional appeal of the image, generated by its help-less victims and exacerbated in the empathetic response that James associates with English spectators, means that the defense of these women and the sanc-tity of their memory is in the hands not so much of the Highland soldiers as of the viewers themselves.

The vulnerability of the women, then, is not simply a reassertion of the Victorian gender divide, but a tool that intersects with the politics of racial dif-ference and justifies a violent revenge on the mutineers. Even in its altered state, with the Highlanders on the point of rescuing the women, the painting en-courages such a response, as the critic in *Fraser's Magazine* recognized: "It is a picture that makes a man hold his breath, and unconsciously clench his hands, feeling as he used when he read the papers during that awful summer, and was conscious how much of the tiger was still left in the human heart, while he pic-tured a Sepoy within reach of his quivering right hand."[24]

In Memoriam takes its place alongside other texts and images that used the events at Cawnpore as a way of morally legitimating revenge. When the full horror of the massacre of the women and children was unfolding, *Punch* pro-duced some of its most violent images, one of which showed a lion pouncing on a tiger who stands over the slaughtered body of a mother and baby. The al-legory was explained in the caption, "The British Lion's Vengeance on the Ben-gal Tiger."[25] The cartoon was duplicated the following week on a flag held by an army officer as he recruits a group of noble and willing farmhands. Although the new soldiers are essentially comic, following in the tradition of Falstaff's motley crew, there is a reminder of events to come as they ominously brandish their scythes and pickaxes.[26] Because of Cawnpore, *Punch* warned, "terrified India shall tell to all time / How Englishmen paid her for murder and lust."[27] And pay they did. When the British troops recaptured Cawnpore the Indian soldiers were apparently forced to lick up the blood that lay two inches deep in the house where the massacre had occurred, before being taken outside and hanged.

It was in the original bloody conclusion of Paton's narrative, however, that this cry for revenge was achieved most effectively. According to Ruskin, the hor-ror of the first version of the painting was justified because it was designed "at the time of the fit of miserable public weakness which had like to have checked the doing of judgement and justice on the Indian murderers."[28] His allusion is to the policy of Lord Canning, the governor-general and viceroy of India, who sought to maintain the distinction between those Indian soldiers who had ac-tually taken part in the uprising and bloodshed and those who had not. His mercy caused an outcry among the white population in India and the British public. The *Times* called him "Clemency Canning," and *Punch* pictured him

patting the head of a childlike Indian, whose sword is still dripping with blood. In all of these texts and images are the memories of, if not direct references to, the massacre of women and children at Cawnpore. When Canning wrote to the queen to voice his concerns about widespread British hostility toward the Indians, she responded by arguing that its cause lay in "the *horror produced* by the *unspeakable* atrocities perpetrated against the innocent women & children which really makes one's blood run cold."[29] By the time Paton exhibited his painting Cawnpore was more a symbol than a real event. It had come to seem obvious that any representation of this particular massacre should be read as a call for vengeance on the Indian mutineers, and it is in this context that the image was designed and interpreted.

In Memoriam demands that its viewers reject any appeals for clemency, and it is this ideological project that determines its representation of the women as passive and vulnerable. It also goes some way to explain their religious fervor. The English women not only are morally righteous but have God on their side, embodying an extreme religious faith that, according to the *Times,* assuaged the pain of the image.[30] Paton's picture, then, plays its own part in what was often viewed as a war between religions. The Indian Mutiny had begun with a religious dispute—the greasing of the cartridges for the new Enfield rifle with cow and pig fat, which was offensive to Hindus and Muslims—but, on a wider scale, the revolt was blamed on the growing concerns among higher-caste Indians that their culture and religion were being suppressed in favor of Western modes of education and the imposition of Christianity. While the Indian soldiers might have seen their task as an eradication of Christian values, the British responded by asserting their religious beliefs. *In Memoriam* is one of these responses. The interest in religious subjects seen in several of Paton's paintings is reworked in the form of this group of Christian martyrs, bathed in a divine light that emanates from the right-hand side of the image and floods down onto the upturned faces of the two central figures, one of whom clutches a Bible. Even the frame was inscribed with the words of the twenty-third psalm, "Yea though I walk through the Valley of the Shadow of Death, I will fear no evil."

By employing such devices *In Memoriam* itself becomes a Christian icon. A critic commented that the painting was "one of those sacred subjects before which we stand not to criticize, but to solemnly meditate. We feel it almost a profanation to hang this picture in a show-room; it should have a chapel to itself."[31] Perhaps, indeed, the most appropriate chapel to house such an image was the memorial church that was later built on the site of the massacre at Cawnpore and was commonly regarded as a fitting reminder not just of the barbarity of the Indians but of the civilized morality and victory of Christianity.

III

The political significance of *In Memoriam* accounts for the sexual appeal of the image, what Linda Nochlin calls its "fantasy potential."[32] The Pre-Raphaelite beauty on the left of the painting exudes sensuality, from the ripples of skin on her arched feet, the shift that falls seductively from her shoulder, to her long strained neck choked with a black ribbon. Her extraordinary pose and dress (she was disturbed, it seems, in her bed) encompass both a virginal purity and a sexual awakening. What is hinted at here and renders this painting titillating, in spite of the horror of its subject matter and the idealization of its women, is the specter of rape.

Jenny Sharpe suggests that allegations of the sexual abuse of English women were, in fact, at the forefront of accounts of the events of 1857. These accusations, rather than having any basis in fact, were strategic in that they placed emphasis on the position of women in the war and detracted from the slaughter of British men at the hands of the natives. They also put into play those ideologies that were so central to the mutiny: the English female, contends Sharpe, was a symbol of the moral validity of colonialism, and her violation was regarded as a threat to that morality, proving the Indians' savagery and justifying British retribution.[33] In Paton's image the Indian Mutiny is fought over the bodies of women. As J. W. M. Hichberger has contended, the painting uses the image of white women at the mercy of black men to stand in for the other abuses of power and control that occurred in the war.[34] But there is a sense, as Sharpe seems to suggest, in which this aspect of the image subsumes its other politics. The threat to colonial power relations is reinscribed as a threat to the family, a move that ties the politics of race to the politics of gender, but effaces the facts of a war in which black men dared to revolt against their white masters, as well as the class issues involved in this revolt. The emphasis on a group of women sexualizes and contains the mutiny by placing all the blame on the mutineers and diminishing the barbarity of the colonizers and the act of colonization itself.

A "correct" reading of *In Memoriam* depends on and reveals the painting's successful polarization of the heroes and villains, a distinction between white and black, good and evil, purity and sexual depravity, the Christian and the demonic. These binarisms are central to Edward Said's discussion of orientalism. Said argues that, although antitheses work to construct an absolute difference between East and West, they actually render them interdependent, with the West defined only in its opposition to the East and vice versa.[35] In its depiction of binaries, *In Memoriam* deals explicitly with the constitution of colonial and racial identities, but it is also concerned with how these identities intersect with

gender. The hierarchical relations that the image establishes revolve around an opposition between Indian man and English woman, the females appearing as angelic and pure because they are juxtaposed with a force that is represented as evil and corrupt. The painting is set alongside contemporary texts that labeled the Cawnpore soldiers as "hell-hounds"[36] under the control of the archvillain, the satanic Nana Sahib, who ordered the massacre of the women and children.[37] The reviews of *In Memoriam* reasserted such definitions, with the *Times* labeling the Indians in the picture as "murderers," "maddened Sepoys, hot after blood,"[38] and the *Athenaeum* describing them as "ogre-like."[39] The Indians are this image's other, the element that jeopardizes both the values that the painting represents and the picture space itself. In a curious way the Indian soldiers mimic the act of the painter, exposing and making present the extent of their crime, but also threatening to eradicate the women and children, to obliterate them as they themselves are to be obliterated, to hide them from view as they will be hidden. The death that the Indians forebode is itself a kind of overpainting, their poised bayonets standing as the mirror image of the artist's brush. In their simultaneous absence and presence, the Indian soldiers question the limits of pictoriality, momentarily disrupting the fixed distinction between what is visible and invisible, what is present on the canvas and excluded from it. Indeed, this disruption is part of the definition of their otherness: the Indians should be hidden, screened from view; the version of the picture in which they are represented should not be shown.

But if the Indians are presented, even when visible, in terms of their invisibility and unrepresentability, the Highland soldiers, complete with their distinctive bright red uniforms, are eminently seeable. The inclusion of these particular soldiers in the second version of the painting was a mixture of historical accuracy and nationalism for the Scottish Paton. The 78th Regiment, who are pictured here, complete with their Mackenzie tartan kilts, played an integral part in the siege at Lucknow and Cawnpore, for which they received several Victoria Crosses. The historical realism of this scene, however, does not exclude the potential for the more subversive meanings generated by the presence of a group of Highland soldiers in a painting that is all about colonization. In fact, it was issues of national identity and the relation between Scotland and England that were uppermost in Paton's mind during the years that he painted and exhibited *In Memoriam*. In 1856 he entered a competition with an allegorical design for a monument to William Wallace that showed the Lion of Scotland, broken from its chains, standing over the King of England and a Typhon. The allusion was to Wallace's defeat of the English at Stirling Bridge in 1297, a subject that was considered offensive by many of the competition organizers. After initially choosing Paton's entry, they changed their minds and opted instead for a Gothic tower.

Paton was not disillusioned by this rejection, however, and in 1859 published a plan for a memorial to Wallace and Robert the Bruce and the Scottish War of Independence. A runic cross, the symbol of martyrdom, was to be erected 110 feet high, inscribed with the words "Pro Libertas" and surmounted by a Scottish crown. The martyrdom theme was carried through to the pedestal, which showed a relief of Wallace crowned with thorns and mocked by the English at Westminster, as well as images of Bruce at Bannockburn. The steps on which the monument was to stand were to be adorned with statues of Wallace as guardian of Scotland and the Bruce as king. Unsurprisingly, the project, which had wide support in Edinburgh, was not so popular with patrons south of the border, and the overt nationalism of the piece even forced Paton to affirm his oath to the queen and the Act of Union.[40] Paton's persistence in representing Scottish history and the country's fraught relation with England is the backdrop to his representation of the soldiers in *In Memoriam*. These Highlanders are depicted as symbols of Britishness, "Saviours of India," but their own history of colonization is never far away in a painting that deals with the threatened collapse of empire. As the Highland troops pass by the window of the cellar and break open its door, their powerful figures and weapons of destruction are a reminder of what might happen if this fight for England ever became a fight against it.

In Memoriam attempts to construct a positive and distinct identity for Highlanders at the very time when their identity was disappearing. The last round of Highland clearances, which saw tenants of small holdings evicted from their homes to make way for more profitable sheep farms, occurred in the late 1850s. This displacement became a popular subject in art, with images like Thomas Faed's *The Last of the Clan* (1865) showing a careworn Highlander and family heading off for foreign shores. Some blamed the clearances on colonial aggression—the imposition of modern "English" agrarian methods and the mercenary values of the Anglo-Scottish, and often absentee, landlords. Even if this accusation was unfounded, the consequences of the clearances were similar to those of colonization, virtually eradicating independent clan identities.

It is significant, then, that Paton's Highland soldiers, while wearing the kilt as an outward token of their difference, are assimilated as part of the nation. They are not just Highlanders but primarily soldiers who fight for the cause of empire. The painting suggests not only a physical appropriation but an ideological one too: by quashing the Indian revolt, the colonized Highlanders become the colonizers, adopting the very values that have led to their subordination.[41] Indeed, it might be no coincidence that the Highlanders were frequently represented as leading the cry for vengeance on the Indian soldiers. In February 1858, while Paton was working on *In Memoriam*, the *Dublin University Magazine* pub-

lished "The Highlanders by the Well at Cawnpore," a poem describing the horrific scene that could well have confronted the Scottish soldiers in Paton's image had they, like their historical counterparts, arrived a day too late:

> *Mother and child were lying*
> *Locked in a last embrace,*
> *And death had printed the frenzied look*
> *On the maiden's ghastly face.*
> *And one of the slaughtered victims*
> *They raised with a reverent care,*
> *And shred from her fair and girlish head*
> *The tresses of tangled hair.*
>
> *They parted the locks between them,*
> *And with low, quick breathing sware,*
> *That a life of the cruel foe should fall*
> *For every slender hair.*
> *"Leave to the coward, wailing,*
> *Let woman weep woman's fate,*
> *Our swords shall weep red tears of blood*
> *For the hearts made desolate.*[42]

 In Memoriam holds a significant place among those pictures and texts that used the mutiny as a vehicle for making patriotic heroes of the Highlanders, reconstituting their identity in the light of nation and empire and erasing the memories of their own colonization. However ironic this representation might have been in the case of Paton's painting, it served as an intertext for other representations that emphasized the bravery of the Scottish soldiers. Tennyson's "The Defence of Lucknow," written over twenty years after the outbreak of the mutiny (the events now clearly and respectably located in the past), followed up the suggestion of a clergyman who had written to the poet in 1858, asking for an "'In Memoriam' for the dead in India" to include some scenes from Cawnpore and Lucknow.[43] The request, of course, alludes to Tennyson's poem *In Memoriam,* but it also refers, whether consciously or not, to the painting that had caused such a stir in the Royal Academy just a few months before. Indeed, "The Defence of Lucknow" presents a hauntingly similar picture of innocent women and children, caught up in the atrocities of war, and the heroism of the Highlanders who save them:

> *All on a sudden the garrison utter a jubilant shout,*
> *Havelock's glorious Highlanders answer with conquering cheers,*

Sick from the hospital echo them, women and children come out,
Blessing the wholesome white faces of Havelock's good fusileers,
Kissing the war-hardened hand of the Highlander wet with their tears!
Dance to the pibroch!—saved! we are saved!—is it you? is it you?
Saved by the valour of Havelock, saved by the blessing of Heaven!
"Hold it for fifteen days!" we have held it for eighty-seven!
And ever aloft on the palace roof the old banner of England blew.[44]

It is the Highlanders who are the conquering heroes of Tennyson's poem and secure the victory, but the victory is, of course, an "English" one, signified by the flag that flies from the palace rooftop. Here, in the assimilation of the countries of Britain as "English," in a national difference that is eradicated even as it is voiced, the contradictions that also beset Paton's image are replayed. Both Tennyson and Paton reveal, in the most patriotic terms, the fragility and fragmentation of empire and the power relations that determine it.

In Memoriam is, ultimately, a narrative about these shifting imperial power relations, effective and ineffective colonization. At one extreme is the "unrepresentable" face of empire, the Indian mutineer, and at the other are the Highlanders and even the marginalized figure of the Indian nursemaid, whose fair skin and protection of the white baby mark out her own colonial appropriation, in spite of those details—the costume, earrings, and bracelets—that signify her ethnic difference. She is almost a mirror image of the girl who prays on her mother's knee, and it is possible that Paton used the same model for both figures. They have identical features and expressions, from their dimpled chins and half-opened mouths to their agonized wide eyes. The maid's defense of her charges suggests that, even in the face of colonial insurrection, the memsahibs still hold sway. Or perhaps it is the English women, who cling so tightly to their children and Bibles, their high moral values and chaste sexuality, who are the most colonized of all.

While Paton's painting exposes the effects and workings of colonization, it also reveals the instability of the relations that it puts into play. It would have been inconceivable in the previous century to envision the Highlanders, disarmed, disaffected, and kiltless as a result of the Jacobite rebellion, as upholders of British values. While national identity is precarious and constantly shifting, so are the boundaries of empire. Indeed, it is in this very movement of inclusion and exclusion that nations are created. Bhabha makes a similar point:

> The "locality" of national culture is neither unified nor unitary in relation to itself, nor must it be seen simply as "other" in relation to what is outside or beyond it. The boundary is Janus-faced and the problem of outside/inside must always itself be a process of hybridity, incorpo-

rating new "people" in relation to the body politic, generating other sites of meaning and, inevitably, in the political process, producing un-manned sites of political antagonism and unpredictable forces for po-litical representation.[45]

The distinction between the inside and outside, as Bhabha points out, is radi-cally unstable: even the "inside" contains the trace of what seems to lie outside it. In the mid-nineteenth century not only was what "Britain" signified con-stantly redefined, but "Britain" could not always be relied on to embody "British" values. In November 1857 the *Times* reported that support for the Indian sol-diers and a denunciation of the handling of the insurrection was springing up in sections of the Irish community. This rebellion was certainly not a revolt on the scale of the Indian Mutiny, but it does represent a direct attack on the very values and ideologies that define Britishness, raising questions about the effec-tiveness of the colonial process, and not just in relation to India. For the most serious threat to empire and nation, perhaps the English should have looked a little closer to home.

6

TELLING TALES

Adultery and Maternity in Past and Present

I

Visitors to the Royal Academy exhibition of 1858 might have turned away in horror from the weapons brandished by Paton's Indian soldiers, only to be confronted by another sharp, threatening object that spears the bottom left corner of the middle-class drawing room in the central scene of *Past and Present,* Augustus Egg's triptych of an adulteress's discovery and punishment (plates 6, 7, and 8). But this is not a bayonet about to be thrust into a depicted victim. It is an umbrella, propped up on a portmanteau, that points menacingly to the draperies that sweep down the side of the painting like theatrical curtains and suggest the image's artifice, a boundary between the pictured world and something "offstage."

To whom does this umbrella belong? Why is it there? It baffles and beguiles with its presence, inciting the spectator to read and interpret it, tell its story, locate its truth. Is it another of the symbols that proliferate throughout this picture and fix the woman's guilt, like the rotten apple and the collapsing house of cards? Perhaps it indicates the "storm" that the adulterous wife will now face, the harsh realities of an existence outside the comfort and security of the home, compared to which the umbrella can provide only a partial and superficial shelter. Maybe the umbrella is a device that adds to the painting's verisimilitude. It might belong to the husband, who, returning from a day in the city to discover his wife's infidelity, has left it where it fell, managing only, in his anguish, to stagger to the nearest chair. Equally, the umbrella could be part of the luggage packed by the unfaithful wife in a desperate attempt to elope with her lover before her husband arrives home.[1] Or is this object all that is depicted of the invisible spectators, who watch this story unfolding but, like vampires, are never reflected in the large mirror that hangs opposite? Perhaps the umbrella is none

or all of these. Perhaps it is the one forgotten by Nietzsche and remembered by Jacques Derrida in *Spurs,* for this umbrella is also bound up in storytelling, the deconstruction of outside and inside, and the definition of woman.[2]

Just five words found among Nietzsche's unpublished manuscripts form the basis of one of Derrida's most brilliant and tantalizing discussions. "'I have forgotten my umbrella,'" a statement that seems to announce its meaning precisely and absolutely, becomes a fascinating enigma in Derrida's text. Like the umbrella in *Past and Present,* it elicits readings, and this is suggested in its enclosure in quotation marks that indicate and isolate its signifying status. Nietzsche's umbrella is doubly forgotten because it is also overlooked by editors of his work, who regard it as too trivial and explicit: "Everyone knows," Derrida teases, "what 'I have forgotten my umbrella' means": it presents no problem; it is transparent.[3] But it is this very transparency that evokes the desire to interpret and suggests that the text is far from closed. Derrida seduces and frustrates with these possibilities. Perhaps the fragment is a citation, something that Nietzsche overheard or intended to place elsewhere; perhaps the editors, or even Derrida himself, know what this text means but are refusing to disclose; or perhaps it can be elucidated by the explanations psychoanalysis offers of phallic objects and forgetting. Of course, there is always the prospect, as Derrida concedes at the finale of this rhetorical flourish, that the note will remain inaccessible, that one will never know what it means, or whether it contains a meaning at all.

Past and Present emulates the function of this umbrella, encouraging the spectators to uncover the painting's secrets. Certainly, its symbols and clues situate the painting in a literary context, and it draws on novelistic constructions of the unfaithful wife. The tripartite structure establishes the picture as a narrative, with separate yet interlinked compartments that suggest a pictorial version of the popular three-volume novel.[4] It is no wonder that Victorian reviews and recent criticism of the painting share a tendency to relate its story, making it one of the most enduring and frequently discussed images of the mid-nineteenth century. John Ruskin provided his own version of *Past and Present* in a letter that he intended as a corrective to the "French Romance" that the addressee had constructed around the painting: "The picture does not pretend to represent a pretty story—but a piece of very commonplace vice—an ordinary husband—employed at some house in the city—an ordinary wife—who can't read French well enough to understand the least bit of de Balzac's subtlety or Sand's nobleness but who reads Bulwer, or James, and Harrison Ainsworth; who has been seduced by a sham count, with a moustache—and who has mixed his lost letter with the unexpected Christmas bills."[5] Ruskin's account of the story of *Past and Present,* a response to another story, is all about stories. There is an infinite regression of fictionality as the wife becomes one of the adulteresses in the novels that she

reads: a silly, puerile woman, who is seduced by a counterfeit count. Her crime is seen not in terms of her infidelity so much as in terms of her inability to read correctly, or of her partiality for the wrong sort of texts, a fault that, presumably, is to be contrasted with Ruskin's right reading of Balzac and Sand, and his authoritative interpretation of the triptych itself.

But the endeavors of those such as Ruskin to read and fix *Past and Present* are ultimately frustrated: like Nietzsche's umbrella, the picture refuses, even as it calls for, closure. The plural and unstable meanings of its story were a cause for concern to those who viewed it. William Holman Hunt remarked that, unlike Egg, "Hogarth left no gap in his histories,"[6] and the *Times* commented that the painting "is not easy to read" and suggested that this might explain why so many viewers gathered in front of it.[7] Whereas Hunt and the reviewer in the *Times* were swayed by the painting's merits, however, the critic in the *Illustrated London News* saw its ambiguity as objectionable: "[W]ill everybody understand it without previous explanation?" he asked with some frustration.[8] And the answer to his question might well have been "no." As the *Athenaeum* pointed out, the husband could easily be misconstrued as a drunken gamester who has read the news of his loss and beaten his wife to the floor.[9]

Far from a weakness in Egg's pictorial story, this opacity is actually integral to its meanings. *Past and Present* raises questions about how images can be "read" and explores the possible modes of interpretation open to the viewer. This is intensified in the fact that the picture originally had no title but was accompanied instead by a fictional diary entry in the Royal Academy catalogue.[10] The lack of a label, which conventionally functions to construct and delimit the meanings of narrative paintings, adds to the openness of this image, thwarting any simple interpretation. There is some compensation, however, in the abundance of other storytelling devices: the text in the catalogue, the heavy-handed use of symbolism, and the tripartite structure, all of which allow Meisel to view this image as "a compendium of devices for rendering narrative in picture."[11] In both its refusal to be fixed and its focus on how stories are produced in paint, *Past and Present* is self-referential: it reveals what a narrative painting is and how it signifies, but it also suggests the limitations of the genre, the points at which it differs from the textual.

These generic differences, moreover, are not divorced from the painting's subject matter. Rather, they are bound up in the figure of the adulteress, whose fall onto the drawing room floor mirrors the umbrella's diagonal thrust across the canvas. The picture's exploration of signifying practices focuses on this woman and reveals anxieties about contemporary notions of female sexuality. The adulteress is represented here as corrupt and deviant, an unfit wife and mother who is justifiably punished. The final two images, however, elicit an uneasy sympathy

for her, one that is all the more problematic because, far from rejecting her maternal role, she is intimately connected with it, defined in terms of the ideal wife and mother, the angel in the house. In the figure of Egg's adulteress, two opposing ideologies compete and collide: one that sees this woman as an instigator of domestic ruin, and another that situates her as a symbol of domestic order. This duality is paralleled in the conflicting spectatorial responses that the triptych invites: at once condemnation and pity. The empathetic gaze that James identified as a defining characteristic of English narrative paintings is not necessarily an easy or unproblematic one. In *Past and Present* there is no simple way of choosing between these conflicting meanings: they exist together in the three canvases that make up the image and generate a narrative that is always undecidable. The painting does not tell a truth, it does not enlighten, and the amputated umbrella is the reminder of this. Whatever it might promise, *Past and Present* never puts anyone completely in the picture.

II

The children in the "discovery" scene in *Past and Present* play under the shadow of two paintings that invoke and fix the sinful wife: a miniature portrait and a depiction of the expulsion from Eden. Even as the portrait announces the woman's individuality, she is effaced by the more substantial picture of Eve that hangs above and prefigures her own expulsion from the paradisal bourgeois home. This typological containment is reproduced in the image of the errant wife herself, who lies prostrate and faceless on the floor, an apple at her feet and a golden bracelet, which Lynda Nead compares to a "twining serpent," clasping her wrist.[12] The emblematic status of the adulteress is reiterated in the diary entry that forms the catalogue description of the painting: "August the 4th. Have just heard that B— has been dead more than a fortnight, so his poor children have now lost both parents. I hear *she* was seen on Friday last near the Strand, evidently without a place to lay her head. What a fall hers has been!" The anonymity of the woman, who is labeled only as "her" and "she," and the allusion to her "fall" suggest that the adulteress is a universal figure of female frailty. She is destructive and corrupt, with the implication that she is directly responsible not only for the tragic fate of her children but for her husband's untimely death, which is anticipated in the print that hangs above his miniature: *The Abandoned* by Clarkson Stanfield, a painting of a broken ship tossed about on rough seas, which had been exhibited in the Royal Academy a couple of years before.

This association of the sinful wife with the Fall was a common motif in mid-nineteenth century novels. The adulterous Margaret Sherwin in Wilkie

Collins's *Basil* (1852) is labeled a "serpent" and "fiend-soul";[13] and in Thackeray's *The Newcomes* (1853–55) Edenic imagery is used with bitter irony when a lawyer effectively justifies his client's suit for criminal conversation by describing a picture of corrupted marital bliss that is strikingly similar to Egg's painting:[14] "with what pathos he depicted the conjugal paradise, the innocent children prattling round their happy parents, the serpent, the destroyer, entering into that Belgravian Eden; the wretched and deserted husband alone by his desecrated hearth."[15]

Victorian texts like Thackeray's, which emphasize the sexual frailty of the adulteress, have prompted recent critics to conflate her with that other fallen and deviant woman so popular in contemporary representations: the prostitute.[16] Nead has provided a compelling reading of the way in which Egg's adulteress is transformed in the picture's final stages into an image of the working-class prostitute.[17] Certainly, the public exposure of these two figures was analogous, with the Matrimonial Causes Act of 1857, which dealt directly with the problem of female adultery by altering the procedures and causes for divorce, coinciding with debates on the Great Social Evil. Such an amalgamation, however, is perhaps too simplistic. It relies solely on the fact that both figures are sexually "fallen" and ignores the fundamental disparities between these falls. The peculiarity of the adulteress's act and her conventional middle-class status render her a signifier of difference. Unlike the prostitute, who was firmly located outside the home and associated with the city and the working classes, the unfaithful wife threatened the bourgeois order because she polluted from within its hallowed ground. While the adulteress threatens marriage and the nation at large, it is precisely through marriage that the prostitute can be redeemed and familyarized. The attempts of several philanthropists, including Dickens, to marry off prostitutes and send them to populate the colonies took place alongside parliamentary endeavors to prevent adulteresses from remarrying and even imprison them. Although, as Nead points out, the woman in Egg's painting seems on the verge of drowning herself, a conventional (literary) fate that was associated with the prostitute,[18] there is also the implication that she has been chastised in ways more specific to her crime: the woman accused of adultery was removed from the middle-class home and ostracized from society, and the law prevented her from owning property and obtaining alimony. The possibility of easier divorce and remarriage offered by the Matrimonial Causes Act meant that, when the wife failed in her duties, a more suitable candidate could take her place. The adulteress forfeited her maternal role too. The Infant Custody Act of 1839 refused a wife who had been found guilty of adultery custody of or access to her children and the effects of this are suggested in the catalogue description of Egg's triptych, in which the adulterous mother has renounced any rights to the

daughters, who now belong entirely to her husband: they are "his" not "theirs." When the father dies, the children are orphans: they have "lost both parents."

Although *Past and Present* teases the viewer by constructing the wife as a prostitute and a type of Eve, she does retain her difference as an adulteress. This is reinforced in the two symbols that define her in the central scene: the house of cards and the Balzac novel on which it stands. At the same time that France was being blamed for the crinoline craze, it was also held responsible for the glut of morally dubious literature making its way into Britain. In the mid-nineteenth century the French novel was a familiar trapping of the unfaithful wife. Lady Clara's avid reading of these texts anticipate her elopement in *The Newcomes*, while in George Eliot's *Felix Holt* (1866), the adulterous past of Mrs. Transome is indicated in her penchant for French fiction, which she knows to be wicked but finds most enjoyable nevertheless. It comes as no surprise, then, that the Balzac novel in Egg's triptych provides an unstable base for the house of cards, which collapses along with the sinful wife: like the adulteress herself, the foreign novel threatens society with a licentiousness that is destructive. Hippolyte Taine, the French commentator on English life, describes how Balzac was vilified by the English: "A book like Balzac's *Physiologie du mariage* would shock the public enormously," he asserted; "and *The Society for the repression of vice* would perhaps take action against it; but probably it would not have found a publisher. As for our ordinary novels, a liberal periodical, *The National Review*, cannot find words strong enough in which to condemn them. 'Ignominy without name, the morals of petty speculators and women of the streets.'"[19]

The problem with French novels is that they express a sympathy for the unfaithful wife, a failure to condemn her, that is at odds with dominant English ideologies and seems a world away from what recent critics have identified as the moralistic world of Egg's painting. Nina Auerbach, for example, sees an "irreversible sin and doom" in the triptych that troubles contemporary feminists and Victorian liberalists,[20] while Helene E. Roberts argues that the adulteress is constructed as a monster who is allowed no sympathy.[21] The picture, then, seems to uphold patriarchal constructions of the unfaithful wife as sinful and corrupt. Certainly, it was this view that was prevalent during the years in which Egg painted and exhibited the triptych, especially in relation to the adulteress's potential motherhood. Not only was she legally forbidden a maternal role, but her maternity was seen as dangerous and subversive, engendering offspring labeled by medical and political discourses as "sick" and depraved, unfit to take part in middle-class life. Contemporary science suggested that the sin of infidelity was passed to the fetus like a congenital disease,[22] and Tennyson's King Arthur expresses sentiments common to many Victorians when he acknowledges that it

was for the public good that Guinevere never produced the children who would inherit their mother's sin and instigate war, ruin, and "the breaking up of laws."[23] Unfortunately, this warning comes too late in *Past and Present,* and a gloomy prediction of the children's fate is provided by Holman Hunt: "Upon them too, the sin shall be visited . . . for all their years to come."[24] Tainted with the adulteress's crime, the daughters will be unable to marry well and therefore unable to perpetuate bourgeois values or beget the capitalist managers of the future.

For these reasons it was often regarded as beneficial to completely remove the sinful wife and her daughters from the cycle of reproduction. Medical discourses "sterilized" them by linking barrenness with immorality and the fashionable lifestyle that characterized the adulteress. Wendy Mitchinson discusses examples of this in Victorian Canada, in which one doctor proclaimed that "there is no such thing as a natural barrenness in *natural* women."[25] Closer to home, an eighteenth-century medical book, which reached the height of its popularity in nineteenth-century reprints, asserted that only languid and affluent wives were childless.[26] Sterility was a disease that affected the "pampered, the luxurious, the indolent, the fashionable wife."[27]

These often shocking accounts of the adulteress's deviant maternity might owe something to the threat that she posed to the system of primogeniture. The main justification for the double standard of the Matrimonial Causes Act (which enabled a wife to be divorced for adultery alone, whereas a husband's infidelity had to be accompanied by another offence such as bigamy, cruelty, incest, or desertion) was that a woman threatened property in her possible bearing of illegitimate heirs. This fear was voiced by Chancellor Cranworth, whose emotive speech did much to influence the final content of the bill. He argued:

> A wife might, without any loss of caste, and possibly with reference to
> the interests of her children, or even of her husband, condone an act
> of adultery on the part of the husband; but a husband could not con-
> done a similar act on the part of a wife. No one would venture to sug-
> gest that a husband could possibly do so, and for this, among other
> reasons . . . that the adultery of the wife might be the means of palm-
> ing spurious offspring upon the husband, while the adultery of the
> husband could have no such effect with regard to the wife.[28]

The unfaithful wife embodies the dangerous consequences of a maternity that is transgressive, outside the control and jurisdiction of the family. She adheres to the role of "reproducer" but uses this capacity to subvert its most fundamental function: the protection of property. Because of this threat, she is strictly demarcated from the ideal wife and mother, who is also invoked here: the woman who actually promotes the welfare of her children by ignoring her husband's misdemeanors.

The immorality of the adulteress suggested in Cranworth's speech is intensified in *Past and Present,* in which it threatens to infect not only her daughters but the viewers too. The *Athenaeum* criticized the painting as highly unsuitable for public exhibition, "an impure thing that seems out of place in a gallery of laughing brightness, where young, unstained, unpainted and happy faces come to chat and trifle."[29] *Past and Present* was not the right sort of picture, and a public gallery was not the proper location for it. Presumably, it was this "impurity" that deterred possible buyers, leaving the triptych unsold in the artist's studio until after his death. Perhaps Egg should have followed the example of the duke in Robert Browning's "My Last Duchess" (1842), who contains the polluting power of a dead wife he suspects of committing adultery by concealing her image behind a curtain that only he has the authority to open. Indeed, Leonore Davidoff and Catherine Hall use the image of a hidden picture, seen by a single man, to describe the constraints of Victorian marriage, the institution in which "the beautiful object potentially open to all men's gaze became the possession of one man when kept within the house like a picture fixed to the wall."[30] The ideal wife is and is not a picture. Unlike the adulteress in the triptych, she is not on display but contained within the house, as Browning's duchess is contained behind the curtain.

The status of *Past and Present* as art rather than literature and the spectatorial relations that it puts into play are, therefore, fundamental to the meanings of the painting. On the one hand, this narrative of adultery precipitates a union between text and image; not only is the picture a text but texts are pictured: there is the letter that the cuckolded husband holds, the Balzac novel, the plays advertised on the posters that line the archway in the final scene, and the quote in the Royal Academy catalogue. On the other hand, *Past and Present* exposes the very difference between word and image, the gap that renders each medium irreducible to the other. This problematic relation is suggested in the tripartite structure itself, which furthers the narrative but refuses the linear progression from left to right that characterizes a text. The painting was originally displayed with the discovery scene in the center, the woman under the arches on the left, and the daughters on the right. The result, as Meisel argues, is not a conventional serial order but one that requires the viewer to look back and forth between the images.[31] Indeed, the generic difference of the painting works to (re)produce the adulteress's sin: she is now publicly exhibited, or, in Davidoff and Hall's words, "open to all men's gazes." No longer enclosed by the four walls of the home, she is subject to multiple interpretations in the three walls and three scenes of the picture. It is significant, too, that this shift occurred at precisely the moment when the unfaithful wife was being analyzed in other contemporary discourses, including the legal and parliamentary. It was this exposure to the "outside" that

became the defining aspect of her crime: the adulteress was accused of corrupt-
ing the private haven of the bourgeois home with the immorality of the public
world, while her punishment rectified this crime, expelling her from this inner
sanctum to live the squalid and impoverished existence depicted in the last scene
of *Past and Present*.

The transition from private to public that the adulteress enacts is corrected
by Davidoff and Hall's Victorian husband and Browning's duke. In their hands,
the picture loses its threat and even its formal characteristics. It becomes more
like a book, screened by its cover from external influences. A book gives the il-
lusion of privacy and security because it is sealed from multiple gazes and can be
penetrated by a single person. The open book is not, therefore, necessarily
"open": it produces a triangle, with the reader at its base, that invokes, yet re-
nounces, the adulterous love triangle. To a certain extent, then, the shift between
book and picture that is generated in the representation of the adulteress in Egg's
triptych is also a shift between monogamy and adultery. The Balzac novel and
its popular counterparts are all, paradoxically, "monogamous" texts that suggest
a one-to-one relationship, even if it is "perverse," between text and reader.

While the status of the painting as art constructs the errant wife as stereo-
typically immoral, however, there are ways in which the triptych also undermines
this construction because, although she is exposed to multiple "penetrations," the
adulteress relinquishes her desire, the avid sexuality that defines her and that
one Victorian doctor saw as bordering on nymphomania.[32] Her lover is notice-
ably absent from all three paintings, allowing her only real longing to be di-
rected toward her children. In *Past and Present* the needs that conventionally
define the adulteress can again be located outside the frame: her desire is the de-
sire of the viewer. It is a desire, moreover, that is always unrequited because the
picture can never be reduced to a single and complete interpretation.

This unsatisfied scopic desire is discussed by Jacques Lacan, who argues
that desire is always the effect of a lack because it emerges in the subject's entry
into the symbolic order, the system of language and law, in which needs are
transformed into demands that can be fulfilled but leave out an element that
cannot be fully articulated and that reappears as (unconscious) desire.[33] The in-
vocation of desire in art remains problematic and elusive in Lacan's discussion.
On the one hand, pictures "elevate," "tame," and civilize,"[34] providing an imagi-
nary satisfaction, something for the eye to "feast upon": "How could this *show-
ing* satisfy something, if there is not some appetite of the eye on the part of the
person looking? This appetite of the eye that must be fed produces the hypnotic
value of painting."[35] But any interpretation of *Past and Present* leaves the viewer
only hungry for more. The triptych incites a desire that, like the unfaithful
wife's, is transgressive because it encourages the spectator to "read" across the

boundaries between the painting's inside and outside, bringing other cultural discourses to bear on the interpretation of the image. Perhaps it is this address to a desiring viewer that lies at the heart of the anxiety betrayed in the review in the *Athenaeum,* for, despite their unblemished and fresh faces, the spectators of *Past and Present* are never completely innocent.

III

In 1850 George Henry Lewes offered a typical account of woman's mission: "The grand function of woman, it must always be recollected, is, and ever must be, *Maternity:* and this we regard not only as her distinctive characteristic, and most endearing charm, but as a high and holy office."[36] Two years later, similar views were expressed by Basil in Collins's novel: "Among women, there always seems something left incomplete . . . which love alone can develop, and which maternity perfects still further."[37] Woman, then, is defined through motherhood: it is the "distinctive characteristic" without which she is lacking. The naturalness of the construction of the mother is enforced in these examples because they function as the "codes of reference" described by Roland Barthes:[38] Basil announces his judgment as if it is temporally and culturally transcendent ("there *always* seems something left incomplete"), and Lewes coerces the readers in a shared body of knowledge ("The grand function of woman, it must always be recollected, is . . . *Maternity:* and this *we* regard"). By assuming a collective knowledge, the texts set themselves up as familiar and authoritative. They construct the maternal woman as a truth, disguising the fact that she is produced by the very codes and conventions of which these examples form a part.

For Lewes, motherhood is not simply a "function," but a "holy office." Such divine imagery was common in the mid-Victorian construction of woman. Ironically, however, it was not just the perfect wife and mother who was defined in these terms, but the fallen woman too. The mid-nineteenth century abounds in representations of motherly whores, from Dickens's Nancy, and Mercy Merrick in Collins's *The New Magdalen* (1873), to the image of a fallen Madonna in Ford Madox Brown's unfinished painting *Take Your Son, Sir!* Eric Trudgill discusses this phenomenon, arguing that the "phoney" Madonna of the fast novel, who is sexually voluptuous and immoral, tainted the true ideal and led to that ideal's decline. According to Trudgill, the romantic image of the maternal prostitute was a form of containment, a Victorian idealist's need to believe that all women were fundamentally pure.[39]

This idealization seems to have influenced representations of the adulteress, who is similarly defined in terms of her maternity. In Hawthorne's *The Scarlet*

Letter (1850) the adulterous heroine, Hester Prynne, is frequently identified as a Madonna, despite her often ambivalent feelings toward her daughter. Similarly, Clara's infidelity in *The Newcomes* is an educative and enlightening experience that makes her a better mother and allows her to occupy more fully the role of a "proper" woman. She is timid and sexually passive throughout the novel but, prior to her adultery, not even her children evoke her interest or are able to rouse her from her languid state. After she has eloped, however, there is a dramatic transformation: "a child comes to her: how she clings to it! how her whole being, and hope, and passion centres itself on this feeble infant!"[40] The metamorphosis of Clara into an image of divine maternity reaches its climax with a scathing attack on a legal system that has separated her from her children ("If Barnes Newcome's children meet yonder solitary lady, do they know her?"), and a marriage market that has allowed this "virgin" to be sacrificed.[41] In Mrs. Henry Wood's *East Lynne* (1861) the adulterous Isabel Vane embodies an extreme maternity that some critics have seen as excessive.[42] I am not convinced, however, that it is presented in this way. Her motherhood is disturbing, not because it is threatening, but because it highlights the faults of a patriarchal society that inflicts a punishment that she so clearly does not deserve. Her cuckolded husband mistakes her for an angel on her first appearance in the book, and this celestial imagery increases after her elopement, when her self-sacrificing nature renders her a supreme example of Christian duty. As with Clara Newcome, Isabel's infidelity heightens her maternal impulses. Following the lead of adulteresses such as Anna Karenina and Lady Feverel in George Meredith's *The Ordeal of Richard Feverel* (1859), Wood's heroine cannot bear the enforced separation from her children and returns, albeit in disguise, to her former home. Indeed, such stories are not confined to the fiction of the period. The famous society figure Caroline Norton, accused of adultery by her husband, was physically thrown out of his home when she attempted to visit her children.[43] In her many pamphlets, which argued against the separation of mother and child, Norton frequently described herself in ways that were reminiscent of the maternal adulteress found in contemporary novels: she was the suffering and saintly mother whose only desire and passion were for her children.

There is a sense, as Trudgill suggests, in which the maternal characteristics of the fallen woman seem to enforce the stereotype of the pure and chaste female who was the Victorian ideal. But the representation of the errant wife in these terms is highly problematic. Unlike the prostitute, who adopts maternal significations with comparative ease, such meanings fit uncomfortably on a figure whose very act was seen as a crime against motherhood and who was legally regarded as too corrupt to care for her offspring. Female infidelity was defined in terms of a *rejection* of the family; the adulteress embarked on her sin

in the knowledge that, if discovered, she would never see her children again. This contradiction is made explicit in the clash between *Past and Present*'s three panels: the central section, which depicts the woman's physical turning away from her daughters and her destruction of their home (both the real domestic space and the symbolic house of cards) and the last two paintings, in which the adulteress displays an all-consuming love for her children and an ardent longing for the daughters from whom she is separated.

This containment is itself subversive. The juxtaposition of the two stereotypes of the adulteress (corrupt wife and victimized mother) exposes their disparity and denaturalizes their codes of reference, revealing that they are produced by a signifying system that does not reflect but constructs reality and is always in flux. From being a signifier of difference, against which the ideal can be defined, the maternal adulteress becomes a deconstructive figure of differance. It is in the last scene of the triptych, in which the unfaithful wife is shown at the nadir of her fortunes, that these contradictions come to the fore. The critic in the *Athenaeum* saw a weakness here in the sudden introduction of the illegitimate child, whose legs can be seen protruding from the folds of the woman's cloak, and the confusion of this baby with the adulteress's lost daughters.[44] This apparent failing, however, has the effect of uniting all three children as children and thus highlights the adulteress's motherhood. As mother and daughter gaze at the same moon, there is the implication that, although they are physically divided, they are united emotionally and spiritually. The painting depicts the agony of this separation for the woman, whose continued maternity is emphasized in the child that she holds, and for the daughters themselves, who, in their attempts to comfort each other, emphasize their need for motherly protection.

The adulteress's adoption of the role of mother allows the painting to elicit an uncomfortable sympathy for her predicament, openly condemning the Infant Custody Act and the institutions that have divorced her from her children,[45] and encouraging the spectator to view her, as well as her husband, as "the abandoned."[46] But she is not simply an object of pathos. The image goes as far as to employ iconographical details usually associated with the Virgin Mary to transform this sinful woman into a type of Madonna. Set in an impoverished location and wearing garments that are simple and even "shroud-like," in sharp contrast to her fashionable frills in the central scene, the adulteress appears as a "Madonna of Humility."[47] This figure, identified by the historian Marina Warner, features in a number of Pre-Raphaelite paintings, including Rossetti's *The Girlhood of Mary Virgin* (1849) and *Ecce Ancilla Domini!* (1850), in which she appears stripped of the rich and royal trappings that conventionally surround her. According to Warner, the Madonna of Humility is

pictured "[w]rapped in simple blue homespun, seated on a tussock, with the baby often nursing at her breast, and only the stars and the moon . . . sometimes about her to identify her divinity."[48] It is a simple scene that is hauntingly reminiscent of *Past and Present,* in which the adulteress's change of clothes and environment seem to symbolize not only her tragic fate but a spiritual rebirth. Indeed, the starlike appearance of the lamp and its juxtaposition with the nursing woman call to mind the scene of the Nativity. Or perhaps this picture of the maternal adulteress, bathed in sorrow and holding her (dead?) child in her arms, is more reminiscent of the *Mater Dolorosa.* For Warner, the *Mater Dolorosa* signifies the tension between grief and joy: she is associated with death but also with resurrection and rebirth, a joyful affirmation in the midst of sorrow. "Mary's cry of grief," Warner asserts, "will become a shout of exultation; the agony will be followed by *peripeteia* and triumph; sadness will explode into joy."[49] The adulteress in Egg's triptych cowers in the midst of death and despair, but there is something else here that suggests, even if implicitly, a "shout of exultation" and a celebration of maternity.

This celebratory quality becomes most apparent at the point at which the painting breaks away from its textual structure. *Past and Present* is in many ways the classic Victorian narrative picture, but while it tells a story, it also repeatedly draws attention to its status as visual art. One aspect of this difference in the triptych's "final" scene is the breathtaking use of colors that combine to produce the reflection in the river and contrast with the "hot and oppressive reflection" in the drawing room.[50] Julia Kristeva argues that color in painting can mark the eruption of the "semiotic," those disruptive elements that have not been fixed as signifiers by language. Moreover, in Kristeva's analysis the semiotic is itself associated with maternity, which is on the threshold of the biological and social and cannot adequately be explained by the symbolic order.[51]

It is this interplay between luminosity and motherhood that Egg seems to have been trying to perfect in his preliminary painting for this scene and that he intensifies in the finished picture in the use of chiaroscuro, the confusion of darkness and light. As opposed to the "discovery" picture, in which the shadows are strictly demarcated and designated their own space under the husband's and the daughter's chairs, here they merge with and blur the distinction between the image's various constituents: the rotten hulk of a boat fuses with its shadow on the floor, and the adulteress, engulfed in darkness, blends into this ship and the archway, obscured by and obscuring the posters on the wall. Indeed, these posters are themselves highly ambiguous and highlight the painting's plural and shifting interpretations. In their advertisement of trips from London to Paris and Haymarket plays—Tom Taylor's *Victims* and Tom Parry's *A Cure For Love*—they emphasize the adulteress's unstable and contradictory

construction: she is both an emblem of French immorality and corruption, and a "victim of love," a figure who deserves sympathy.

The use of light and color in this particular picture seems to have been especially problematic for its Victorian critics, who found it difficult to reconcile the beauty of the reflected moonlight, which adds an ethereal, demure quality to the adulteress's face, with a depiction of immorality. Hunt saw the adulteress as possessing a "religious sadness" and went as far as to describe this last scene as "very pure and beautiful,"[52] while Ruskin got himself into all sorts of knots trying to resolve the conflicting meanings of this image: "I don't mean to say the vault is impressive as Rouen Cathedral porch would be—nor that the poor woman is impressive as your heroine would be—but in her own small muddy and shaky way, she *is,* and there's no other word for it."[53] This paradox lay at the heart of the review in the *Athenaeum:* "[T]he mother, under the dark grave-vault shadow of an Adelphi arch,—last refuge of the homeless sin, vice and beggary of London: the thin, starved legs of a bastard child—perhaps dead at her breast—protrude from her rags. She, too, is looking at the moon, full in its royal brightness, and throwing weltering, golden light on the heedless river. . . . There was never such moonlight painted as from that loathsome sewer arch you see mantling the yellow river with liquid gold."[54] The fixing of the adulteress as a transgressive figure, who has rightly been punished and situated among other deviants, the "homeless sin, vice and beggary of London," conflicts with the glorious description of the moon: its "weltering, golden light" "mantles" the river with "liquid gold." The critic attempts to contain the moonlight and place it in the context of the adulteress's corruption, but its sublimity outshines this containment. It does not reflect the "dark grave-vault" or the "Hell" that the reviewer sees hot round the sinful wife's cheek, but suggests a heavenly and divine brightness.[55]

As well as destroying the home in *Past and Present,* the adulteress expands its boundaries, occupying a maternal space that undermines her construction as wholly deviant. She is both an errant and an ideal female, embodying conflicting values that are generated in the triptych's negotiation of textual and visual devices. In this light, even the "loathsome sewer arch" appears more like a sheltering womb, which surrounds the woman with curve upon curve: in the structure of the roof, the moon, the stones, and those other receptacles that invoke the maternal body, the hulk of the ship and the overturned basket. The adulteress herself forms a quadrant in the bottom left corner that is reproduced in the shape of the ship behind her and the heap of rocks opposite. Such congruence is aesthetically pleasing and seems, at last, to offer some satisfaction to the spectator, anticipating the picture's unity and completeness, its envelopment in the arches that meet as a circle outside the frame. But, true to form, and untrue

to the form that it elicits, the triptych never achieves this wholeness and curvature. The unity of the curves is imaginary, constituted by mirror images that are partial and laterally inverted, like the two sweeps of the arch that touch and disappear above the adulteress's head. Ultimately, *Past and Present* defies its title, for its present is always tinged with what is absent, what it does not or cannot signify. Ruptured and fragmented, it opens itself up and closes itself off, exposing the limits of representation, and reproducing in its final stages only those acts and movements that have gone before: the slippages of the adulteress, the gap between text and image, and the folds, perhaps, of an umbrella.

AFTERWORD
(AND -IMAGE)

It might seem especially apt that a picture about the end of a marriage should disrupt the happy marriage between word and image that Victorian hybrid genres like narrative painting and illustration seem to augur. I hope, however, that the examples discussed in this book have suggested another possibility: that there is no simple "union" between the textual and visual, but only points of intersection that are multiple and fragmented, meetings and divergences that are bound up in cultural interests and issues.

Perhaps this realization has implications for our own culture. We only have to look around us, on our walls, our computer or television screens, to recognize that, like our Victorian counterparts, we live in a world where an amalgamation of texts and images jostle for our attention. Even the articulation of our own history—the news—is almost inconceivable without the interplay of words and pictures. If we step into an art gallery we are likely to see not only written commentaries placed next to images, but also images that are themselves constituted by words. These genres, however, are similar to but not the same as those that pervaded the mid-nineteenth century. When we approach Victorian images we come laden with our own cultural baggage and expectations. As readers and viewers today, we have no simple access to their meanings or the ways in which they were interpreted. We can only ever read the past from our place in the present.

But even if we could step back in time and see these pictures with Victorian eyes, would they necessarily offer a window on the world in which they were produced; would they, in other words, show things as they really were? What I have tried to suggest is not only that they would not, but that they could not. As signifiers, images generate multiple and even contradictory meanings. Whether they are exhibited to a select audience at the Royal Academy or adorn the pages of popular novels and magazines, pictures are not transparent representations of their cultural moment, but traces, inscriptions of values that are themselves neither self-evident nor stable. What the humorous representations

of the crinoline in *Punch* and the stark warning to would-be adulteresses in *Past and Present* have in common is that they are both spaces in which emergent and residual ideas and ideals compete and conflict. These values are there in every brushstroke, in every engraved line, but this does not mean that they can always be seen. Louis Althusser has argued that ideologies work to the extent that they mask things, creating an imaginary set of relations that come to seem natural and obvious.[1] In the case of the visual image, it is, paradoxically, its "invisibility," the fact that it can adopt such different forms and guises, that gives it its power, enabling it to infiltrate the very fabric of culture.

This infiltration was already underway in 1842. The opening address of the *Illustrated London News* predicts with almost uncanny accuracy the expansionism that made this publication itself so formative in naturalizing the conjunction that would lead to television news and the pictorial magazines so popular today:

> [T]here is now no staying the advance of this art into all the departments of our social system. It began in a few isolated volumes—stretched itself next over fields of natural history and science—penetrated the arcanae of our own general literature—and made companionship with our household books. At one plunge it was in the depth of the stream of poetry—working with its every current—partaking of the glow, and adding to the sparkles of the glorious waters—and so refreshing the very soul of genius, that even Shakespeare came to us clothed with a new beauty, while other kindred poets of our language seemed as it were to have put on festive garments to crown the marriage of their muses to the arts. Then it walked abroad among the people, went into the poorer cottages, and visited the humblest homes in cheap guises, and perhaps, in roughish forms; but still with the illustrative and the instructive principle strongly worked upon and admirably developed for the general improvement of the human race.[2]

In the introduction to this book I indicated that I wanted to explore the factors that made illustration and narrative painting so popular in the mid-nineteenth century. At its end, however, I would prefer to rethink the terms of this agenda. It seems to me that there were mixed feelings toward mixed genres, that their popularity was always tinged with anxiety. Undoubtedly, the Victorians looked with considerable excitement to a future that would be dominated by pictures as well as words, as the triumphalism of the *Illustrated London News* demonstrates. But even the most enthusiastic account of this burgeoning visual culture is potentially problematic. Is there not something slightly troubling about the progression of an art that cannot be stopped and "advances" with a

military precision that seems out of the control of any human producers or consumers?

This implicit unease has as much to do with the meanings these images generate as with their cultural domination. In fact, these two elements are virtually indivisible: the appeal and impact of illustration and narrative painting in this particular period stem from their interaction with mid-nineteenth-century ideologies. However disparate the pictures discussed here might appear, they all engage with the values that permeate Victorian culture. The precise mode of this engagement, of course, varies from image to image, but in each it is located in and determined by the very generic structure that marks its difference: the dialogue between the textual and visual. It is in the convergences and connections, the fissures and gaps between pictures and words, that the illustrations to *Uncle Tom's Cabin* and Paton's *In Memoriam* explore national and racial identity. It is here too that EVB's designs and Egg's triptych construct and subvert gender roles. What I am arguing, then, is that illustration and narrative painting are highly political genres that tell us something about the shifting values and assumptions of the mid-nineteenth century. This "something" is not necessarily the truth, nor is it a single, unified "thing." The relation between word and image is lacking, heterogeneous, plural, at once a historical fact and a historical fiction.

Tennyson Longfellow Smith once remarked that pictures "may point a moral," yet he also realized that they could be dangerously immoral. The mistress who sits on her lover's knee in *The Awakening Conscience* does not make for easy viewing, and it is this that provokes the ire of Smith's spectator. Nor does she make for easy reading. Even Ruskin's authoritative interpretation of the image is only one of many. Victorian illustrations and narrative paintings occupy a culture fraught with competing values and a signifying system invaded by differance. They might provide the material inscriptions of these meanings, but they never tell the same old stories.

NOTES

Introduction

Note: All citations of the *Times* refer to the London newspaper of that name.

1. Tennyson Longfellow Smith, "The Awakened Conscience by Holman Hunt," in *Poems Inspired by Certain Pictures at the Art Treasures Exhibition, Manchester* (Manchester, 1857), 3.

2. Smith, "Awakened," 3.

3. Smith, "Awakened," 4.

4. *Leader,* May 24, 1856, 499.

5. "Illustrated Works," *London Review* 22 (January 1859): 475.

6. Martin Meisel, *Realizations: Narrative, Pictorial, and Theatrical Arts in Nineteenth-Century England* (Princeton: Princeton University Press, 1983). See also Alison Byerly, who analyses the relation between artistic genres in *Realism, Representation, and the Arts in Nineteenth-Century Literature* (Cambridge: Cambridge University Press, 1997).

7. For a discussion of Hogarth's graphic storytelling, see Ronald Paulson, *Hogarth,* 3 vols. (Cambridge, UK: Lutterworth, 1991–93).

8. The link between nineteenth-century illustrators and Hogarth has been discussed in Stuart Sillars, *Visualisation in Popular Fiction, 1860–1960* (London: Routledge, 1995), 3–17.

9. L. V. Fildes, *Luke Fildes, R. A.: A Victorian Painter* (London: Michael Joseph, 1968), 120.

10. On the transformation of art objects into the "new language" of wood engraving, see Allan Ellenius, "Reproducing Art as a Paradigm of Communication: The Case of the Nineteenth-Century Illustrated Magazines," *Figura* 21 (1984): 69–92. Ellenius argues that in the context of illustrated magazines viewers were actively encouraged to read art objects in terms of their narratives.

11. John Ruskin, *The Works of John Ruskin,* 39 vols., ed. E. T. Cook and Alexander Wedderburn (London: George Allen; New York: Longmans, Green, 1903–12), 5:126–27.

12. Gerard Curtis, *Visual Words: Art and the Material Book in Victorian England* (Aldershot, UK: Ashgate, 2002), 6–55 passim.

13. For a discussion of the Victorian reaction to Lessing, see Meisel, *Realizations,* 17–28.

14. David Wilkie, "Remarks on Painting," in *The Life of Sir David Wilkie,* by Allan Cunningham (London: John Murray, 1843), 3:154.

15. Ruskin, *Works,* 3:87.

16. Elizabeth Eastlake, "Modern Painters," *Quarterly Review* 98 (March 1856): 384–433.

17. For an outline of these debates, see Julia Thomas, ed., *Reading Images* (Hampshire,UK: Palgrave, 2000), introduction.

18. This relation between word and image has been the subject of recent anthologies such as Richard Wendorf, ed., *Articulate Images: The Sister Arts from Hogarth to Tennyson* (Minneapolis: University of Minnesota Press, 1983); James A. W. Heffernan, ed., *Space, Time, Image, Sign: Essays on Literature and the Visual Arts* (New York: Peter Lang, 1987); Norman Bryson, ed., *Calligram: Essays in New Art History from France* (Cambridge: Cambridge University Press, 1988); Norman Bryson, Michael Ann Holly, and Keith Moxey, eds., *Visual Theory: Painting and Interpretation* (Cambridge: Cambridge University Press, 1991); Stephen W. Melville and Bill Readings, eds., *Vision and Textuality* (London: Macmillan, 1995). The relation has also been explored in Mieke Bal, *Reading "Rembrandt": Beyond the Word-Image Opposition* (Cambridge: Cambridge University Press, 1991).

19. Norman Bryson, "Semiology and Visual Interpretation," in Bryson, Holly, and Moxey, *Visual Theory,* 61–73.

20. David Summers, "Real Metaphor: Towards a Redefinition of the 'Conceptual' Image," in Bryson, Holly, and Moxey, *Visual Theory,* 231–59. See also James Elkins, *On Pictures and the Words That Fail Them* (Cambridge: Cambridge University Press, 1998).

21. Summers, "Real Metaphor," 236.

22. Roger Fry, *Reflections on British Painting* (London: Faber and Faber, 1934). For a discussion of Fry's attitude to narrative painting, see chapter 4. Summers, "Real Metaphor," 256.

23. Ferdinand de Saussure, *Course in General Linguistics,* ed. Charles Bally and Albert Sechehaye, trans. Wade Baskin (New York: McGraw-Hill, 1966), 68, 16–17.

24. Peter Brunette and David Wills, "The Spatial Arts: An Interview with Jacques Derrida," in *Deconstruction and the Visual Arts: Art, Media, Architecture,* ed. Peter Brunette and David Wills (Cambridge: Cambridge University Press, 1994), 15.

25. A notable exception is Curtis, who discusses a range of images, including Ford Madox Brown's *Work* and William Powell Frith's *Derby Day*, in *Visual Words.*

26. Catherine J. Golden, ed., *Book Illustrated: Text, Image, and Culture, 1770–1930* (New Castle, DE: Oak Knoll, 2000); Richard Maxwell, ed., *The Victorian Illustrated Book* (Charlottesville: University Press of Virginia, 2002); J. Hillis Miller, *Illustration* (London: Reaktion, 1992); Lorraine Janzen Kooistra, *The Artist as Critic: Bitextuality in* Fin-de-Siècle *Illustrated Books* (London: Scolar, 1995). Other books that have been instrumental in exploring the interplay between word and image in specific nineteenth-century genres are B. E. Maidment's *Reading Popular Prints, 1790–1870* (Manchester, UK: Manchester University Press, 1996); Rosemary Mitchell's *Picturing the Past: English History in Text and Image, 1830–1870* (Oxford: Clarendon, 2000); and Peter W. Sinnema's *Dynamics of the Pictured Page: Representing the Nation in the "Illustrated London News"* (Aldershot, UK: Ashgate, 1998).

27. Edward Hodnett, *Five Centuries of English Book Illustration* (Aldershot, UK: Scolar, 1988), 144. See also Paul Goldman, *Victorian Illustrated Books, 1850–1870: The Heyday of Wood-Engraving* (London: British Museum, 1994), 21.

28. "*Enoch Arden:* By Alfred Tennyson," *Athenaeum,* December 23, 1865, 894.

29. "Book-Prints," *Chambers's Journal of Popular Literature, Science and Arts,* August 30, 1862, 136.

30. Summers, "Real Metaphor," 256.

31. George Eliot to Frederic Leighton, September 10, 1862, in *The George Eliot Letters,* vol. 4, 1862–68, ed. Gordon S. Haight (London: Oxford University Press, 1956), 55–56. For a discussion of Eliot's view on the visual arts, see Hugh Witemeyer, *George Eliot and the Visual Arts* (New Haven, CT: Yale University Press, 1979).

32. Maidment, *Reading Popular Prints,* 56. Kate Flint's analysis of the importance of vision and visuality in Victorian culture would seem to contradict this view, however (*The Victorians and the Visual Imagination* [Cambridge: Cambridge University Press, 2000]).

33. "Book-Prints," 136.

34. "Picture-Books," *Blackwood's Edinburgh Magazine,* March 18, 1857, 310, 316.

35. "Illustrated Books," *Quarterly Review* 74 (1844): 171.

36. For the plural meanings of this painting see Kate Flint, "Reading *The Awakening Conscience* Rightly," in *Pre-Raphaelites Re-viewed,* ed. Marcia Pointon, 45–65 (Manchester, UK: Manchester University Press, 1989).

37. John Ruskin, "The Awakening Conscience," in *Works,* 12:334–35; originally published in the *Times,* May 25, 1854.

38. Flint, "Reading."

39. Smith, *Poems,* 3.

40. For a discussion of the mythology surrounding the prostitute, including her association with death, see Lynda Nead, *Myths of Sexuality: Representations of Women in Victorian Britain* (Oxford: Blackwell, 1988), 138–95.

41. Nead, *Myths of Sexuality,* 127 passim.

42. N. John Hall, *Trollope and His Illustrators* (London: Macmillan, 1980); John Harvey, *Victorian Novelists and Their Illustrators* (New York: New York University Press, 1971).

43. For one of the few accounts of the significance of the reader of illustrated texts, see David Skilton, "The Relation between Illustration and Text in the Victorian Novel: A New Perspective," in *Word and Visual Imagination: Studies in the Interaction of English Literature and the Visual Arts,* ed. Karl Josef Höltgen, Peter M. Daly, and Wolfgang Lottes, 303–25 (Erlangen, Germany: Universitätsbund Erlangen-Nürnberg, 1988).

44. For an account of Dickens's approach to the illustration of his texts, see Michael Steig, *Dickens and Phiz* (Bloomington: Indiana University Press, 1978).

45. Fildes, *Luke Fildes,* 15.

46. Mark Twain, *Life on the Mississippi* (1875; repr., New York: Harper and Row, 1951), 358.

47. Ibid., 359. Twain's remarks are discussed at some length in Miller, *Illustration,* 61–67.

48. Edward Hodnett, *Image and Text: Studies in the Illustration of English Literature* (Hampshire, UK: Scolar, 1982), 12.

49. Sam Smiles, *Eye Witness: Artists and Visual Documentation in Britain, 1770–1830* (Aldershot, UK: Ashgate, 2000), 1–11 passim.

50. Charles Lamb, qtd. in David Bland, *The Illustration of Books* (London: Faber and Faber, 1951), 56.

51. Bland, *The Illustration of Books,* 56.

52. Ruskin to Alfred Tennyson, July 26, 1857, in *Works,* 36:265.

53. Brunette and Wills, "The Spatial Arts," 13.

54. Meisel, *Realizations,* 3.

55. W. J. T. Mitchell, "Going Too Far with the Sister Arts," in Heffernan, *Space, Time, Image, Sign,* 3.

56. W. J. T. Mitchell, *Iconology: Image, Text, Ideology* (Chicago: University of Chicago Press, 1986), 43.

57. Mary Cowling, *Victorian Figurative Painting: Domestic Life and the Contemporary Social Scene* (London: Andreas Papadakis, 2000), 9.

58. See, for example, Cowling, who argues that genre painters "preserved for us a unique record of many aspects of Victorian life" (*Victorian Figurative Painting,* 22).

59. Maidment, *Reading Popular Prints,* 11.

60. Walter Crane, *Of the Decorative Illustration of Books Old and New* (1896; repr., London: Bracken, 1984), 14–16.

61. Peter W. Sinnema, *Dynamics of the Pictured Page,* 48.

62. Edward Burne-Jones, "Essay on *The Newcomes,*" *Oxford Magazine,* January 1856, 61.

Chapter 1

1. William Makepeace Thackeray to Mrs. Dunlop, December 12, 1856, in *The Letters and Private Papers of William Makepeace Thackeray,* vol. 3, 1852–56, ed. Gordon N. Ray (Cambridge MA: Harvard University Press, 1946), 655. Thackeray had ideas for a pack of comic playing cards, of which this was an example. Other cards included Macbeth, Banquo and the witches, and Gibbon, Boswell, and Johnson. See Gordon N. Ray, *The Illustrator and the Book in England, 1790–1914* (New York: Pierpont Morgan Library; Oxford: Oxford University Press, 1976), 77.

2. Marcus Wood, *Blind Memory: Visual Representations of Slavery in England and America, 1780–1865* (Manchester, UK: Manchester University Press, 2000), 149.

3. Ibid., 143.

4. Ibid., 146.

5. The story of how the publisher and engraver Henry Vizetelly initially came by this book is told in Henry Vizetelly, *Glances Back through Seventy Years: Autobiographical and Other Reminiscences,* vol. 1 (London: Kegan Paul, Trench, Trubner, 1893), 360–61. An account of the early British editions can be found in Charles Edward Stowe, *Life of Harriet Beecher Stowe Compiled from Her Letters and Journals* (London: Sampson Low, 1889), 189–92.

6. Stowe, *Life,* 190.

7. "*Uncle Tom's Cabin* and Its Opponents," *Eclectic Review* 5 (December 1852): 721.

8. "Book-Prints," 135.

9. [W. J. Linton], "Illustrative Art," *Westminster Review* 51 (1849): 92–93.

10. John Ruskin, *The Cestus of Aglaia,* in *Works,* 19:139.

11. Ibid., 19:139.

12. Ibid., 19:140.

13. Harriet Beecher Stowe, *Uncle Tom's Cabin,* ed. Jean Fagan Yellin (1852; repr., Oxford: Oxford University Press, 1998), 137. Subsequent references are given in the text.

14. Jacques Derrida, *Of Grammatology,* trans. Gayatri Chakravorty Spivak (Baltimore: Johns Hopkins University Press, 1974), 144–45.

15. David Blewett, *The Illustration of "Robinson Crusoe," 1719–1920* (Gerrards Cross, UK: Colin Smythe, 1995), 15.

16. For a comparison of the two images, see Wood, *Blind Memory,* 178–82.

17. Peter Wagner, *Reading Iconotexts: From Swift to the French Revolution* (London: Reaktion, 1995).

18. Peter A. Dorsey, "De-authorizing Slavery: Realism in Stowe's *Uncle Tom's Cabin* and Brown's *Clotel,*" *ESQ: A Journal of the American Renaissance* 41 (1995): 262.

19. For a discussion of the linear arrangement of Hogarth's prints, see Ronald Paulson, "Hogarth and the English Garden: Visual and Verbal Structures," in *Encounters: Essays on Literature and the Visual Arts,* ed. John Dixon Hunt (London: Studio Vista, 1971), 84–85.

20. Harriet Beecher Stowe, *Uncle Tom's Cabin with Twenty-seven Illustrations on Wood by George Cruikshank* (London: John Cassell, 1852), xiv.

21. Ruskin, *Cestus,* 137.

22. Ibid., 103. For another of Ruskin's comparisons between engraving and slavery, see *Ariadne Florentina,* in *Works,* vol. 22.

23. Jane Tompkins, *Sensational Designs: The Cultural Work of American Fiction, 1790–1860* (New York: Oxford University Press, 1985), 122–46.

24. Early illustrations of the novel influenced subsequent film versions and recent advertising campaigns. See Janet Staiger, *Interpreting Films: Studies in the Historical Reception of American Cinema* (Princeton: Princeton University Press, 1992), 101–23. See also Robert M. MacGregor, "The Eva and Topsy Dichotomy in Advertising," in *Images of the Child,* ed. Harry Eiss, 287–305 (Bowling Green, OH: Bowling Green State University Popular Press, 1994).

25. Tompkins, *Sensational Designs,* 133.

26. Ruskin, *Works,* 5:96–97.

27. The figure of justice was also depicted in an earlier illustration based on a painting by R. Smirke for James Montgomery, James Grahame, and E. Benger, *Poems on the Abolition of the Slave Trade* (London: R. Bowyer, 1809). As the seated figure of Britannia listens to the lamentation of a group of slaves, Justice, scales in hand, appears in the clouds.

28. Stephen C. Behrendt, "The Functions of Illustration—Intentional and Unintentional," in *Imagination on a Long Rein, English Literature Illustrated,* ed. Joachim Möller (Marburg, Germany: Jonas Verlag, 1988), 37.

29. Maidment discusses such engravings in *Reading Popular Prints,* 104–11.

30. "Royal Academy," *Art Journal,* May 1852, 167.

31. Christiana Payne has argued that Victorian paintings of cottage interiors worked to demonstrate the goodness and morality of the rural poor (*Rustic Simplicity: Scenes of Cottage Life in Nineteenth-Century British Art* [Nottingham, UK: Djanogly Art Gallery, 1998], 5 passim).

32. Karen Sayer, *Country Cottages: A Cultural History* (Manchester, UK: Manchester University Press, 2000), 113–41.

33. See, for example, Arthur Helps, who criticized this aspect of the novel in *Fraser's Magazine* 46 (1852): 237–44.

34. Douglas A. Lorimer, *Colour, Class, and the Victorians: English Attitudes to the Negro in the Mid-nineteenth Century* (Leicester, UK: Leicester University Press, 1978), 102. The *Eclectic Review* argued against this comparison ("*Uncle Tom's Cabin*," 739–40).

35. For an account of this tradition, see David Dabydeen, *Hogarth's Blacks: Images of Blacks in Eighteenth Century English Art* (Manchester, UK: Manchester University Press, 1987), 23–37. This iconography is also manifest in nineteenth-century paintings like Rossetti's *Beloved* and Manet's *Olympia*.

36. Wood, *Blind Memory,* 190.

37. Simon Nowell-Smith, *The House of Cassell, 1848–1958* (London: Cassell, 1958), 38.

38. See, for example, Hilary and Mary Evans, who argue that these illustrations "lack fire and imagination" in *The Man Who Drew the Drunkard's Daughter: The Life and Art of George Cruikshank, 1792–1878* (London: Frederick Muller, 1978), 162–63. John Buchanan-Brown contends that the failure of the illustrations was due to Cruikshank's unfamiliarity with the subject matter and the inferior paper on which they were printed (*The Book Illustrations of George Cruikshank* [Newton Abbot, UK: David and Charles, c. 1980], 19). Marcus Wood also sees Cruikshank's illustrations as testimony to his "inability to move beyond the narrow conventions he had lately adopted for the description of blacks" (*Blind Memory,* 176).

39. Thomas Carlyle, "Occasional Discourse on the Nigger Question" (London: Thomas Bosworth, 1853), 14; originally published in *Fraser's Magazine,* December 1849.

40. Robert L. Patten, *George Cruikshank's Life, Times, and Art,* vol. 2 (Cambridge, UK: Lutterworth, 1996), 323.

41. Lorimer, *Colour, Class, and the Victorians,* 69–91.

42. Henry Mayhew and George Cruikshank, *1851; or, The Adventures of Mr and Mrs Sandboys and Family, Who Came to London to Enjoy Themselves and to See the Great Exhibition* (London: George Newbold, 1851), frontispiece.

43. Tim Barringer identifies this contrast of clothing as a familiar strategy in pictorial constructions of otherness ("Images of Otherness and the Visual Production of Difference: Race and Labour in Illustrated Texts, 1850–1865," in *The Victorians and Race,* ed. Shearer West [Aldershot, UK: Scolar, 1996], 38–40).

44. Daniel Defoe, *The Life and Surprising Adventures of Robinson Crusoe of York, Mariner with an Account of His Travels Round Three Parts of the Globe with Numerous Engravings from Drawings by George Cruikshank* (London: David Bogue, 1853), facing 139.

45. When color illustrations became more popular George and Eliza were frequently depicted with blond hair, as in the edition of *Uncle Tom's Cabin* published by Ward, Lock, and Tyler in 1878.

46. The symbolic difference of clothing can also be seen in the visual juxtaposition of Eva and Topsy. The *People's Illustrated Edition* shows a woolly-haired Topsy in African garments, with a swath of material draped over one shoulder and a rude skirt that exposes her legs, alongside an Eva who stands as the representative of Western civilization with her lace-trimmed dress and fair locks.

47. Cruikshank's depiction of George is in stark contrast to one of his earlier pictures for the song sheet "Barclay and Perkins's Drayman," in which a black man appears only the more ridiculous in a gentleman's outfit. His folly is emphasized in the lyrics, in which he is replaced in the affections of a widow and frightened off the scene by a nasty-looking drayman. George Cruikshank, "Barclay and Perkins's Drayman," in *The Universal Songster*, vol. 2 (London, 1826).

48. Sarah Smith Ducksworth, "Stowe's Construction of an African Persona and the Creation of White Identity for a New World Order," in *The Stowe Debate: Rhetorical Strategies in "Uncle Tom's Cabin,"* ed. Mason I. Lowance Jr., Ellen E. Westbrook, and R. C. De Prospo, 205–35 (Amherst: University of Massachusetts Press, 1994).

49. Homi K. Bhabha, "The Other Question," *Screen* 24, no. 6 (1983): 29.

50. William Makepeace Thackeray, "An Essay on the Genius of George Cruikshank," in *The Paris Sketch Book and Art Criticisms,* ed. George Saintsbury (London: Oxford University Press, n.d.), 446; originally published in the *Westminster Review,* June 1840.

51. "Negro Slavery in the States," *English Review* 18 (October 1852): 96.

Chapter 2

1. On "sixties" illustration, see George and Edward Dalziel, *The Brothers Dalziel: A Record of Work, 1840–1890* (1901; repr., London: Batsford, 1978); Joseph Pennell, *Modern Illustration* (London: Bell, 1901); Forrest Reid, *Illustrators of the Sixties* (1928; repr., London: Constable, 1975); Gleeson White, *English Illustration: "The Sixties"; 1855–1870* (1897; repr., Bath, UK: Kingsmead Reprints, 1970).

2. Dante Gabriel Rossetti to William Morris, n.d., in *Letters of Dante Gabriel Rossetti,* vol. 1, 1835–60, ed. Oswald Doughty and John Robert Wahl (Oxford: Clarendon, 1965), 325.

3. Caroline Fox, qtd. in Norman Page, ed., *Tennyson: Interviews and Recollections* (London: Macmillan, 1983), 77.

4. Emily Sellwood Tennyson to John Forster, October 31, 1858, in *Letters of Alfred Lord Tennyson,* vol. 2, 1851–70, ed. Cecil Y. Lang and Edgar F. Shannon Jr. (Oxford: Clarendon, 1987), 209–11.

5. William Holman Hunt, *Pre-Raphaelitism and the Pre-Raphaelite Brotherhood,* vol. 2 (London: Macmillan, 1905), 124–25.

6. "Photographic Illustrations of Tennyson," *Times,* October 14, 1875, 4.

7. Ibid.

8. Ibid.

9. This view has been corrected by Carol Armstrong, who argues that Cameron's photographs exceed Tennyson's text, which comes to "illustrate" the pictures rather than vice versa. See Armstrong, *Scenes in a Library: Reading the Photograph in the Book, 1843–1875* (Cambridge, MA: MIT Press, 1998), 361–421.

10. White, *English Illustration,* 105.

11. William Michael Rossetti, *Dante Gabriel Rossetti: His Family Letters with a Memoir,* vol. 1 (London: Ellis and Elvey, 1895), 189.

12. George Somes Layard, *Tennyson and His Pre-Raphaelite Illustrators: A Book about a Book* (London: Elliot Stock, 1894), 9.

13. Ibid., 55.

14. Rossetti, *Dante Gabriel Rossetti*, 190.

15. William Sharp, *Dante Gabriel Rossetti: A Record and a Study* (London: Macmillan, 1882), 110–11.

16. Alfred, Baron Tennyson, "The Palace of Art," in *Tennyson's Poems* (London: Moxon, 1857), 118.

17. Alfred, Lord Tennyson, *Some Poems of Alfred Lord Tennyson: With illustrations by W. Holman Hunt, J. E. Millais and D. G. Rossetti . . . With a Preface by J. Pennell treating of the illustrators of the sixties and an introduction by W. Holman Hunt* (London: Freemantle, 1901).

18. Layard, *Tennyson*, 56.

19. Ibid., 57–59.

20. William Vaughan, "Incongruous Disciples: The Pre-Raphaelites and the Moxon *Tennyson*," in *Imagination on a Long Rein: English Literature Illustrated,* ed. Joachim Möller (Marburg, Germany: Jonas Verlag, 1988), 158–59.

21. Dante Gabriel Rossetti to Wiliam Allingham, January 23, 1855, in *Letters,* 239.

22. "Reviews," *Art Journal,* July 1857, 231.

23. Ibid.

24. Ibid.

25. Blewett, *Illustration,* 15.

26. "Reviews," 232.

27. Ray, *Illustrator,* xxiv.

28. "Tennyson, Illustrated by Doré," *Times,* December 29, 1868, 10.

29. White, *English Illustration,* 162.

30. John Ruskin, *Time and Tide: Twenty-five Letters to a Working Man of Sunderland on the Laws of Work,* in *Works,* 17:401.

31. For a further discussion of how critics regarded Rossetti as "foreign," see Laurel Bradley, "The 'Englishness' of Pre-Raphaelite Painting: A Critical Review," in *Collecting the Pre-Raphaelites: The Anglo-American Enchantment,* ed. Margaretta Frederick Watson (Aldershot, UK: Ashgate, 1997), 205–6.

32. White, *English Illustration,* 158.

33. John Guille Millais, *The Life and Letters of Sir John Everett Millais* (London: Methuen, 1899), 26–27.

34. For an account of how the Moxon *Tennyson* was bound up with questions of national identity, see Joel M. Hoffmann, "What is Pre-Raphaelitism, Really? In Pursuit of Identity through *The Germ* and the Moxon *Tennyson*," in *Pocket Cathedrals: Pre-Raphaelite Book Illustration,* ed. Susan P. Casteras, 43–53 (New Haven, CT: Yale Center for British Art, 1991).

35. Layard, *Tennyson,* 54.

36. Fildes, *Luke Fildes,* 120.

37. Edmund J. Sullivan, *The Art of Illustration* (London: Chapman and Hall, 1921), 135–36.

38. See Richard D. Altick, *Paintings from Books: Art and Literature in Britain, 1760–1900* (Columbus: Ohio State University Press, 1985), 453–54.

39. Edith Heraud, *Lecture on Tennyson, as Delivered at Unity Church and before the Society for the Fine Arts* (London: Simpkin, Marshall, 1878), 8.

40. "A May-Day Feast," *Dublin University Magazine,* May 1851, 537.

41. Alexander H. Japp, *Three Great Teachers of Our Own Time: Being an Attempt to Deduce the Spirit and Purpose Animating Carlyle, Tennyson, and Ruskin* (London: Smith, Elder, 1865), 94.

42. Alfred Tennyson, *The May Queen Illuminated by Mrs W. H. Hartley, Chromolithographed by W. R. Tymms* (London: Day and Sons, 1861); Alfred Tennyson, *The May Queen in Illuminated Borders Designed by L. Summerbell* (London: George Berridge, 1872).

43. For an account of the significance of clocks in Victorian illustration, see Steven Dillon, "Watches, Dials, and Clocks in Victorian Pictures," in Maxwell, *The Victorian Illustrated Book,* 52–90.

44. Albert B. Friedman, "The Tennyson of 1857," *More Books,* January 23, 1948, 22.

45. See, for example, Alfred, Lord Tennyson, *The May Queen,* illustrated by C. E. Brock (London: Ernest Nister; New York: E. P. Dutton, 1908).

46. For the most comprehensive account to date of EVB's life and work, see Robin de Beaumont's biography and bibliography in the *Imaginative Book Illustration Society Newsletter* 14 (Spring 2000): 22–48. Much of de Beaumont's biographical material is taken from an unpublished manuscript written by the artist's great-great-granddaughter, Margaret de Wend-Fenton.

47. Rodney K. Engen, *Dictionary of Wood Engravers* (Cambridge, UK: Chadwyck-Healey, 1985), 28.

48. Ray, *Illustrator,* 67.

49. Alfred Tennyson, *The May Queen,* illustrated by EVB (London: Sampson Low, 1861).

50. Hallam, Lord Tennyson, *Tennyson and His Friends* (London: Macmillan, 1911), 292.

51. Rossetti, *Dante Gabriel Rossetti,* 166.

52. Dante Gabriel Rossetti to William Allingham, September 19, 1854, in *Letters,* 55.

53. "Picture-Books," 315.

54. EVB, *The Peacock's Pleasaunce* (London: John Lane, 1908), 250.

55. EVB, *Child's Play* (London: Addey, 1852).

56. "Our Address," *Illustrated London News,* May 14, 1842, 1.

57. Kooistra, *The Artist as Critic,* 9–12.

58. *Elegant Arts for Ladies* (London: Ward and Lock, 1856), iv.

59. Ibid., 92.

60. Margaret de Wend-Fenton, "E.V.B.: The Hon. Mrs. Eleanor Vere Boyle; A Biography," unpublished manuscript.

61. Ellen C. Clayton, *English Female Artists,* vol. 2 (London: Tinsley Brothers, 1876), 350.

62. Ibid., 348.

63. Ibid., 359.

64. [Linton], "Illustrative Art," 100–1.

65. Francis Turner Palgrave, "A Few Words on 'E.V.B.' and Female Artists," *Macmillan's Magazine* 15 (1867): 327–30.

66. EVB, *The Peacock's Pleasaunce,* 246.

Chapter 3

1. "Crinolineomania," *Punch,* December 27, 1856, 253.

2. "Luggage Trains for Ladies," *Punch,* October 30, 1858, 173.

3. Sally Shuttleworth, "Female Circulation: Medical Discourse and Popular Advertising in the Mid-Victorian Era," in *Body/Politics: Women and the Discourses of Science,* ed. Mary Jacobus, Evelyn Fox Keller, and Sally Shuttleworth (New York: Routledge, 1990), 61.

4. Fred Davis, *Fashion, Culture, and Identity* (Chicago: University of Chicago Press, 1992), 17.

5. For an account of feminism in the 1850s, see Lee Holcombe, *Wives and Property: Reform of the Married Women's Property Law in Nineteenth-Century England* (Oxford: Martin Robertson, 1983), 48–87.

6. *Times,* January 12, 1858, 4. Indeed, the *Times* and *Punch* appealed to a similar readership. *Punch* drew on topics that were reported in the newspaper and often directly alluded to them, while the *Times* reprinted some of *Punch*'s features. See Richard D. Altick, *"Punch": The Lively Youth of a British Institution, 1841–1851* (Columbus: Ohio State University Press, 1997), 68.

7. *Times,* January 28, 1860, 7.

8. See, for example, J. C. Flugel, *The Psychology of Clothes,* International Psychoanalytical Library, no. 18 (London: Hogarth, 1940), 47. Altick also sees *Punch* as a "mirror of its times" that displayed social habits and customs (*"Punch,"* xviii, 522).

9. Roland Barthes, *The Fashion System,* trans. Matthew Ward and Richard Howard (1967; repr., Berkeley and Los Angeles: University of California Press, 1983), 3–5.

10. See, for example, Helene E. Roberts, who argues that the crinoline "transformed women into caged birds surrounded by hoops of steel" ("The Exquisite Slave: The Role of Clothes in the Making of the Victorian Woman," *Signs: Journal of Women in Culture and Society* 2 [1977]: 557).

11. R. Broby-Johansen, *Body and Clothes: An Illustrated History of Costume,* trans. Karen Rush and Erik I. Friis (London: Faber and Faber, 1968), 190.

12. Rachel Weathers, "The Pre-Raphaelite Movement and Nineteenth-Century Ladies' Dress: A Study in Victorian Views of the Female Body," in *Collecting the Pre-Raphaelites,* 95–108.

13. David Kunzle has used a similar argument to undermine recent accounts of nineteenth-century corsetry. Dress reformers, he argues, were not libertarian or feminist but the very opposite, and tight-lacing was seen as an act of defiance against medical and moral authority ("Dress Reform as Antifeminism: A Response to Helene E. Roberts's 'The Exquisite Slave: The Role of Clothes in the Making of the Victorian Woman,'" *Signs* 2 [1977]: 570–79).

14. "A Good Dressing for the Ladies," *Punch,* June 25, 1856, 258.

15. Flugel, *The Psychology of Clothes,* 34.

16. *Anno vicesimo secundo & vicesimo tertio Victoriae Reginae. Cap. CCXXXVIII. An Act for the reform and regulation of female apparel and to amend and refrenate the customs relating to crinoline and other artificial superfluities. . . .* (London: William Coney, 1859).

17. See, for example, *The Glories of Crinoline by a Doctor of Philosophy* (London: Dalton and Lucy, 1866).

18. Harriet Martineau, "Female Dress in 1857," *Westminster and Foreign Quarterly Review,* October 1, 1857, 317.

19. John Harvey has also identified this gender divide in the colors used in Victorian dress, with the blackness of men's costume associated with authority, and the brightness and intricacy of female dress signifying frivolity (*Men in Black* [Chicago: University of Chicago Press, 1995], 195–98).

20. For a discussion of this law, see Mary Lyndon Shanley, *Feminism, Marriage and the Law in Victorian England* (Princeton: Princeton University Press, 1989), 22–48, and Holcombe, *Wives and Property,* 3–109.

21. Caroline Norton, *A Letter to the Queen on Lord Chancellor Cranworth's Marriage and Divorce Bill* (London: Longman, Brown, Green and Longmans, 1855), and *English Laws for Women in the Nineteenth Century* (privately printed, 1854).

22. "The Rights of Women," *Punch,* May 23, 1857, 209.

23. *Hansard* 145 (May 14, 1857): 278. Qtd. in Shanley, *Feminism,* 47.

24. "Why Ladies Cannot Sit in Parliament," *Punch,* March 7, 1857, 99.

25. "Female MP's," *Punch,* August 7, 1858, 59.

26. For the failure of the bill, see Shanley, *Feminism,* 47–48.

27. "Glorious News for the Gentlemen," *Punch,* January 31, 1857, 43.

28. This seems to be another narrative device that was commonly accepted as truth. Oskar Fischel and Max von Boehn argue that the empress actually had little to do with the invention of the crinoline (*Modes and Manners of the Nineteenth Century,* vol. 3, trans. M. Edwardes [London: J. M. Dent, 1909], 38–39).

29. "Crinoline Viewed as a Depopulating Influence," *Punch,* May 2, 1857, 171.

30. "Marriage and its Difficulties," *Punch,* May 16, 1857, 194.

31. Henry Mayhew, *London Characters and Crooks,* ed. Christopher Hibbert (London: Folio, 1996), 416.

32. "Hoop and Jupe," *Punch,* February 14, 1857, 63.

33. Fischel and von Boehn, *Modes and Manners,* 65.

34. "The Anti-Cinderella Costume," *Punch,* January 31, 1857, 42.

35. *Crinoline Reprinted from the "Illustrated News of the World"* (London: Emily Faithfull, 1863), 5.

36. *Punch,* July 24, 1858, 34.

37. Charles Baudelaire, "The Painter of Modern Life," in *The Painter of Modern Life and Other Essays,* trans. and ed. Jonathan Mayne (London: Phaidon, 1964), 31, 30.

38. "Literature for Ladies," *Punch,* February 7, 1857, 51.

39. "Crinoline in the Studio," *Punch,* May 2, 1857, 177.

40. White, *English Illustration,* 17.

41. Madame de Chatelain, *Little Ada and Her Crinoline: A Tale of the Times for Little Folks* (London: Dean and Son, 1862).

42. Frank Losack, *Crinoline: Its Mysteries and Enormities Unmasked* (London, 1865), 15.

43. Anthony Trollope to George Smith, May 23, 1860, in *The Letters of Anthony Trollope,* vol. 1, 1835–70, ed. N. John Hall with the assistance of Nina Burgis (Stanford: Stanford University Press, 1983), 104.

44. See David Skilton, *Anthony Trollope and His Contemporaries: A Study in the*

Theory and Conventions of Mid-Victorian Fiction (Basingstoke, UK: Macmillan, 1972), 55. See also Skilton, "The Relation between Illustration and Text in the Victorian Novel," in Höltgen, Daly, and Lottes, *Word and Visual Imagination,* 314; Jennifer M. Ullman, "The 'Perfect Delineation of Character': Process and Perfection in the Book Illustrations of John Everett Millais," in Casteras, *Pocket Cathedrals,* 61; Hall, *Trollope and His Illustrators,* 14–18.

45. According to Michael Mason, Millais had, in fact, forgotten about this illustration. It had to be drawn in a hurry and was sent late to the engravers ("The Way We Look Now: Millais' Illustrations to Trollope," *Art History* 1 [1978]: 336).

46. Anthony Trollope, *An Autobiography,* ed. David Skilton (1883; repr., Harmondsworth, UK: Penguin, 1996), 98–99.

47. "*Framley Parsonage,*" *Saturday Review of Politics, Literature, Science, and Art* 4 (May 1861): 452.

48. "Our Library Table," *Sharpe's London Magazine,* August 1861, 103.

49. Allan R. Life, "The Periodical Illustrations of John Everett Millais and Their Literary Interpretation," *Victorian Periodicals Newsletter* 9 (1976): 51.

50. Mason, "The Way We Look," 313–19.

51. Trollope, *An Autobiography,* 95.

52. Hall, *Trollope and His Illustrators,* 153.

53. Anthony Trollope to George Smith, July 21, 1860, in *Letters of Anthony Trollope,* 111.

54. "Aids to Beauty, Real and Artificial," *Cornhill Magazine* 7 (1863): 399.

55. Anthony Trollope, *He Knew He Was Right,* ed. David Skilton (1868–69; repr., London: J. M. Dent, 1993), 54–55. I am indebted to David Skilton for this reference. A similar use of the crinoline to describe the character of a conservative old spinster had appeared several years earlier. In *East Lynne* Miss Cornelia Carlyle "disdained long dresses as much as she disdained crinoline; or, as the inflated machines were then called, corded petticoats, for crinoline had not come in" (Mrs. Henry Wood, *East Lynne,* ed. Andrew Maunder [1860–61; repr., Ontario: Broadview, 2000], 86).

56. "Who Killed Crinoline?" *Once a Week,* May 8, 1869, 371.

Chapter 4

1. Roland Barthes, "The Death of the Author," in *Image Music Text,* ed. and trans. Stephen Heath (London: Fontana, 1977), 146.

2. Nikolaus Pevsner, *The Englishness of English Art* (London: Penguin, 1956).

3. William Vaughan, "The Englishness of British Art," *Oxford Art Review* 13, no. 2 (1990), 11–23.

4. John Barrell, "Sir Joshua Reynolds and the Englishness of English Art," in *Nation and Narration,* ed. Homi K. Bhabha, 154–76 (London: Routledge, 1990).

5. Raymond Williams, *Culture and Society, 1780–1950* (London: Chatto and Windus, 1958), 130 passim.

6. Fry, *Reflections on British Painting,* 21.

7. [J. B. Atkinson], "The Royal Academy and Other Exhibitions," *Blackwood's Edinburgh Magazine* 88 (July 1860): 65.

8. Ibid., 70.

9. James McNeill Whistler, "Mr Whistler's Ten O' Clock," in *The Gentle Art of Making Enemies* (1890; repr., London: William Heinemann, 1994), 146.

10. Fry, *Reflections,* 36.

11. Ibid., 96–97.

12. Ibid., 90.

13. Charles Baudelaire, "The Exposition Universelle, 1855," in *The Mirror of Art,* trans. and ed. Jonathan Mayne (London: Phaidon, 1955), 191.

14. For a detailed account of the way in which the international exhibitions constituted ideas of nation and participated in the growth and glorification of empire, see Peter Greenhalgh, *Ephemeral Vistas: The* Expositions Universelles, *Great Exhibitions and World's Fairs, 1851–1939* (Manchester, UK: Manchester University Press, 1988).

15. "French Criticism on British Art," *Art Journal,* August 1855, 229.

16. Ibid.

17. Ibid.

18. Ibid.

19. "French Criticism on British Art," *Art Journal,* November 1855, 299–300.

20. "French Criticism on British Art: M. Maxime Du Camp," *Art Journal,* March 1856, 77.

21. Ibid.

22. Qtd. in Patricia Mainardi, *Art and Politics of the Second Empire: The Universal Expositions of 1855 and 1867* (New Haven, CT: Yale University Press, 1987), 105.

23. Ibid., 106.

24. For a discussion of how genre painting continued to be regarded as a national school of art in the second half of the nineteenth century, see Shearer West, "Tom Taylor, William Powell Frith, and the British School of Art," *Victorian Studies* 33 (1990): 307–26.

25. Sacheverell Sitwell, *Narrative Pictures: A Survey of English Genre and Its Painters* (1936; repr., London: Batsford, 1969).

26. F. G. Stephens, *Memorials of William Mulready* (London: Bell and Daldy, 1867), 1.

27. Richard and Samuel Redgrave, *A Century of British Painters* (London: Phaidon, 1947), 289.

28. Charles Baudelaire, "The Salon of 1859: Letters to the Editor of the *Revue Française,*" in *Art in Paris, 1845–1862: Salons and Other Exhibitions,* trans. and ed. Jonathan Mayne (London: Phaidon, 1965), 145.

29. Redgrave and Redgrave, *Century of British Painters,* 288.

30. Graham Storey, Kathleen Tillotson, and Angus Easson, eds., *The Letters of Charles Dickens,* vol. 7, 1853–55 (Oxford: Clarendon, 1993), 743.

31. Bhabha, *Nation and Narration,* 2.

32. bell hooks, "The Oppositional Gaze," in *Black Looks: Race and Representation* (Boston: South End, 1992), 115–31.

33. For a discussion of the politics of viewing in the work of John Ruskin and its association with nationalism, see Elizabeth Helsinger, "Ruskin and the Politics of Viewing: Constructing National Subjects," *Nineteenth-Century Contexts* 18 (1994): 125–46. Helsinger argues that Ruskin advocates a "national" mode of viewing, but with strict and defined spectatorial positions for women and the working classes.

34. "French Criticism on British Art," *Art Journal,* September 1855, 252.

35. "French Criticism on British Art: M. Maxime Du Camp," *Art Journal,* March 1856, 79.

36. "French Criticism on British Art," *Art Journal,* November 1855, 297.

37. William Sharp, *Progress of Art in the Century* (1902; repr., London: W. R. Chambers, 1906), 113.

38. For a discussion of the way in which this emotional response to genre painting manifested itself in the late nineteenth century, see Caroline Arscott, "Sentimentality in Victorian Paintings," in *Art for the People: Culture in the Slums of Late Victorian Britain,* ed. G. Waterfield, 65–81 (Dulwich, UK: Dulwich Picture Gallery, 1994).

39. "French Criticism on British Art: M. Maxime Du Camp," 79.

40. William Makepeace Thackeray, *The Paris Sketch Book and Art Criticisms* (London: Oxford University Press, n.d.), 647; originally published in *Fraser's Magazine,* June 1845.

41. Henry James, *The Painter's Eye: Notes and Essays on the Pictorial Arts,* ed. John L. Sweeney (London: Rupert Hart-Davis, 1956), 150.

42. John Stuart Mill, *Considerations on Representative Government,* vol. 19 of *Collected Works of John Stuart Mill,* ed. J. M. Robson (Toronto: University of Toronto Press; London: Routledge and Kegan Paul, 1977), 546.

43. Ernest Renan, "What Is a Nation?" trans. Martin Thom, in Bhabha, *Nation and Narration,* 19.

44. Flint, *Victorians,* 176.

45. Norman Bryson, *Word and Image: French Painting of the* Ancien Régime (Cambridge: Cambridge University Press, 1981).

46. Ibid., 15.

47. Arscott, "Sentimentality in Victorian Paintings," 76.

48. Susan P. Casteras, "Seeing the Unseen: Pictorial Problematics and Victorian Images of Class, Poverty, and Urban Life," in *Victorian Literature and the Victorian Visual Imagination,* ed. Carol T. Christ and John O. Jordan (Berkeley and Los Angeles: University of California Press, 1995), 264.

49. Hippolyte Taine, *Notes on England,* trans. Edward Hyams (1872; repr., Fair Lawn, NJ: Essential, 1958), 19–20.

50. Charles Kingsley, *Literary and General Lectures and Essays* (London: Macmillan, 1898), 220.

51. Antony Easthope, *Englishness and National Culture* (London: Routledge, 1999), 22.

52. Slavoj Žižek, *Looking Awry: An Introduction to Jacques Lacan through Popular Culture* (Cambridge, MA: MIT Press, 1991), 11–12.

53. Lynda Nead, *Victorian Babylon: People, Streets and Images in Nineteenth-Century London* (New Haven, CT: Yale University Press, 2000), 186.

54. Bhabha, *Nation and Narration,* 3.

Chapter 5

1. "Royal Academy," *Athenaeum,* May 8, 1858, 597.

2. "The Exhibition of the Royal Academy," *Illustrated London News,* May 15, 1858, 498.

3. M. H. Noel-Paton and J. P. Campbell, *Noel Paton, 1821–1901,* ed. Francina Irwin (Edinburgh: Ramsay Head Press, 1990), 20.

4. The *Art Journal* commented on the "more than Roman virtue" of the central female figure ("Royal Academy," June 1, 1858, 169).

5. Ibid.

6. Bryson, *Word and Image,* 39–40.

7. For an account of the involvement of this regiment in the Indian Mutiny, see Michael Edwardes, *Battles of the Indian Mutiny* (London: B. T. Batsford, 1963), 73–83.

8. "The Cawnpore Massacres," *Times,* September 30, 1857, 6.

9. William Russell, the war correspondent of the *Times,* acknowledges that these inscriptions were false but that they did incite men to fury (*William Russell: Special Correspondent of the "Times,"* ed. Roger Hudson [London: Folio, 1995], 109).

10. This was Edward Leckey's *Fictions Connected with the Indian Outbreak of 1857 Exposed* (Bombay, 1859).

11. "The Exhibition of the Royal Academy," *Times,* May 1, 1858, 5.

12. Ernest Chesneau, *The English School of Painting,* trans. Lucy N. Etherington (London: Cassell, 1885), 211.

13. Ibid., 208.

14. For a discussion of this and other images of the Indian Mutiny, see Brian Allen, "The Indian Mutiny and British Painting," *Apollo* 132 (1990): 152–58.

15. Louis Marin, "Towards a Theory of Reading in the Visual Arts: Poussin's *The Arcadian Shepherds,"* in Bryson, *Calligram,* 67.

16. It is this gender divide that Linda Nochlin finds so reprehensible in the painting ("Women, Art, and Power," in *Women, Art, and Power and Other Essays* [London: Thames and Hudson, 1989], 4–8).

17. Noel-Paton and Campbell, *Noel Paton,* 19.

18. Pamela Gerrish Nunn, *Problem Pictures: Women and Men in Victorian Painting* (Aldershot, UK: Scolar, 1995), 73–74.

19. Just three years before the outbreak of the mutiny, Florence Nightingale had flouted contemporary notions that women should be sheltered from the horrors of war by organizing a team of nurses to treat the wounded in the Crimea.

20. *Punch,* October 3, 1857.

21. George Whyte-Melville, "Strong-Minded Women," *Fraser's Magazine for Town and Country* 68 (1863): 677–78.

22. Jane Robinson, *Angels of Albion: Women of the Indian Mutiny* (London: Viking, 1996), 95.

23. When news broke of the massacre at Cawnpore, the *Times* commented, "The feelings of every British soldier in India may therefore be imagined, and, if they should in future be accused of cruelty in their vengeance, it need only be replied,—Remember Cawnpore!" (September 19, 1857, 6).

24. Whyte-Melville, "Strong-Minded Women," 677.

25. *Punch,* August 22, 1857. This cartoon seems to have inspired another allegorical image of the Indian Mutiny, Edward Armitage's *Retribution* (1858), in which a bare-breasted Britannia drives a sword through an Indian tiger. On the ground beneath her lie a woman and two children.

26. "Willing Hands for India," *Punch,* August 29, 1857.

27. "Liberavimus Animam," *Punch,* September 12, 1857, 108.

28. John Ruskin, "Academy Notes, 1858," *Works,* 14:156.

29. Queen Victoria to Lord Canning, November 9, 1857, qtd. in Michael Maclagan, *"Clemency" Canning* (London: Macmillan, 1962), 141.

30. "Exhibition of the Royal Academy," *Times,* May 1, 1858, 5.

31. "The Royal Academy," *Critic* 15 (May 1858): 235.

32. Nochlin, "Women, Art, and Power," 8.

33. Jenny Sharpe, *Allegories of Empire: The Figure of Woman in the Colonial Text* (Minneapolis: University of Minnesota Press, 1993), 57–82.

34. J. W. M. Hichberger, *Images of the Army: The Military in British Art, 1815–1914* (Manchester, UK: Manchester University Press, 1988), 60.

35. Edward W. Said, *Orientalism* (London: Routledge, 1978).

36. "Liberavimus Animam," 108.

37. For representations of Nana Sahib in popular Victorian fiction, see Patrick Brantlinger, *Rule of Darkness: British Literature and Imperialism, 1830–1914* (Ithaca, NY: Cornell University Press, 1988), 204–6.

38. "Exhibition of the Royal Academy," *Times,* May 1, 1858, 5.

39. "Royal Academy," *Athenaeum,* May 8, 1858, 597.

40. Noel-Paton and Campbell, *Noel Paton,* 79–81.

41. An article that appeared in 1860 justified the Highland clearances on the grounds that they allowed the Highlanders to emigrate and colonize unoccupied lands ("The Highlander at Home and Abroad," *Good Words* 1 [1860]: 468–72).

42. "The Highlanders by the Well at Cawnpore," *Dublin University Magazine* 302 (1858): 209.

43. Hallam, Lord Tennyson, *A Memoir,* vol. 1 (London: Macmillan, 1897), 435.

44. Alfred, Lord Tennyson, "The Defence of Lucknow," in *The Poems of Tennyson,* vol. 3, ed. Christopher Ricks (Essex, UK: Longman, 1987), 38–39, lines 98–106.

45. Bhabha, *Nation and Narration,* 4.

Chapter 6

1. A similar scene is depicted in Geraldine Jewsbury's *The Half Sisters* (1848). Alice agrees to elope with Conrad Percy and is writing a letter of explanation when her husband unexpectedly arrives home. In her shock, she falls senseless at his feet, leaving the written proof of her intended crime, which her husband later destroys. This story differs from *Past and Present,* however, because Alice dies repentant and with her husband's forgiveness (*The Half Sisters,* ed. Joanne Wilkes [1848; repr., Oxford: Oxford University Press, 1994], 286–88).

2. Jacques Derrida, *Spurs: Nietzsche's Styles,* trans. Barbara Harlow (Chicago: University of Chicago Press, 1979).

3. Ibid., 129.

4. Many critics have made this connection. See Nead, *Myths of Sexuality,* 72; Peter Conrad, *The Victorian Treasure-House* (London: Collins, 1973), 51; and Graham Reynolds, *Victorian Painting* (London: Herbert, 1987), 117.

5. John Ruskin, qtd. in John Lewis Bradley, "An Unpublished Ruskin Letter," *Burlington Magazine* 100 (1958): 25.

6. William Holman Hunt, "Notes of the Life of Augustus L. Egg," *Reader* 9 (January 1864): 57.

7. "Exhibition of the Royal Academy," *Times,* May 22, 1858, 9.

8. "The Exhibition of the Royal Academy," *Illustrated London News,* May 8, 1858, 70.

9. "Royal Academy," *Athenaeum,* May 1, 1858, 566.

10. For a discussion of how "Past and Present" emerged as the painting's title, see T. J. Edelstein, "Augustus Egg's Triptych: A Narrative of Victorian Adultery," *Burlington Magazine* (1983): 208–9, and Rosemary Treble, *Great Victorian Pictures: Their Paths to Fame* (London: Arts Council of Great Britain, 1978), 33.

11. Meisel, *Realizations,* 25.

12. Nead, *Myths of Sexuality,* 74.

13. Wilkie Collins, *Basil,* ed. Dorothy Goldman (1852; repr., Oxford: Oxford University Press, 1990), 45, 174.

14. Egg painted illustrations of Thackeray's work and would have met him through his friendship with Dickens. He might well have been influenced by the two writers' sympathetic representations of unfaithful wives. Certainly, his literary circle contained many authors who were interested in the question of female adultery, including Wilkie Collins.

15. William Makepeace Thackeray, *The Newcomes: Memoirs of a Most Respectable Family,* ed. D. J. Taylor (1853–55; repr., London: Dent, 1994), 593.

16. Nina Auerbach conflates adulteresses and prostitutes in her chapter on fallen women in *Woman and the Demon: The Life of a Victorian Myth* (Cambridge, MA: Harvard University Press, 1982), 150–84, as does Linda Nochlin in "Lost and *Found:* Once More the Fallen Woman," in *Women, Art, and Power,* 57–85.

17. Nead, *Myths of Sexuality,* 75–77.

18. Ibid., 75.

19. Taine, *Notes on England,* 80.

20. Auerbach, *Woman and the Demon,* 159.

21. Helene E. Roberts, "Marriage, Redundancy or Sin: The Painter's View of Women in the First Twenty-five Years of Victoria's Reign," in *Suffer and Be Still: Women in the Victorian Age,* ed. Martha Vicinus (Bloomington: Indiana University Press, 1972), 72–73. Christopher Wood also views the triptych in these terms, as a "stern homily on the subject of adultery" (*Victorian Panorama: Paintings of Victorian Life* [London: Faber, 1976], 141).

22. For a discussion of this, see Wendy Mitchinson, *The Nature of Their Bodies: Women and Their Doctors in Victorian Canada* (Toronto: University of Toronto Press, 1991), 157.

23. Alfred, Lord Tennyson, *Guinevere: The Idylls of the King,* in *The Poems of Tennyson,* ed. Christopher Ricks, Longman Annotated English Poets (Harlow: Longman, 1987), 953, line 423.

24. Hunt, "Notes," 57.

25. Eugene Becklard, qtd. in Mitchinson, *Nature of Their Bodies,* 33.

26. This was William Buchan's *Domestic Medicine.* See Shuttleworth, "Female Circulation," 59.

27. Pye Henry Chavasse, qtd. in Mitchinson, *Nature of Their Bodies,* 74.

28. *Hansard's Parliamentary Debates,* vol. 145, 3rd ser., May 25, 1857, col. 813. Qtd in Nead, *Myths of Sexuality,* 53.

29. "Royal Academy," *Athenaeum,* May 1, 1858, 566.

30. Leonore Davidoff and Catherine Hall, *Family Fortunes: Men and Women of the English Middle Class, 1780–1850* (London: Hutchinson Education, 1987), 451.

31. Meisel, *Realizations,* 26.

32. This was William Acton, who wrote, "It is too true, I admit, as the divorce courts show, that there are some few women who have sexual desires so strong that they surpass those of men. . . . I admit, of course, the existence of sexual excitement terminating even in nymphomania" (*The Functions and Disorders of the Reproductive Organs, in Youth, in Adult Age, and in Advanced Life: Considered in Their Physiological, Social, and Psychological Relations* [1857; repr., London, 1865], 112).

33. See Jacques Lacan, "The Signification of the Phallus," in *Ecrits: A Selection,* trans. Alan Sheridan, 281–91 (London: Routledge, 1977).

34. Jacques Lacan, *The Four Fundamental Concepts of Psycho-Analysis,* ed. Jacques-Alain Miller, trans. Alan Sheridan (Harmondsworth, UK: Penguin, 1994), 111, 116.

35. Lacan, *Four Fundamental Concepts,* 115.

36. George Henry Lewes, "Currer Bell's *Shirley,*" *Edinburgh Review* 91 (January 1850): 155. Lewes, of course, had his own experience of female adultery. Having condoned his wife's extramarital affair and brought up the children of this relationship as his own, he was unable to sue for divorce and marry George Eliot.

37. Collins, *Basil,* 30.

38. Roland Barthes, *S/Z,* trans. Richard Miller (Oxford: Blackwell, 1974), 18–22.

39. Eric Trudgill, *Madonnas and Magdalens: The Origins and Development of Victorian Sexual Attitudes* (New York: Holmes and Meier, 1976), 291.

40. Thackeray, *The Newcomes,* 595.

41. Ibid.

42. Lyn Pykett regards Isabel's maternity as excessive and "improper" in *The "Improper" Feminine: The Women's Sensation Novel and the New Woman Writing* (London: Routledge, 1992), 129–34. Sally Shuttleworth provides a more balanced view in "Demonic Mothers: Ideologies of Bourgeois Motherhood in the Mid-Victorian Era," in *Rewriting the Victorians: Theory, History, and the Politics of Gender,* ed. Linda M. Shires (New York: Routledge, 1992), 47–49.

43. Caroline Norton was constructed as an adulteress, even after she was exonerated in the suit of criminal conversation that her husband brought against Lord Melbourne in 1836.

44. "Royal Academy," *Athenaeum,* May 1, 1858, 566.

45. Significantly, the Infant Custody Act was repealed in 1873, allowing unfaithful wives access to their children. Even if these fictional adulteresses did not directly influence this decision, they certainly played a substantial part in the culture that allowed the change to occur.

46. The review in the *Examiner* did, in fact, describe her in these very terms (May 1, 1858, 277).

47. Susan P. Casteras describes the cloak of the adulteress in *Past and Present* as a "shroud" (*The Substance or the Shadow: Images of Victorian Womanhood* [New Haven, CT: Yale Center for British Art, 1982], 38).

48. Marina Warner, *Alone of All Her Sex: The Myth and Cult of the Virgin Mary* (London: Picador, 1985), 182.

49. Warner, *Alone,* 219.

50. Hunt, "Notes," 57.

51. Julia Kristeva, "Motherhood according to Giovanni Bellini," in *Desire in Language: A Semiotic Approach to Literature and Art,* ed. Leon S. Roudiez, trans. Thomas Gora, Alice Jardine, and Leon S. Roudiez, 237–70 (Oxford: Blackwell, 1981). For another discussion of the way in which color resists linguistic nomination, see Stephen Melville, "Colour Has Not Yet Been Named: Objectivity in Deconstruction," Brunette and Wills, *Deconstruction,* 33–48.

52. Hunt, "Notes," 57.

53. Ruskin, qtd. in Bradley, "An Unpublished Ruskin Letter," 25.

54. "Royal Academy," *Athenaeum,* May 1, 1858, 566.

55. Ibid.

Afterword

1. Louis Althusser, "Ideology and Ideological State Apparatuses (Notes towards an Investigation)," in *Lenin and Philosophy, and Other Essays,* trans. Ben Brewster, 121–73 (London: NLB, 1971).

2. "Our Address," *Illustrated London News,* May 14, 1842, 1.

BIBLIOGRAPHY

Note: All citations of the *Times* refer to the London newspaper of that name.

Acton, William. *The Functions and Disorders of the Reproductive Organs, in Youth, in Adult Age, and in Advanced Life: Considered in Their Physiological, Social, and Psychological Relations.* 1857. Reprint, London, 1865.

Allen, Brian. "The Indian Mutiny and British Painting." *Apollo* 132 (1990): 152–58.

Althusser, Louis. "Ideology and Ideological State Apparatuses (Notes towards an Investigation)." In *Lenin and Philosophy, and Other Essays,* trans. Ben Brewster, 121–73. London: NLB, 1971.

Altick, Richard D. *Paintings from Books: Art and Literature in Britain, 1760–1900.* Columbus: Ohio State University Press, 1985.

———. *"Punch": The Lively Youth of a British Institution, 1841–1851.* Columbus: Ohio State University Press, 1997.

Anderson, Patricia. *The Printed Image and the Transformation of Popular Culture, 1790–1860.* Oxford: Clarendon, 1991.

Anno vicesimo secundo & vicesimo tertio Victoriae Reginae. Cap. CCXXXVIII. An Act for the reform and regulation of female apparel and to amend and refrenate the customs relating to crinoline and other artificial superfluities. . . . London: William Coney, 1859.

"The Anti-Cinderella Costume." *Punch,* January 31, 1857. 42.

Armstrong, Carol. *Scenes in a Library: Reading the Photograph in the Book, 1843–1875.* Cambridge, MA: MIT Press, 1998.

Arscott, Caroline. "Sentimentality in Victorian Paintings." In *Art for the People: Culture in the Slums of Late Victorian Britain,* ed. G. Waterfield, 65–81. Dulwich: Dulwich Picture Gallery, 1994.

Atkinson, J. B. "The Royal Academy and Other Exhibitions." *Blackwood's Edinburgh Magazine* 88 (July 1860): 65–84.

Auerbach, Nina. *Woman and the Demon: The Life of a Victorian Myth.* Cambridge, MA: Harvard University Press, 1982.

Bal, Mieke. *Reading "Rembrandt": Beyond the Word-Image Opposition.* Cambridge: Cambridge University Press, 1991.

Barrell, John. "Sir Joshua Reynolds and the Englishness of English Art." In Bhaba, *Nation and Narration,* 154–76.

Barringer, Tim. "Images of Otherness and the Visual Production of Difference: Race and Labour in Illustrated Texts, 1850–1865." In *The Victorians and Race,* ed. Shearer West, 34–52. Aldershot, UK: Scolar, 1996.

Barthes, Roland. *S/Z.* Trans. Richard Miller. Oxford: Blackwell, 1974.

———. *Image Music Text.* Ed. and trans. Stephen Heath. London: Fontana, 1977.

———. *The Fashion System.* Trans. Matthew Ward and Richard Howard. Berkeley and Los Angeles: University of California Press, 1983.

Baudelaire, Charles. *The Mirror of Art.* Trans. and ed. Jonathan Mayne. London: Phaidon, 1955.

———. *The Painter of Modern Life and Other Essays.* Trans. and ed. Jonathan Mayne. London: Phaidon, 1964.

———. *Art in Paris, 1845–1862: Salons and Other Exhibitions.* Trans. and ed. Jonathan Mayne. London: Phaidon, 1965.

Beaumont, Robin de. "Biography and Bibliography: Eleanor Vere Boyle (E.V.B.)." *Imaginative Book Illustration Society Newsletter* 14 (Spring 2000): 22–48.

Behrendt, Stephen C. "The Functions of Illustration—Intentional and Unintentional." In *Imagination on a Long Rein, English Literature Illustrated,* ed. Joachim Möller, 29–44. Marburg: Jonas Verlag, 1988.

Bendiner, Kenneth. *An Introduction to Victorian Painting.* New Haven, CT: Yale University Press, 1985.

Bhabha, Homi K. "The Other Question." *Screen* 24, no. 6 (1983): 18–36.

———, ed. *Nation and Narration.* London: Routledge, 1990.

Bland, David. *The Illustration of Books.* London: Faber and Faber, 1951.

———. *A History of Book Illustration: The Illustrated Manuscript and the Printed Book.* London: Faber and Faber, 1958.

Blewett, David. *The Illustration of "Robinson Crusoe," 1719–1920.* Gerrards Cross, UK: Colin Smythe, 1995.

"Book-Prints." *Chambers's Journal of Popular Literature, Science and Arts,* August 30, 1862, 135–37.

Boyle, Eleanor Vere (EVB). *Child's Play.* London: Addey, 1852.

———, illustrator. *The May Queen,* by Alfred, Lord Tennyson. London: Sampson Low, 1861.

———. *A Dream Book.* London: Sampson Low, 1870.

———. *The Peacock's Pleasaunce.* London: John Lane, 1908.

Bradley, John Lewis. "An Unpublished Ruskin Letter." *Burlington Magazine* 100 (1958): 25–26.

Bradley, Laurel. "The 'Englishness' of Pre-Raphaelite Painting: A Critical Review." In *Collecting the Pre-Raphaelites: The Anglo-American Enchantment,* ed. Margaretta Frederick Watson, 199–208. Aldershot, UK: Ashgate, 1997.

Brantlinger, Patrick. *Rule of Darkness: British Literature and Imperialism, 1830–1914.* Ithaca: Cornell University Press, 1988.

Broby-Johansen, R. *Body and Clothes: An Illustrated History of Costume.* Trans. Karen Rush and Erik I. Friis. London: Faber and Faber, 1968.

Brunette, Peter, and David Wills. "The Spatial Arts: An Interview with Jacques Derrida." In *Deconstruction and the Visual Arts: Art, Media, Architecture,* ed. Peter Brunette and David Wills, 9–32. Cambridge: Cambridge University Press, 1994.

Bryson, Norman. *Word and Image: French Painting of the* Ancien Régime. Cambridge: Cambridge University Press, 1981.

———, ed. *Calligram: Essays in New Art History from France.* Cambridge: Cambridge University Press, 1988.

Bryson, Norman, Michael Ann Holly, and Keith Moxey, eds. *Visual Theory: Painting and Interpretation.* Cambridge: Cambridge University Press, 1991.

Buchanan-Brown, John. *The Book Illustrations of George Cruikshank.* Newton Abbot, UK: David and Charles, c. 1980.

Burton, Anthony. "Cruikshank as an Illustrator of Fiction." *Princeton University Library Chronicle* 35 (1974): 93–128.

Burne-Jones, Edward. "Essay on *The Newcomes.*" *Oxford Magazine* (January 1856): 50–61.

Byerly, Alison. *Realism, Representation, and the Arts in Nineteenth-Century Literature.* Cambridge: Cambridge University Press, 1997.

Carlyle, Thomas. "Occasional Discourse on the Nigger Question." London: Thomas Bosworth, 1853. Originally published in *Fraser's Magazine,* December 1849.

Casteras, Susan P. *The Substance or the Shadow: Images of Victorian Womanhood.* New Haven, CT: Yale Center for British Art, 1982.

———, ed. *Pocket Cathedrals: Pre-Raphaelite Book Illustration.* New Haven, CT: Yale Center for British Art, 1991.

———. "Seeing the Unseen: Pictorial Problematics and Victorian Images of Class, Poverty, and Urban Life." In *Victorian Literature and the Victorian Visual Imagination,* ed. Carol T. Christ and John O. Jordan, 264–88. Berkeley and Los Angeles: University of California Press, 1995.

"The Cawnpore Massacres." The *Times,* September 30, 1857, 6.

Chatelain, Madame de. *Little Ada and Her Crinoline: A Tale of the Times for Little Folks.* London: Dean and Son, 1862.

Chesneau, Ernest. *The English School of Painting.* Trans. Lucy N. Etherington. London: Cassell, 1885.

Christ, Carol T., and John O. Jordan, eds. *Victorian Literature and the Victorian Visual Imagination.* Berkeley and Los Angeles: University of California Press, 1995.

Clayton, Ellen C. *English Female Artists.* 2 vols. London: Tinsley Brothers, 1876.

Collins, Wilkie. *Basil.* Ed. Dorothy Goldman. 1852. Reprint, Oxford: Oxford University Press, 1990.

Conrad, Peter. *The Victorian Treasure-House.* London: Collins, 1973.

Cowling, Mary. *Victorian Figurative Painting: Domestic Life and the Contemporary Social Scene.* London: Andreas Papadakis, 2000.

Crane, Walter. *Of the Decorative Illustration of Books Old and New.* 1896. Reprint, London: Bracken, 1984.

"Crinoline in the Studio." *Punch,* May 2, 1857, 177.

Crinoline Reprinted from "The Illustrated News of the World." London: Emily Faithfull, 1863.

"Crinoline Viewed as a Depopulating Influence." *Punch,* May 2, 1857, 171.

"Crinolineomania." *Punch,* December 27, 1856, 253.

Cruikshank, George. "Barclay and Perkins's Drayman." In *The Universal Songster,* vol. 2. London, 1826.

Curtis, Gerard. *Visual Words: Art and the Material Book in Victorian England.* Aldershot, UK: Ashgate, 2002.

Dabydeen, David. *Hogarth's Blacks: Images of Blacks in Eighteenth Century English Art.* Manchester, UK: Manchester University Press, 1987.

Dalziel, George, and Edward Dalziel. *The Brothers Dalziel: A Record of Work, 1840–1890.* 1901. Reprint, London: Batsford, 1978.

Daniels, Morna. *Victorian Book Illustration.* London: British Library, 1988.

Davidoff, Leonore, and Catherine Hall. *Family Fortunes: Men and Women of the English Middle Class, 1780–1850.* London: Hutchinson Education, 1987.

Davis, Fred. *Fashion, Culture, and Identity.* Chicago: University of Chicago Press, 1992.

Defoe, Daniel. *The Life and Surprising Adventures of Robinson Crusoe of York, Mariner with an Account of His Travels Round Three Parts of the Globe with Numerous Engravings from Drawings by George Cruikshank.* London: David Bogue, 1853.

Derrida, Jacques. *Of Grammatology.* Trans. Gayatri Chakravorty Spivak. Baltimore: Johns Hopkins University Press, 1974.

———. *Spurs: Nietzsche's Styles.* Trans. Barbara Harlow. Chicago: University of Chicago Press, 1979.

Dickens, Charles. *The Letters of Charles Dickens.* Vol. 7, 1853–1855. Ed. Graham Storey, Kathleen Tillotson, and Angus Easson. Oxford: Clarendon, 1993.

Dillon, Steven. "Watches, Dials, and Clocks in Victorian Pictures." In *The Victorian Illustrated Book,* ed Richard Maxwell, 52–90. Charlottesville: University Press of Virginia, 2002.

Dorsey, Peter A. "De-authorizing Slavery: Realism in Stowe's *Uncle Tom's Cabin* and Brown's *Clotel.*" *ESQ: A Journal of the American Renaissance* 41 (1995): 256–88.

Ducksworth, Sarah Smith. "Stowe's Construction of an African Persona and the Creation of White Identity for a New World Order." In *The Stowe Debate: Rhetorical Strategies in "Uncle Tom's Cabin,"* ed. Mason I. Lowance Jr., Ellen E. Westbrook, and R. C. De Prospo, 205–35. Amherst: University of Massachusetts Press, 1994.

Easthope, Antony. *Englishness and National Culture.* London: Routledge, 1999.

Eastlake, Elizabeth. "Modern Painters." *Quarterly Review* 98 (March 1856): 384–433.

Edelstein, T. J. "Augustus Egg's Triptych: a Narrative of Victorian Adultery." *Burlington Magazine* (1983): 202–10.

Edwardes, Michael. *Battles of the Indian Mutiny.* London: B. T. Batsford, 1963.

Elegant Arts for Ladies. London: Ward and Lock, 1856.

Eliot, George. *The George Eliot Letters,* ed. Gordon S. Haight. London: Oxford University Press, 1956.

Elkins, James. *On Pictures and the Words That Fail Them.* Cambridge: Cambridge University Press, 1998.

Ellenius, Allan. "Reproducing Art as a Paradigm of Communication: The Case of the Nineteenth-Century Illustrated Magazines." *Figura* 21 (1984): 69–92.

Engen, Rodney K. *Dictionary of Wood Engravers.* Cambridge, UK: Chadwyck-Healey, 1985.

"*Enoch Arden:* By Alfred Tennyson." *Athenaeum,* December 23, 1865, 894.

Evans, Hilary, and Mary Evans. *The Man Who Drew the Drunkard's Daughter: The Life and Art of George Cruikshank, 1792–1878.* London: Frederick Muller, 1978.

"Female Dress in 1857." *Westminster and Foreign Quarterly Review,* October 1, 1857, 315–40.

"Female MP's." *Punch,* August 7, 1858, 59.

Fildes, L. V. *Luke Fildes, R.A.: A Victorian Painter.* London: Michael Joseph, 1968.

Fisch, Audrey A. "'Exhibiting Uncle Tom in Some Shape or Other': The Commodification and Reception of *Uncle Tom's Cabin* in England." *Nineteenth-Century Contexts* 17 (1993): 145–52.

Fischel, Oskar, and Max von Boehn. *Modes and Manners of the Nineteenth Century.* Vol. 3. Trans. M. Edwardes. London: J. M. Dent, 1909.

Flint, Kate. "Reading *The Awakening Conscience* Rightly." In *Pre-Raphaelites Re-viewed,* ed. Marcia Pointon, 45–65. Manchester, UK: Manchester University Press, 1989.

————. *The Victorians and the Visual Imagination.* Cambridge: Cambridge University Press, 2000.

Flugel, J. C. *The Psychology of Clothes.* The International Psychoanalytical Library, no. 18. London: Hogarth, 1940.

Fox, Celina. "The Development of Social Reportage in English Periodical Illustration During the 1840s and Early 1850s." *Past and Present* 74 (1977): 90–111.

"Framley Parsonage." Saturday Review of Politics, Literature, Science, and Art, May 4, 1861, 451–52.

"French Criticism on British Art." *Art Journal,* August 1855, 229–32.

"French Criticism on British Art." *Art Journal,* September 1855, 250–52.

"French Criticism on British Art." *Art Journal,* November 1855, 297–300.

"French Criticism on British Art. M. Maxime Du Camp." *Art Journal,* March 1856, 77–79.

Friedman, Albert B. "The Tennyson of 1857." *More Books,* January 23, 1948, 15–22.

Fry, Roger. *Reflections on British Painting.* London: Faber and Faber, 1934.

The Glories of Crinoline by a Doctor of Philosophy. London: Dalton and Lucy, 1866.

"Glorious News for the Gentlemen." *Punch,* January 31, 1857, 43.

Golden, Catherine J., ed. *Book Illustrated: Text, Image, and Culture, 1770–1930.* New Castle, DE: Oak Knoll Press, 2000.

Goldman, Paul. *Victorian Illustrated Books, 1850–1870: The Heyday of Wood-Engraving.* London: British Museum, 1994.

————. *Victorian Illustration: The Pre-Raphaelites, the Idyllic School and the High Victorians.* London: Scolar, 1996.

"A Good Dressing for the Ladies." *Punch,* June 25, 1856, 258.

Greenhalgh, Peter. *Ephemeral Vistas: The* Expositions Universelles, *Great Exhibitions and World's Fairs, 1851–1939.* Manchester, UK: Manchester University Press, 1988.

Gresty, Hilary. "Millais and Trollope, Author and Illustrator." *The Book Collector* 30 (Spring 1981): 43–60.

Guise, Hilary. *Great Victorian Engravings: A Collector's Guide.* London: Astragal, 1980.

Hadfield, John. *Every Picture Tells a Story.* London: Herbert, 1985.

Hall, N. John. *Trollope and His Illustrators.* London: Macmillan, 1980.

————, ed., with the assistance of Nina Burgis. *The Letters of Anthony Trollope.* Vol. 1, 1835–1870. Palo Alto, CA: Stanford University Press, 1983.

Harthan, John. *The History of the Illustrated Book: The Western Tradition.* London: Thames and Hudson, 1981.

Harvey, John. *Victorian Novelists and Their Illustrators.* New York: New York University Press, 1971.

————. *Men in Black.* Chicago: University of Chicago Press, 1995.

Heffernan, James A. W., ed. *Space, Time, Image, Sign: Essays on Literature and the Visual Arts.* New York: Peter Lang, 1987.

Helps, Arthur. "Uncle Tom's Cabin." *Fraser's Magazine* 46 (1852): 237–44.

Helsinger, Elizabeth. "Ruskin and the Politics of Viewing: Constructing National Subjects." *Nineteenth-Century Contexts* 18 (1994): 125–46.

Heraud, Edith. *Lecture on Tennyson, as Delivered at Unity Church and before the Society for the Fine Arts.* London: Simpkin, Marshall, 1878.

Hichberger, J. W. M. *Images of the Army: The Military in British Art, 1815–1914.* Manchester, UK: Manchester University Press, 1988.

"The Highlander at Home and Abroad." *Good Words* 1 (1860): 468–72.

"The Highlanders by the Well at Cawnpore." *Dublin University Magazine* 302 (1858): 209.

Hodnett, Edward. *Image and Text: Studies in the Illustration of English Literature.* Hampshire, UK: Scolar, 1982.

———. *Five Centuries of English Book Illustration.* Aldershot, UK: Scolar, 1988.

Hoffmann, Joel M. "What is Pre-Raphaelitism, Really? In Pursuit of Identity through *The Germ* and the Moxon *Tennyson.*" In *Pocket Cathedrals: Pre-Raphaelite Book Illustration,* ed. Susan P. Casteras, 43–53. New Haven, CT: Yale Center for British Art, 1991.

Holcombe, Lee. *Wives and Property: Reform of the Married Women's Property Law in Nineteenth-Century England.* Oxford: Martin Robertson, 1983.

Höltgen, Karl Josef, Peter M. Daly, and Wolfgang Lottes, eds. *Word and Visual Imagination: Studies in the Interaction of English Literature and the Visual Arts.* Erlangen, Germany: Universitätsbund Erlangen-Nürnberg, 1988.

hooks, bell. "The Oppositional Gaze." In *Black Looks: Race and Representation,* 115–31. Boston: South End Press, 1992.

"Hoop and Jupe." *Punch,* February 14, 1857, 63.

Houfe, Simon. *Dictionary of 19th Century British Book Illustrators and Caricaturists.* Woodbridge, UK: Antique Collectors' Club, 1996.

Hunt, William Holman. "Notes of the Life of Augustus L. Egg." *Reader* 9 (January 1864): 56–57.

———. *Pre-Raphaelitism and the Pre-Raphaelite Brotherhood.* Vol. 2. London: Macmillan, 1905.

"Illustrated Books." *Quarterly Review* 74 (1844): 167–99.

"Illustrated Works." *The London Review* 22 (January 1859): 474–92.

Japp, Alexander H. *Three Great Teachers of Our Own Time: Being an Attempt to Deduce the Spirit and Purpose Animating Carlyle, Tennyson, and Ruskin.* London: Smith, Elder, 1865.

James, Henry. *The Painter's Eye: Notes and Essays on the Pictorial Arts.* Ed. John L. Sweeney. London: Rupert Hart-Davis, 1956.

James, Philip Brutton. *English Book Illustration, 1800–1900.* Harmondsworth, UK: Penguin, 1947.

Jewsbury, Geraldine. *The Half Sisters.* Ed. Joanne Wilkes. 1848. Reprint, Oxford: Oxford University Press, 1994.

Katz, Bill, ed. *A History of Book Illustration: 29 Points of View.* Metuchen, NJ: Scarecrow, 1994.

Kingsley, Charles. *Literary and General Lectures and Essays.* London: Macmillan, 1898.

Kooistra, Lorraine Janzen. *The Artist as Critic: Bitextuality in* Fin-de-Siècle *Illustrated Books.* London: Scolar, 1995.

———. *Christina Rossetti and Illustration: A Publishing History.* Athens: Ohio University Press, 2002.

Kristeva, Julia. "Motherhood according to Giovanni Bellini." In *Desire in Language: A Semiotic Approach to Literature and Art*, ed. Leon S. Roudiez, trans. Thomas Gora, Alice Jardine, and Leon S. Roudiez, 237–70. Oxford: Blackwell, 1981.

Kunzle, David. "Dress Reform as Antifeminism: A Response to Helene E. Roberts's 'The Exquisite Slave: The Role of Clothes in the Making of the Victorian Woman.'" *Signs* 2 (1977): 570–79.

Lacan, Jacques. "The Signification of the Phallus." In *Ecrits: A Selection,* trans. Alan Sheridan, 281–91. London: Routledge, 1977.

———. *The Four Fundamental Concepts of Psycho-Analysis.* Ed. Jacques-Alain Miller. Trans. Alan Sheridan. Harmondsworth, UK: Penguin, 1994.

Lambourne, Lionel. *An Introduction to "Victorian" Genre Painting, from Wilkie to Frith.* London: H.M.S.O, 1982.

———. *Victorian Painting.* London: Phaidon, 1999.

Layard, George Somes. *Tennyson and His Pre-Raphaelite Illustrators: A Book about a Book.* London: Elliot Stock, 1894.

Leckey, Edward. *Fictions Connected with the Indian Outbreak of 1857 Exposed.* Bombay, 1859.

Lewes, George Henry. "Currer Bell's *Shirley.*" *Edinburgh Review* 91 (January 1850): 155.

"Liberavimus Animam." *Punch,* September 12, 1857, 108.

Life, Allan R. "The Periodical Illustrations of John Everett Millais and Their Literary Interpretation." *Victorian Periodicals Newsletter* 9 (1976): 50–68.

[Linton, W. J.] "Illustrative Art." *Westminster Review* 51 (1849): 92–104.

"Literature for Ladies." *Punch,* February 7, 1857, 51.

Lorimer, Douglas A. *Colour, Class, and the Victorians: English Attitudes to the Negro in the Mid-nineteenth Century.* Leicester, UK: Leicester University Press, 1978.

Losack, Frank. *Crinoline: Its Mysteries and Enormities Unmasked.* London, 1865.

"Luggage Trains for Ladies." *Punch,* October 30, 1858, 173.

Maas, Jeremy. *Victorian Painters.* London: Barrie and Jenkins, 1969.

MacGregor, Robert M. "The Eva and Topsy Dichotomy in Advertising." In *Images of the Child,* ed. Harry Eiss, 287–305. Bowling Green, OH: Bowling Green State University Popular Press, 1994.

Maclagan, Michael. *"Clemency" Canning.* London: Macmillan, 1962.

Maidment, B. E. *Reading Popular Prints, 1790–1870.* Manchester, UK: Manchester University Press, 1996.

Mainardi, Patricia. *Art and Politics of the Second Empire: The Universal Expositions of 1855 and 1867.* New Haven, CT: Yale University Press, 1987.

Marin, Louis. "Towards a Theory of Reading in the Visual Arts: Poussin's *The Arcadian Shepherds.*" In *Calligram: Essays in New Art History from France,* ed. Norman Bryson, 63–90. Cambridge: Cambridge University Press, 1988.

"Marriage and its Difficulties." *Punch,* May 16, 1857, 194.

Marsh, Jan. "'Hoping you will not think me too fastidious': Pre-Raphaelite Artists and the Moxon *Tennyson.*" *Journal of Pre-Raphaelite Studies* 2 (1989): 11–17.

Marsh, Jan, and Pamela Gerrish Nunn. *Women Artists and the Pre-Raphaelite Movement.* London: Virago, 1989.

Mason, Michael. "The Way We Look Now: Millais' Illustrations to Trollope." *Art History* 1 (1978): 309–40.

"A May-Day Feast," *Dublin University Magazine* (May 1851): 537–56.

Maxwell, Richard, ed. *The Victorian Illustrated Book*. Charlottesville: University Press of Virginia, 2002.

Mayhew, Henry, and George Cruikshank. *1851; or, The Adventures of Mr and Mrs Sandboys and Family, Who Came to London to Enjoy Themselves and to See the Great Exhibition*. London: George Newbold, 1851.

———. *London Characters and Crooks*. Ed. Christopher Hibbert. London: Folio, 1996.

McGarvie, Michael. "Eleanor Vere Boyle (1825–1916) (E.V.B.): Writer and Illustrator; Her Life, Work and Circle." In *Transactions of the Ancient Monuments Society*. Vol. 26:94–145. London: The Ancient Monuments Society, 1982.

Meisel, Martin. *Realizations: Narrative, Pictorial, and Theatrical Arts in Nineteenth-Century England*. Princeton: Princeton University Press, 1983.

Melville, Stephen. "Colour Has Not Yet Been Named: Objectivity in Deconstruction." In *Deconstruction and the Visual Arts: Art, Media, Architecture*, ed. Peter Brunette and David Wills, 33–48. Cambridge: Cambridge University Press, 1994.

Melville, Stephen, and Bill Readings, eds. *Vision and Textuality*. London: Macmillan, 1995.

Mill, John Stuart. *Considerations on Representative Government*. Vol. 19, *Collected Works of John Stuart Mill*, ed. J. M. Robson. Toronto: University of Toronto Press; London: Routledge and Kegan Paul, 1977.

Millais, John Guille. *The Life and Letters of Sir John Everett Millais*. London: Methuen, 1899.

Miller, J. Hillis. *Illustration*. London: Reaktion, 1992.

Mitchell, Rosemary. *Picturing the Past: English History in Text and Image, 1830–1870*. Oxford: Clarendon, 2000.

Mitchell, W. J. T. *Iconology: Image, Text, Ideology*. Chicago: University of Chicago Press, 1986.

———. "Going Too Far with the Sister Arts." In *Space, Time, Image, Sign: Essays on Literature and the Visual Arts*, ed. James A. W. Heffernan, 1–11. New York: Peter Lang, 1987.

Mitchinson, Wendy. *The Nature of Their Bodies: Women and Their Doctors in Victorian Canada*. Toronto: University of Toronto Press, 1991.

Montgomery, James, et al. *Poems on the Abolition of the Slave Trade*. London: R. Bowyer, 1809.

Muir, Percy. *Victorian Illustrated Books*. New York: Prager, 1971.

Nead, Lynda. *Myths of Sexuality: Representations of Women in Victorian Britain*. Oxford: Blackwell, 1988.

———. *Victorian Babylon: People, Streets and Images in Nineteenth-Century London*. New Haven, CT: Yale University Press, 2000.

"Negro Slavery in the States." *English Review* 18 (October 1852): 80–115.

Nochlin, Linda. *Women, Art, and Power and Other Essays*. London: Thames and Hudson, 1989.

Noel-Paton, M. H., and J. P. Campbell. *Noel Paton, 1821–1901*. Ed. Francina Irwin. Edinburgh: Ramsay Head Press, 1990.

Norton, Caroline. *English Laws for Women in the Nineteenth Century*. Privately printed, 1854.

———. *A Letter to the Queen on Lord Chancellor Cranworth's Marriage and Divorce Bill.* London: Longman, Brown, Green and Longmans, 1855.

Nowell-Smith, Simon. *The House of Cassell, 1848–1958.* London: Cassell, 1958.

Nunn, Pamela Gerrish. *Problem Pictures: Women and Men in Victorian Painting.* Aldershot, UK: Scolar, 1995.

"Our Address." *Illustrated London News,* May 14, 1842, 1.

"Our Library Table." *Sharpe's London Magazine,* August 1861, 103–5.

Page, Norman, ed. *Tennyson: Interviews and Recollections.* London: Macmillan, 1983.

Palgrave, Francis Turner. "Women and the Fine Arts." *Macmillan's Magazine* 12 (May 1865): 118–27.

———. "A Few Words on 'E.V.B.' and Female Artists." *Macmillan's Magazine* 15 (February 1867): 327–30.

Park, Roy. "'Ut Pictura Poesis': The Nineteenth-Century Aftermath." *Journal of Aesthetics and Art Criticism* 28 (1969): 155–64.

Patten, Robert L. *George Cruikshank's Life, Times, and Art.* Vol. 2. Cambridge, UK: Lutterworth, 1996.

Paulson, Ronald. "Hogarth and the English Garden: Visual and Verbal Structures." In *Encounters: Essays on Literature and the Visual Arts,* ed. John Dixon Hunt, 82–95. London: Studio Vista, 1971.

———. *Hogarth.* 3 vols. Cambridge, UK: Lutterworth, 1991–93.

Payne, Christiana. *Rustic Simplicity: Scenes of Cottage Life in Nineteenth-Century British Art.* Nottingham, UK: Djanogly Art Gallery, 1998.

Pennell, Joseph. *Modern Illustration.* London: Bell, 1901.

Pevsner, Nikolaus. *The Englishness of English Art.* London: Penguin, 1956.

"Photographic Illustrations of Tennyson." The *Times,* October 14, 1875, 4.

"Picture-Books." *Blackwood's Edinburgh Magazine,* March 18, 1857, 309–18.

Poovey, Mary. *Uneven Developments: The Ideological Work of Gender in Mid-Victorian England.* Chicago: University of Chicago Press, 1988.

Pykett, Lyn. *The "Improper" Feminine: The Women's Sensation Novel and the New Woman Writing.* London: Routledge, 1992.

Ray, Gordon N., ed. *The Illustrator and the Book in England, 1790–1914.* New York: Pierpont Morgan Library; Oxford: Oxford University Press, 1976.

Redgrave, Richard and Samuel Redgrave. *A Century of British Painters.* London: Phaidon, 1947.

Reid, Forrest. *Illustrators of the Sixties.* 1938. Reprint, London: Constable, 1975.

Renan, Ernest. "What is a nation?" Trans. Martin Thom. In *Nation and Narration,* ed. Homi K. Bhaba, 8–22. London: Routledge, 1990.

"Reviews." *The Art Journal,* July 1857, 231–32.

Reynolds, Graham. *Victorian Painting.* London: Herbert, 1987.

"The Rights of Women." *Punch,* May 23, 1857, 209.

Roberts, Helene E. "Marriage, Redundancy or Sin: The Painter's View of Women in the First Twenty-five Years of Victoria's Reign." In *Suffer and Be Still: Women in the Victorian Age,* ed. Martha Vicinus, 45–76. Bloomington: Indiana University Press, 1972.

———. "The Exquisite Slave: The Role of Clothes in the Making of the Victorian Woman." *Signs: Journal of Women in Culture and Society* 2 (1977): 554–69.

Robinson, Jane. *Angels of Albion: Women of the Indian Mutiny.* London: Viking, 1996.

Rossetti, Dante Gabriel. *Letters of Dante Gabriel Rossetti.* Vol. 1, 1835–1860. Ed. Oswald Doughty and John Robert Wahl. Oxford: Clarendon, 1965.

Rossetti, William Michael, ed. *Dante Gabriel Rossetti: His Family Letters with a Memoir.* Vol. 1. London: Ellis and Elvey, 1895.

———. *Ruskin, Rossetti, Prerapahaelitism.* London: George Allen, 1899.

Ruskin, John. *The Works of John Ruskin.* 39 vols. Ed. E. T. Cook and Alexander Wedderburn, London: George Allen; New York: Longmans, Green, 1903–12.

———. "The Awakening Conscience." In *The Works of John Ruskin,* vol. 12.

———. "Academy Notes, 1858." In *The Works of John Ruskin,* vol. 14.

———. *Time and Tide: Twenty-five Letters to a Working Man of Sunderland on the Laws of Work.* In *The Works of John Ruskin,* vol. 17.

———. *The Cestus of Aglaia.* In *The Works of John Ruskin,* vol. 19.

———. *Ariadne Florentina.* In *The Works of John Ruskin,* vol. 22.

Russell, William. *William Russell: Special Correspondent of the "Times."* Ed. Roger Hudson. London: Folio, 1995.

Said, Edward W. *Orientalism.* London: Routledge, 1978.

Saussure, Ferdinand de. *Course in General Linguistics.* Ed. Charles Bally and Albert Sechehaye. Trans. Wade Baskin. New York: McGraw-Hill, 1966.

Sayer, Karen. *Country Cottages: A Cultural History.* Manchester, UK: Manchester University Press, 2000.

Shanley, Mary Lyndon. *Feminism, Marriage and the Law in Victorian England.* Princeton: Princeton University Press, 1989.

Sharp, William. *Dante Gabriel Rossetti: A Record and a Study.* London: Macmillan, 1882.

———. *Progress of Art in the Century.* 1902. Reprint, London: W. R. Chambers, 1906.

Sharpe, Jenny. *Allegories of Empire: The Figure of Woman in the Colonial Text.* Minneapolis: University of Minnesota Press, 1993.

Shuttleworth, Sally. "Female Circulation: Medical Discourse and Popular Advertising in the Mid-Victorian Era." In *Body/Politics: Women and the Discourses of Science,* ed. Mary Jacobus, Evelyn Fox Keller, and Sally Shuttleworth, 47–68. New York: Routledge, 1990.

———. "Demonic Mothers: Ideologies of Bourgeois Motherhood in the Mid-Victorian Era." In *Rewriting the Victorians: Theory, History, and the Politics of Gender,* ed. Linda M. Shires, 31–51. New York: Routledge, 1992.

Sillars, Stuart. *Visualisation in Popular Fiction, 1860–1960.* London: Routledge, 1995.

Sinnema, Peter W. *Dynamics of the Pictured Page: Representing the Nation in the "Illustrated London News."* Aldershot, UK: Ashgate, 1998.

Sitwell, Sacheverell. *Narrative Pictures: A Survey of English Genre and Its Painters.* 1936. Reprint, London: Batsford, 1969.

Skilton, David. *Anthony Trollope and His Contemporaries: A Study in the Theory and Conventions of Mid-Victorian Fiction.* Basingstoke, UK: Macmillan, 1972.

———. "The Relation between Illustration and Text in the Victorian Novel: A New Perspective." In *Word and Visual Imagination: Studies in the Interaction of English Literature and the Visual Arts,* ed. Karl Josef Höltgen, Peter M. Daly, and Wolfgang Lottes, 303–25. Erlangen, Germany: Universitätsbund Erlangen-Nürnberg, 1988.

Smiles, Sam. *Eye Witness: Artists and Visual Documentation in Britain, 1770–1830.* Aldershot, UK: Ashgate, 2000.

Smith, Tennyson Longfellow. *Poems Inspired by Certain Pictures at the Art Treasures Exhibition, Manchester.* Manchester, 1857.

Staiger, Janet. *Interpreting Films: Studies in the Historical Reception of American Cinema.* Princeton: Princeton University Press, 1992.

Steig, Michael. *Dickens and Phiz.* Bloomington: Indiana University Press, 1978.

Stein, Richard L. "The Pre-Raphaelite Tennyson." *Victorian Studies* 24 (1981): 279–301.

Stephens, F. G. *Memorials of William Mulready.* London: Bell and Daldy, 1867.

Stowe, Charles Edward. *Life of Harriet Beecher Stowe Compiled from Her Letters and Journals.* London: Sampson Low, 1889.

Stowe, Harriet Beecher. *Uncle Tom's Cabin: A Tale of Life among the Lowly; or, Pictures of Slavery in the United States of America.* London: Ingram, Cooke, 1852.

———. *Uncle Tom's Cabin; or, Negro Life in the Slave States of America.* People's Illustrated Edition. London: Clarke, 1852.

———. *Uncle Tom's Cabin; or, the History of a Christian Slave.* London: Partridge and Oakey, 1852.

———. *Uncle Tom's Cabin with Twenty-seven Illustrations on Wood by George Cruikshank.* London: John Cassell, 1852.

———. *Uncle Tom's Cabin: A Tale of Life among the Lowly.* London: T. Nelson and Sons, 1853.

———. *Uncle Tom's Cabin; or, Life among the Lowly: A Tale of Slave Life in America.* London: Nathaniel Cooke, 1853.

———. *Uncle Tom's Cabin; or, Life among the Lowly.* London: Ward, Lock and Tyler, 1878.

———. *Uncle Tom's Cabin.* Ed. Jean Fagan Yellin. Oxford: Oxford University Press, 1998.

Sullivan, Edmund J. *The Art of Illustration.* London: Chapman and Hall, 1921.

Summers, David. "Real Metaphor: Towards a Redefinition of the 'Conceptual' Image." In *Visual Theory: Painting and Interpretation,* ed. Norman Bryson, Michael Ann Holly, and Keith Moxey, 231–59. Cambridge: Cambridge University Press, 1991.

Suriano, Gregory R. *The Pre-Raphaelite Illustrators.* London: British Library, 2000.

Taine, Hippolyte. *Notes on England.* Trans. Edward Hyams. 1872. Reprint, Fair Lawn, NJ: Essential, 1958.

Tales of Irish Life, Illustrative of the Manners, Customs, and Condition of the People: With Designs by George Cruikshank. 2 vols. London, 1824.

Taylor, Tom. "Magenta." *Once a Week,* July 2, 1859, 10.

Tennyson, Alfred Baron (later Lord). *Tennyson's Poems.* London: Moxon, 1857.

———. *The May Queen.* Illustrated by EVB. London: Sampson Low, 1861.

———. *The May Queen Illuminated by Mrs W. H. Hartley, Chromolithographed by W. R. Tymms.* London: Day and Sons, 1861.

———. *The May Queen in Illuminated Borders Designed by L. Summerbell.* London: George Berridge, 1872.

———. *Some Poems of Alfred Lord Tennyson: With Illustrations by W. Holman Hunt, J. E. Millais and D. G. Rossetti . . . With a Preface by J. Pennell treating of the illustrators of the sixties and an introduction by W. Holman Hunt.* London: Freemantle, 1901.

———. *The May Queen.* Illustrated by C. E. Brock. London: Ernest Nister; New York: E. P. Dutton and Co., 1908.

———. "The Defence of Lucknow." In *The Poems of Tennyson,* vol. 3, ed. Christopher Ricks, 36–39. Essex: Longman, 1987.

———. *Letters of Alfred Lord Tennyson.* Vol. 2, 1851–1870. Ed. Cecil Y. Lang and Edgar F. Shannon Jr. Oxford: Clarendon, 1987.

———. *Guinevere: The Idylls of the King.* In *The Poems of Tennyson.* Ed. Christopher Ricks, 941–59. Essex: Longman, 1987.

Tennyson, Hallam, Lord. *A Memoir.* Vol. 1. London: Macmillan, 1897.

———. *Tennyson and His Friends.* London: Macmillan, 1911.

"Tennyson, Illustrated by Doré." The *Times,* December 29, 1868, 10–11.

Thackeray, William Makepeace. *The Paris Sketch Book and Art Criticisms.* Ed. George Saintsbury. London: Oxford University Press, n.d.

———. *The Newcomes: Memoirs of a Most Respectable Family.* Ed. D. J. Taylor. 1853–55. Reprint, London: Dent, 1994.

———. *The Letters and Private Papers of William Makepeace Thackeray.* Vol. 3, 1852–1856. Ed. Gordon N. Ray. Cambridge, MA: Harvard University Press, 1946.

Thomas, Julia, ed. *Reading Images.* Hampshire: Palgrave, 2000.

———. *Victorian Narrative Painting.* London: Tate, 2000.

Tompkins, Jane. *Sensational Designs: The Cultural Work of American Fiction, 1790–1860.* New York: Oxford University Press, 1985.

Treble, Rosemary. *Great Victorian Pictures: Their Paths to Fame.* London: Arts Council of Great Britain, 1978.

Treuherz, Julian. *Victorian Painting.* London: Thames and Hudson, 1993.

Trollope, Anthony. *He Knew He Was Right.* Ed. David Skilton. 1868–69. Reprint, London: J. M. Dent, 1993.

———. *An Autobiography.* Ed. David Skilton. 1883. Reprint, Harmondsworth, UK: Penguin, 1996.

Trudgill, Eric. *Madonnas and Magdalens: The Origins and Development of Victorian Sexual Attitudes.* New York: Holmes and Meier, 1976.

Twain, Mark. *Life on the Mississippi.* New York: Harper and Row, 1951.

Ullman, Jennifer M. "The 'Perfect Delineation of Character': Process and Perfection in the Book Illustrations of John Everett Millais." In *Pocket Cathedrals: Pre-Raphaelite Book Illustration,* ed. Susan P. Casteras, 55–65. New Haven, CT: Yale Center for British Art, 1991.

"*Uncle Tom's Cabin* and Its Opponents." *Eclectic Review* 4 (December 1852): 717–44.

Vaughan, William. "Incongruous Disciples: The Pre-Raphaelites and the Moxon *Tennyson.*" In *Imagination on a Long Rein: English Literature Illustrated,* ed. Joachim Möller, 148–60. Marburg, Germany: Jonas Verlag, 1988.

———. "The Englishness of British Art." *Oxford Art Review* 13, no. 2 (1990): 11–23.

Vizetelly, Henry. *Glances Back through Seventy Years: Autobiographical and Other Reminiscences.* Vol. 1. London: Kegan Paul, Trench, Trubner and Co. 1893.

Wagner, Peter. *Reading Iconotexts: From Swift to the French Revolution.* London: Reaktion, 1995.

Wakeman, Geoffrey. *Victorian Book Illustration: The Technical Revolution.* Newton Abbot, UK: David and Charles, 1973.

Warner, Marina. *Alone of All Her Sex: The Myth and Cult of the Virgin Mary.* London: Picador, 1985.

Weathers, Rachel. "The Pre-Raphaelite Movement and Nineteenth-Century Ladies' Dress: A Study in Victorian Views of the Female Body." In *Collecting the Pre-Raphaelites: The Anglo-American Enchantment,* ed. Margaretta Frederick Watson, 95–108. Aldershot, UK: Ashgate, 1997.

Wendorf, Richard, ed. *Articulate Images: The Sister Arts from Hogarth to Tennyson.* Minneapolis: University of Minnesota Press, 1983.

West, Shearer. "Tom Taylor, William Powell Frith, and the British School of Art." *Victorian Studies* 33 (1990): 307–26.

Whistler, James McNeill. "Mr Whistler's Ten O' Clock." In *The Gentle Art of Making Enemies.* 1890. Reprint, London: William Heinemann, 1994.

White, Gleeson. *English Illustration: "The Sixties"; 1855–1870.* 1897. Reprint, Bath, UK: Kingsmead Reprints, 1970.

Whiting, George Wesley. "The Artist and Tennyson." *Rice University Studies* 50 (Summer 1964): 1–84.

"Who Killed Crinoline?" *Once a Week,* May 8, 1869, 369–71.

"Why Ladies Cannot Sit in Parliament." *Punch,* March 7, 1857, 99.

Whyte-Melville, George. "Strong-Minded Women." *Fraser's Magazine for Town and Country* 68 (1863): 667–78.

Wilkie, David. "Remarks on Painting." In *The Life of Sir David Wilkie,* by Allan Cunningham, vol. 3. London: John Murray, 1843.

Williams, Raymond. *Culture and Society, 1780–1950.* London: Chatto and Windus, 1958.

"Willing Hands for India." *Punch,* August 29, 1857.

Willmott, Robert Aris, ed. *The Poets of the Nineteenth Century.* London: George Routledge, 1858.

Witemeyer, Hugh. *George Eliot and the Visual Arts.* New Haven, CT: Yale University Press, 1979.

Wood, Christopher. *Victorian Panorama: Paintings of Victorian Life.* London: Faber and Faber, 1976.

———. *The Pre-Raphaelites.* London: Weidenfeld and Nicolson, 1981.

———. *Victorian Painting.* London: Weidenfeld and Nicolson, 1999.

Wood, Marcus. *Blind Memory: Visual Representations of Slavery in England and America, 1780–1865.* Manchester, UK: Manchester University Press, 2000.

Wood, Mrs. Henry. *East Lynne.* Ed. Andrew Maunder. 1860–61. Reprint, Ontario: Broadview, 2000.

Žižek, Slavoj. *Looking Awry: An Introduction to Jacques Lacan through Popular Culture.* Cambridge, MA: MIT Press, 1991.

INDEX

Note: Page numbers in italics refer to illustrations